Streaming the Formula 1 Rivalry

COMMUNICATION, SPORT, AND SOCIETY

Lawrence A. Wenner, Andrew C. Billings, and Marie C. Hardin
General Editors

Vol. 10

Raymond Boyle and Richard Haynes

Streaming the Formula 1 Rivalry

Sport and the Media in the Platform Age

PETER LANG

New York · Berlin · Bruxelles · Chennai · Lausanne · Oxford

Library of Congress Cataloging-in-Publication Control Number: 2023054701

Bibliographic information published by the Deutsche Nationalbibliothek.
The German National Library lists this publication in the German
National Bibliography; detailed bibliographic data is available
on the Internet at http://dnb.d-nb.de.

Cover design by Peter Lang Group AG

ISSN 1080-5397
ISBN 9781433198182 (hardback)
ISBN 9781433198175 (paperback)
ISBN 9781433198151 (ebook pdf)
ISBN 9781433198168 (epub)
DOI 10.3726/b21634

© 2024 Peter Lang Group AG, Lausanne
Published by Peter Lang Publishing Inc., New York, USA
info@peterlang.com - www.peterlang.com

This publication has been peer reviewed.

For Noelle, Lauren and Liam (RB)
For Susan, Alice and Adam (RH)

CONTENTS

ACKNOWLEDGMENTS

As always thanks to those who have helped with this book along the way. In particular, to our colleagues in both the Centre for Cultural Policy Research (CCPR) at the University of Glasgow and the Division of Communications, Media and Culture at the University of Stirling. Although we have worked together on articles and book chapters this is our first co-authored book project in over a decade and also our first book-length return to the area of media and sport. Much has changed, but much remains recognisable about the terrain and we argue that taking a longer historically informed view of the sports media relationship remains important, not least when academic myopia appears to be on the increase. There was a sports media culture that predates the internet.

Thanks to Larry Wenner, Andy Billings and Marie Hardin for commissioning us for their Communication, Sport and Society series. This type of empirically grounded research is completely reliant on getting access to key stakeholders across the sports and media industries. Hence a heartfelt thanks to all those who agreed to speak with us on the record for this book or helped more generally with the fieldwork process. In particular thanks to: Ben Anderson, James Bareham, Andrew Benson, Matt Bishop, Rebecca Clancy, Amanda Docherty, Mark Gallagher, Maurice Hamilton, Ian Holmes, Ben

Hunt, Bradley Lord, Jess McFadyen, Stuart Morrison, Ellie Norman, Liam Parker, Craig Slater and Richard Williams. We also acknowledge the use of previously unpublished material from an oral history interview with the late motor sport commentator Murray Walker and television producer Peter Dimmock conducted as part of a British Academy small grant project 'Behind The Mic' in 2008.

A special mention to Stuart Morrison, Head of Communications at MoneyGram Hass F1 team and former University of Stirling student (who one author even taught, way back when) and has gone on to enjoy great success in the media, communications and motorsport industries both in the UK and the USA. Thanks for helping to open a few doors.

INTRODUCTION: RE-INVENTING SPORT

Inside the world of Formula One, things are rarely as they seem.

Richard Williams (1998) *Racers*, London: Penguin, page 3.

Television: Back to the Future

Journalist Richard Williams spent a year, getting inside Formula 1 (F1) back in the mid 1990s. His analysis, suggested a sporting and business culture shrouded in secrecy and misdirection, with the media often complicit in this process. A quarter of a century later it remains a sporting culture that continues to intrigue and attract massive media attention. However, the relationship between the media and sport has never been one of equal partners. While both parties have often derived benefit from the marriage, over the years, one partner, television has come to dominate the media sport nexus. We've argued before about the various staging posts in this relationship, often as new waves of technological innovation disrupt established patterns of media production, distribution and consumption (Boyle & Haynes, 2004, 2009). In truth it is often only in retrospect that periods of relative stability in the media sport relationship appear and these moments often get reconstructed as some form of a 'golden age' of sport. They are often characterised as a more innocent time, with less media intrusion, often less commercially orientated and certainly less complex than the contemporary media sporting environment. Of course, such discourses, often deeply embedded in sporting narratives, offer only a partial insight into sports long relationship with various forms of media and commercial drivers and can obscure as much as they illuminate.

That we are living through a moment of profound change in the media landscape is beyond dispute and its impact is being felt well beyond sport. Dan McGolpin, a senior BBC executive and Controller of the corporation's iPlayer platform argues that:

> We are heading towards another era [one defined by the migration of viewers from broadcast television, via channels, to] internet-delivered television…That transition is taking a period of time, but that's the journey we are on. (Harvey, 2022: 74)

It is a journey with profound implications for sport. What these are and how these are being played out across the production, distribution and consumption of a sport such as Formula One (F1) are at the core of this book.

As discussed in more detail in the next chapter, the media and television in particular has always played a central role in the transformation of elite sport. The nineteenth century, saw the creation of sporting heroes by the newspaper industry, while the immediacy of live commentary on radio helped create national media events, and then, most profoundly, the reshaping of sport by television since the 1950s and 1960s. Change in the media-sport relationship has been constant, with the erosion of strictly limited television and radio, for example in the UK, from the late 1980s, disrupting the established media sport relationships with the arrival of pay-TV. The arrival and growth of the internet in the 1990s and video sharing channels a decade later add further complexity and finally the arrival of the platform economy of more recent times that was supposed to kill linear television, but has in fact led to internet delivered television across multiple, often mobile devices.

Almost by stealth, something has happened to sport along the way through a combination of this whirlwind of media change (and the accompanying money flowing to the elite end of sport), and also, as we see throughout the book, major changes in the patterns of how the audience consume, engage and pay for media content. This transformative change is more evident in some sports than others. In the UK, football, in many ways has been at the leading edge of change and is the most high-profile chameleon in this respect. As Aaron Gourley, Editor of the trade *fcbusiness* magazine suggests:

> Clubs have transformed into sporting and business empires that stretch far beyond their local footprint. Many are complex, multi-functional, multi-national businesses which employ the very best people across performance and business. Many do not see themselves as sporting organisations anymore – they are entertainment operations where audience figures in Asia or the accumulative spend of a fan in the US counts. These clubs have a complex understanding of how people interact with them, how much they spend and their purchasing habits and brand desires that make them hugely valuable to potential sponsors. (Gourley, 2021: 11)

On this journey sport has shifted from being less popular cultural ritual to a more consumer-based media product, funded through a mixture of private equity, State backed owners, international sports franchise entrepreneurs and almost anyone but the original 'legacy' fans who are left to simply consume the live and mediated 'product'. This shift, specifically in the UK from sport

as a cultural form to a media-based entertainment product is now raising issues around the governance of sport, the impact of ownership structures on competitive balance, and perhaps more fundamentally, who or what is sport for in the age of digital streaming.

The Sporting Reveal

Sometimes moments in media sport reveal more than they intend. Sport is driven by narratives. It is the stories in and around sport that make it such a compelling cultural form. In some sports, television and the media more generally, amplify pre-existing sporting narratives, often around success and failure. In others, it's the media that have constructed (or indeed invented) the narratives and shape the form and structure of the sporting contest. But ultimately all sport is transformed by its engagement with the media that re-represents the sport often to millions of viewers unable to attend the event live. And the value of sport (to both fans and the media) is often in its live-ness, the way it can at a particular time create a moment of historical sporting significance that transcends the sport itself.

One such media moment was the conclusion of the Abu Dhabi F1 (Formula One) Grand Prix at the Yas Marina Circuit, on the Sunday evening of 12 December 2021. Watched live by an audience of 108.8 million across over 200 countries worldwide (F1-2021 Global Fact Sheet). The final F1 Grand Prix of the 2021 season, drew a UK television viewership that accounted for 60% of the available TV audience, with 4.4 m watching on the free-to-air Channel 4, while 3 million watched across the subscription-based Sky Sports network. In the age of digital immersion, many (but not all) also took to social media to express their opinion and engage in the sports chatter that is such an integral part of the value of sport to the media and various platforms, as well as integral to the pleasure it offers to dedicated fans, by extending the conversation long after the event has finished.

This was the final F1 race that would decide who would become World Champion, with Mercedes AMG Petronas F1 team (Mercedes) driver Lewis Hamilton attempting to win an unprecedented eighth world title, while being pursued by the Red Bull Racing driver Max Verstappen who had to win this race to take his first ever world title. Ben Anderson, then Editor of GP Racing argues that this had been an F1 season unlike any in recent memory. He notes:

> this was no ordinary season. This is an age of polarisation; divisions amplified and solidified by the toxic power of unfettered and irresponsible social media. As true in F1 as it is in life. Lewis Hamilton, Max Verstappen, Mercedes and Red Bull tore lumps out of each other – on track and off- creating an atmosphere of mutual distrust and resentment, which spilled beyond the paddock. (Anderson, 2022: 4)

In fact, the race was playing out as many had anticipated with Hamilton leading with a degree of comfort and seemingly progressing to the world title. All this changed with just six laps to go, when the driver Nicholas Latifi spun his Williams car into the barriers and forced the Safety car to be deployed. Verstappen pitted his Red Bull car for new tyres, while Hamilton remained out, concerned that if he pitted, he would concede his position on the track, with the strong possibility that the race would end under the auspices of the safety car.

What happened next became a major media controversy, resulting in the governing body of world motorsport and F1, the Federation Internationale de l'Automobile (FIA) launching an investigation into events (FIA, 2022) resulting in the demotion of the Race Director Michael Masi from his position. Masi, being openly lobbied by the team principals and their representatives, seemingly disregarded two elements of the FIA rulebook to allow the race to finish under what are called 'green flag' conditions. Masi, allowed just 5 cars to unlap themselves, thus allowing Verstappen to move immediately behind Hamilton, and then with only one lap remaining allowed the race to restart (technically it should have been restarted only at the end of the lap when the lapped cars had been allowed to move clear).

In short, we now had a one lap race off for the World Title, with the challenger's car on new tyres and the evaporation of Hamilton's substantial lead built up during the race. Verstappen duly passed Hamilton on the final lap and became World Champion. For many the decisions appeared at odds with notions of sporting integrity and were more designed to appease a television audience. As journalist Matthew Syed reflected:

> It is hardly original to note that the climax to last season wasn't a pure instance of sporting drama. No, this felt more like scripted entertainment: a race director under pressure from the overlords of the sport to ensure that the narrative reached a peak of dramatic tension. (Syed, 2022: 56)

The drama continued after the race with protests being lodged by Mercedes, with the stewards eventually throwing them out citing regulations that gave the race director 'overriding authority' over the safety car regulations. The

online social media reaction was extensive and vitriolic often breaking along supporter lines of Hamilton and Verstappen, with talk in the aftermath that Hamilton may step away from F1 following a lack of faith in the governance of the sport.

What this moment revealed is the growing tension between a sport being mediated by television, and one that is being scripted or reshaped directly for a television audience at the expense of traditional notions of sporting etiquette and integrity. One of the underpinning values of sport has always been its inherent unpredictability, although as money has flowed to the elite end of sport, this has increasingly eroded this one crucial element of sports appeal. Interestingly, unpredictability is one trait that private investors wish to avoid. Yet for sport it is the possibility that on any given day the underdog, might spring a surprise, that in part differentiates sport on television from scripted entertainment, where the outcome is ultimately predetermined.

The subsequent FIA (FIA, 2022) investigation, eventually published in March 2022, concluded that 'human error' was responsible for the decisions that led to the last lap race off for the world title. It made a number of recommendations including the restructuring of F1 race control. The suspicion remains that the pressure to increase the media profile of the sport and grow its digital online presence as it raises its profile and fan base through, for example the Netflix series *Drive To Survive* (see Chapter Five) may have played a part in this sporting moment. McLaren driver, Lando Norris was quoted as saying that the race climax had been 'made for TV', with teammate Daniel Riccardo adding that 'I'm glad I wasn't part of that' (Benson, 2002). The fact that such suspicions arose around this event is indicative of the challenges faced by any sport that is increasingly pulled into the orbit of the demands of television, and these are amplified in a social media age, where opinion, information and conspiracy theories abound and help shape broader public perceptions and particular narratives. Hence, an interest in this tension between sporting integrity and the demands of being a media entertainment business runs through the book.

F1: The Global Sport

F1 is an international sport that offers ten construction teams the opportunity to provide 20 cars and drivers to take part in motorsport's highest level single seater racing for an annual World Championship and Constructors

Championship. The formula in F1 comes from the agreed set of rules that must be adhered to by the cars involved in this top level of motorsport. The 2022 season ran from Spring to the year-end and took place across 22 Grand Prix races that were staged across the globe in cities in Europe, Asia, North and South America and Oceania. The competition has been running since 1950 (when initially there were only 7 races). At the centre sits the Grand Prix weekend, with the race itself the pinnacle after two days of practice and qualifying (to determine the starting position of the twenty cars on race day). It lasts usually around 2 hours and involves intense high spread racing with points allocated to the top ten place finishers of the race, with the top three drivers securing podium finishes.

However, F1 is more than a sport. It has become an international business, driven by marketing, high-end technological innovation, branding, car manufacturers, corporate advertising and is financially underwritten by international television. The construction teams, some such as Ferrari, McLaren, Aston Martin or Mercedes are direct car manufacturers, that have historically used their F1 involvement to showcase their brands, while offering a media space to promote various corporate partners willing to pay vast amounts of money to help sustain the teams, in return for global media exposure and evolving forms of various sponsorship activation. In short, F1 teams offer a global platform to investors to promote their brand and secure a return on their investment. Given the cost of running a contemporary F1 team, such sponsorship is an integral part of the business. For example, until the introduction of the budget cap in 2021 to a spend of around $145m, teams such as Mercedes might have spent close to $480m in previous seasons, in so doing they were outspending rival teams such as HaasF1 by almost four to one.

The drivers and the cars are the stars of the sporting narrative, yet they sit at the apex of a massive sporting, technological and commercial business operation unlike any other sport. Some F1 teams can be employing a workforce of up to 3000 across multiple sites and countries. A successful Constructors team such as Mercedes, eight times winners of the Constructors championship in the last decade or so, employ well over a 1000 people who rarely attend the actual Grand Prix events and work around the clock at their state-of-the-art technology centre based on a 60,000 m² site in Brackley, 70 mile north of London. These designers, engineers, operational managers and business support workers in areas such as finance, legal and IP are all part of the operation that underpins a modern F1 team on a scale that dwarfs other sporting global institutions such as say Manchester United or Real Madrid in football. In a

F1 team you will have organisational divisions such as a Management team, Commercial department, Research and Development, Technical division, Finance and administration, Marketing and PR and a Legal department.

As we discuss in Chapter Three, F1 as a sport and the running of an F1 team was not always such a complex, industrial and corporate finance driven business. The history of the sport has ebbed and flowed in terms of the development of teams and its attendant media coverage (Hamilton, 2021) while the corporate professionalisation and hyper commercialisation of the sport really begins in earnest in the 1980s with the growing influence of Bernie Ecclestone on the direction of the sport and the central role that global television exposure would offer to brands and businesses. More recent years have seen the expansion in both the number of Grand Prix races per season and the introduction of new city locations from China, to Russia and perhaps most controversially the Gulf States, where staging a Grand Prix, has become part of a wider political mobilisation of sport to both normalise and promote a city and State through an international media platform.

In this study then F1 offers a microcosm of many of the dominant trends that are re-shaping modern elite sport across the globe, and in so doing are forcing some to ask, what do we actually mean by sport? Is its integration into a modern media entertainment business model now so complete, that money and commercial opportunities solely drive the sport and its appetite to commodify all aspects of the industry and seek to monetise these? What role does it play in the promotion of 'soft power' associated with a state's desire to alter its global reputation and reshape its economy? How will the rise of the platform as the dominant mode of content distribution change the nature of the relationships between stakeholders in the sports media network? And what of the fans, viewers, social media content creators and spectators of F1, how are they changing and evolving and what does their relationship with the sport tell us about the nature of modern sports fandom in platform age? To this there is an added interest in this study. In F1 we have to all intents and purposes a sport now controlled by a media corporation and while such patterns of ownership are growing among sports clubs, control of the commercial rights to an entire sport are unique and make F1 with its fusion of media and sporting interests a compelling case study.

F1 Changes: Liberty Media and New Racing

The recent changes introduced by F1 for the 2022 season, were driven by the change of ownership of the sport when it was secured by Liberty Media back in 2017 from CVC Capital who had secured the sport in 2005, from Bernie Ecclestone, allowing him to stay on as CEO. The new rules, the most significant since the 2014 introduction of the hybrid power units were to increase competition and make it easier for cars to overtake during races. In short, it was to improve the televisual spectacle of the sport. As Toto Wolff, the Mercedes team principal commented after the second ace of the 2022 series

> The cars delivered on what F1 hoped for [from regulation changes this season]- great overtaking and providing a great show. F1 has achieved what they wanted to; spectacular racing, good overtaking and the grid has been shaken up. The midfield is extremely close, so overall I'm happy about the hype around F1. (Clancy, 2022)

The importance of the television spectacle for the sport is crucial. In the contemporary media environment, with access to multiple mobile platforms to access sports related content or what we might call supplementary on-demand sports content, the live television event remains central in F1.

Ironically, in many ways F1 is not the ideal sport for the medium of television. Operationally working on the minimum space, maximum action adage of television sports coverage, a F1 Grand Prix is a complex event to televise given the speed of the cars, and the physical scale and layout of the tracks. In addition, television does not reveal the struggles, nor the intense range of skills required by the modern driver, sitting deep within the car with only their branded helmet visible to the audience. Matt Bishop, then Chief Communications Officer of the Aston Martin F1 team reflects on how the sport has changed over the years:

> I think that nature of man and machine against the circuit is still there, and the courage is still there and the skill is still there. It's just very difficult to see.
> [] Tennis on television you can see the agility and the brilliance and the inventiveness of the players, you can see every rippling sinew you can see that sweat drops you can see the look of hope or fear on their face or their desperation or ambition. In Formula One everybody's covered in racing overalls and a helmet. Now you can't even see their hands moving, you used to be able to see that. So, it is hard to see but it's still going on. It's the same athleticism updated and modernised. (Interview with Author, 11 July 2022)

Hence television and its codes and conventions have to work hard to communicate the speed, danger and athleticism involved in the sport, and as we see later in Chapter Four technology has aided this process, as has the building of pre and post-race coverage and extensive analysis in more recent years. This has occurred at a time when traditional television consumption is in decline, although television type content is being consumed across a range of platforms in what appears to be a changing video content ecosystem. As Robert Szabo-Rowe, the Senior Vice President of video production and distribution company The Switch argues:

> The new era of live sports consumption sees short, snappy, on-demand highlights of a broad range of content take preference beyond just the main broadcast – including pre-game interviews, betting odd analysis, player and coach interviews and full post-show press conferences. This whole range of content- which always begins life as live Tv but has a much longer shelf life through social and video-on-demand platforms-creates an exciting content continuum and a far richer media landscape for broadcasters and other rightsholders to capitalise on. (Szabo-Rowe, Broadcast, 26/8/22)

The live sports event remains central, with much of the traditional value in media rights still in the liveness of the sporting moment, but the streamer services and the social media platforms are now increasingly in the market for supplementary on-demand content generated around sports, such as any exclusive behind the scenes material, much of this content being curated by a new generation of social media influencers and content creators (see chapter Six). This is part of the backdrop to the focus of the book on F1 and the changing nature of sports media consumption.

This book is also about examining what feels like an important moment in the long history between sport and its mediation. Identifying such moments is notoriously difficult not least when you are in the middle of maelstrom. Barry Hearn, sports promoter, and someone who has both shaped and born witness to the evolution of sports relationship with the media over the last 40 years across sports from snooker to boxing, feels we are at such a moment. Reflecting on the pressure traditional Pay-Tv models of sport are under in the platform age from new players such as DAZN, an OTT video streaming service only launched in 2016, he argues:

> Attitudes change, people change, and money certainty changes. Companies such as DAZN are able to muscle in on the market, pay more money to begin with to be disruptive while they create their own market, taking advantage of the fact youngsters no longer want to sit on the settee at home with Mum and Dad. They want to

watch wherever they want to be and on whatever device they choose. It all points to a whole new operation in terms of pay TV. Time will tell whether DANZ will be the ones to get it right, but my guess is they will and in so doing will become the Netflix of sport. (Hearn, 2022: 270)

Are we seeing sport move from a business to business (B2B) model to one characterised by a direct to consumers (D2C) paradigm? One key issue in the digital age of sport is access rights holders have to viewer/fan data. As Barr and Kretchmer (2022) remind us:

> While attracting subscribers with bundles of exclusive content is a key pillar of the streaming model, another key element of on-demand video services is accumulation and control of valuable data pertaining to audience viewing habits and personal interests. Here the global streaming brands hold considerable informational advantages over Channel 4 as a provider of a largely domestic offering for UK audiences. These troves of valuable data inform the commissioning strategy of streamers as well as driving algorithmic recommendation mechanisms. As such, this type of data is deemed commercially sensitive and not shared with external production companies, broadcasters or Ofcom. (Barr & Kretchmer, 2022)

During this maelstrom of media change, we argue it can be illuminating to try to take the long view of sport's relationship with the media and technological change.

Before the take-over by Liberty Media, F1 operated a hybrid model of sports organisation. By this we mean its European origins were clear in its rather unstructured evolution with the numbers of teams and cars on the grid for example changing over time. There was of the course the FIA oversight through the implementation of the formula regulations, but these were constantly being renegotiated, and there were no cost limits on the spend of the teams involved. However, the semi-closed nature of the competition, and the rather unclear pathway for teams wishing to enter the sport at F1 level (with Bernie Ecclestone as the ultimate gatekeeper), was more akin to the North American sports model, which has always viewed and positioned sport as a business. And more than this, not just any business, but part of the entertainment business, free from wider social or cultural responsibilities.

We argue that the Liberty Media takeover has ended any confusion over the dominant model being developed by the sport. Unsurprisingly they have adopted the North American model, with its semi-closed competition (no relegation for finishing bottom of the constructor's championship). They were also keen to offset the financial challenges that the sport had faced in previous

seasons, where the last three years had seen only three teams being represented on the podium, and with major teams (MRT, Manor Racing Team) having to leave F1 due to financial issues. To that end they decided to adopt the US sport model of cost capping, in this case in terms of the spend of the teams involved, in order to retain some element of competitive balance in the paddock. Allied with this, they also undertook to pursue all revenue generating avenues, again in keeping with the North American sports paradigm.

While it would take time to implement, the direction of travel was clear. F1 would be modelled on the franchise-based US sports model, of controlled access, offsetting of some risk, but aligned with market intervention to protect the competitive integrity of the competition, which actively sought to maximise revenues, from in the case of F1, expanding the number of Grand Prix per season.

In essence the book argues that F1 is a 'for profit' media entertainment business, and while distinctive in some ways, in others the sport represents the logical endgame of the journey elite sports have been on for many years (Boyle & Haynes, 2009; Boyle, 2011) and their position within the wider media and cultural ecology that has been continually evolving. In short, the sport represents the exchange model of the future of many elite sports. The sport is part mass ritual, part conduit for selling high end consumer products and services. It is about delivering a significant return to Liberty Media shareholders and seeks to build and deepen relationships with an international fan base of avid consumers, the vast majority of whom will engage and experience the sport through various forms of media platforms. As technology develops and key media players mobilise this to disrupt existing paradigms, more and more of this sports content will potentially be delivered through a direct to consumer commercial model, with a significant impact on the existing selling and distribution of media rights and current public service and Pay-Tv incumbents.

We have previously argued (Boyle & Haynes, 2000, 2009) that sport reflects wider social, cultural and economic aspects of society. The notion of keeping politics out of sport, has always been a fallacy, sport is deeply embedded in politics, economy and society. Understanding this process, its implications for a range of sporting and media stakeholders and identifying its wider cultural, social, economic and at times political importance is what the book seeks to explore.

A Brief Note on Methods

The use of secondary data is often common in academic engagements with the sports industry and we have mobilised this approach ourselves through examining previous research, industry reports and publically available corporate documents. Importantly though we have aimed to extend this through a range of interviews with key stakeholders across both the media and sporting landscape. To do this we rely on the generous giving of time by invariably busy people who gain nothing commercially from speaking freely with us. To that end (as we acknowledge at the start of the book) thanks to all those who agreed to speak on the record, in so doing adding we feel real value and insight into both a sport and a media industry in the midst of organisational and cultural change. There were others we would have liked to speak with, but were unable to engage, but these are offset by the quality of those who did.

Finally, by way of introduction a brief outline of the structure of the book is explained below.

Structure of the Book

Chapter 1: Scene Setting: Sport, Media and the Platform Economy

This chapter places the study in the context of recent academic work on the relationship between media and sport. In particular it examines the concept of mediatisation, and research into the networked sports media relationship, as well as the nature of research into global sports networks. The chapter also looks at the growing research around the platform economy defining its use in this study and examining the conceptual issues raised by this shift in media distribution including its impact on the production and consumption of media content. The chapter sets out the conceptual framework within which this book locates its original study of F1 with its focus on the importance of political economy, sports business model, cultural representations and the globalisation of sports culture.

Chapter 2: Racing History: F1 and the Media

This chapter places this study within the broader cultural, political and economic history of F1 since its inception in the early 1950s. It places the relationship with the media, and television in particular, which has been at the core of the sport since its inception within a broader historical media context.

Drawing on original material from the BBC archives it maps out the various stages of media development that have shaped the history, structure and governance of the sport as it evolves from an amateur pursuit into the professional era of the 1960s and 1970s. It investigates the first re-invention of the sport in the mid 1970s when control was secured by Bernie Ecclestone, who used media rights to re-shape the sport and internationalise it while establishing a framework for its coverage by the media and journalists that would exist until his exit from the sport almost 40 years later. The chapter sets up the key historical antecedents of the relationship between F1 and the media that would see its re-invention over the last decade.

Chapter 3: Digital F1 and Reinventing Sport

This chapter draws on original fieldwork research to examine the re-invention of F1 in the digital age. It maps out the key changes taking place across the media and communication sectors and how these are mobilised by the new owners of F1 Liberty Media to re-think the sport, its relationship with investors, sponsors, fans and most crucially the media. The development of social media strategy and a more comprehensive digital framework help re-position the sport as it seeks a new digital audience, while attempting to retain its legacy audience. It also examines the political and economic context as the sport increases its global reach and in so doing highlights the growing importance of the geo-politics of sporting discourse as the media sport environment is disrupted by the growth of platforms and new media players.

Chapter 4: Telling the Story: F1, Journalism & Media Representations

This chapter focuses specifically on the relationship between journalism, journalists and the F1 circuit. Drawing on original material and interviews with key stakeholders the chapter examines the importance of story-telling and the construction of narratives around the F1 season. It places this within the context of the battle to control the narratives that exist around the on and off-track rivalries that exist in the highly politicised world of F1. It examines issues of access and control and how the digital environment has restructured the relationship between sports journalism and the sport. It also examines the range of representations that exist around F1 and how these are shifting and changing as social media profiles and brand management have become more important among the drivers, the teams and the organisers of the sport.

Chapter 5: Streaming F1, Media Rights and the Netflix Effect

This chapter drawing on original research examines the impact the streamers are having on the sport both as new competition in terms of media rights, but also as conduits for related sports content such as the Netflix's Drive to Survive documentary series. This has been credited with increasing the profile of the sport in the USA and also among a differing audience demographic for F1 content. How accurate are these assumptions? And how is Liberty Media as the F1 rights owner shaping the strategy of the sport in this more fluid environment? In examining this area, what insights are offered into the changing nature of the sports-media relationship and what we understand by sport in the platform age.

Chapter 6: Consuming F1: New Patterns of Fandom?

This chapter focuses on how the consumption of F1 content, for many years tightly controlled by limited media coverage, has dramatically altered in the last few years. The advent of social media and digital media engagement strategies across investors, teams, drivers and other stakeholders in the media and sports industries has been significant in transforming the opportunities to engage with F1 content. This chapter examines the impact of this on the type and nature of the audience engagement and in turn asks whether this change also plays back into changing structures and tensions within the sport itself. Are we seeing a growth in the entertainment and commercial values of F1 clashing with some of the wider ethical, political and social values associated with such a high profile, international and controversial sport?

Conclusion: Into Tomorrow

This chapter returns to the issues raised at the start of the book and highlights some of the key findings from this study that emerge from both the case study of F1, but also the wider evolving media-sports relationship. As we stand on the cusp of more technological innovation through the potential cultural and commercial changes offered by the metaverse, what does this case study of F1 tell us about the future of sport and its relationship with the audience, the media and its ongoing cultural, economic and cultural impact?

· 1 ·

SCENE SETTING: SPORT, MEDIA AND THE PLATFORM ECONOMY

Sport is simultaneously a global phenomenon and a local and personal one. It is simultaneously a gigantic commercial business and a gigantic voluntary exercise. It is both dependent on government and a major influence on public policy. It offers simultaneously role models and bad examples, conformists and free spirits. It serves to promote good citizenship and as a vehicle for crime. It combines entertainment and authority: it can serve millions of people as a diversion from ordinary life and give millions of others a meaning to their lives. Sport fulfils all these conflicting roles in global society through a multi-layered and mutually dependent relationship with the media and other commercial interests. There is no simple definition of what modern sports stands for and therefore no simple solutions to its many problems.

Mihir Bose (2012) *The Spirit of the Game: How Sport Made the Modern World*, page 570.

Mihir Bose's closing thoughts on the role of sport in society are over a decade old, yet his analysis and investigation in the business of sport captures some of the contradictions that run through the sport-media relationship. It is also a relationship marked by change as patterns of media production, distribution and consumption continually evolve. The cultural critic (and dedicated television sports fan) Raymond Williams (1961) wrote well over half a century with regard to the challenges about understanding the long revolution that was ongoing between culture, society and the mass media. He noted the difficulty of making sense of trends when you were in the midst of social and cultural change. The challenges faced by Williams, writing in the early analogue years of television in the1960s appear even greater to those of us trying to make sense of the current digital and technological maelstrom through which sports, the media and society are navigating.

This chapter places the study in the context of recent academic work on the relationship between media and sport. In particular it examines the concept of mediatisation, and research into the networked sports media relationship, as well as the nature of research into global sports networks. The chapter also looks at the growing research around the platform economy defining its use in this study and examining the conceptual issues raised by this shift in media distribution including its impact on the production and consumption of media content. The chapter sets out the conceptual framework within which this book locates its original study of F1 with its focus on the importance of political economy, the sports business model, cultural representations and the globalisation of sports culture.

Sport and the Media

Growth and consolidation of media sport research

The mediated coverage of sport is built into the fabric of everyday popular culture, a process that began in the nineteenth century and consolidated in the twentieth century once broadcasting developed. This was first evident in Europe and North America, but has now reached most parts of the globe, accelerated further in the twenty-first century with the expansion of the internet. In spite of sports predominance across media platforms, practices and consumption, scholars in communications and media research, with some notable exceptions, largely avoided critical analysis of sports coverage in the latter half of the twentieth century (Wenner, 1989). The multi-disciplinary approaches to the media tended to focus on political communications or what may have been considered 'serious' social issues, often ignoring the socio-cultural importance of sport in everyday life and its epistemological value for research into society, the economy, politics and culture.

Within the emerging field of the sociology of sport, media analysis has long featured as a way to understand other phenomena, for example football hooliganism in the 1970s and 1980s (Hall, 1978). But it wasn't until the 1990s with work by Barnett (1990), Whannel (1991), Rowe (1995), Wenner (1989 and 1998) and others in the early 2000s (Boyle & Haynes, 2000; Billings, 2008; Hills & Kennedy, 2009), that more fundamental questions of production, representation and consumption of what Lawrence Wenner termed 'MediaSport' and others have termed the 'media-sports cultural complex' (Jhally, 1989; Rowe, 1999) began to be systematically unpicked. The

formation of international journals in the field of media and sport, along with collegial networks of international scholars, have certainly challenged and changed such perceptions in the wider disciplinary fields of communication and media studies, but there remain echoes of sport being side-lined or omitted altogether from major works in media histories, the political economy of communications, collections on media representation and identities, media consumption or the wider importance of the media in society.

There have been various reasons as to why this should be so; avoidance of the 'frivolity' of sport in relation to the 'seriousness' of political journalism, documentaries or current affairs, or a desire to focus on fictional genres and representations in film and television, which are primarily cultural theories applied to investigations of production processes, narrative storytelling and identity. But we would also argue there has been a professional decision to avoid some of the complexities of media and sport among both communications disciplines and social sciences of sport. The media and sport bring two powerful, and increasingly global industries that deliver myriad experiences for citizens and forms of consumption within contemporary popular culture. They do so in ways which can be difficult to comprehend and critique with clarity, because the social relations and agents of power in the media and sport can be opaque, difficult to identify and therefore challenging to analyse. Mediated sport can be personal, communal, ritualistic, generational, environmental, national, global, social, economic, political, cultural, divisive, destructive, pleasurable, spiritual and very ordinary. Recognising this complexity is just the beginning of unpacking the multifarious ways in which the media and sport are inter-connected and impact on many people's lives. Recent research on media and sport has attempted to apply a wider spectrum of social theory to help understand these complexities. What follows is a brief overview of where these theoretical conversations have taken the field, which hint at where critical approaches to the media and sport may take us in the future.

The Logics of Media Sport and Mediatisation

Foremost in the attempts to understand the relationships between the media and sport is the recognition of how capitalism, or late-capitalism, has transformed media structures and practices, which in turn are part of capitalism's influence on sport in society more widely. David L. Andrews (2021: 275) has described it as 'Uber-capitalism' where processes of 'replicative corporatization', 'expansive commercialization', 'creative spectacularization' and 'celebritization' have turned elite sport towards the maximisation of profit, focused

on sport brands and media entertainment for the embellishment of sport stars. Any fan or consumer of sport can identify these processes at play in contemporary sport, which, because of their structures of power, dictate that they have an influence and impact on all levels of sport, intentionally or not.

The theoretical concern for how sport and the media inter-relate has gained further impetus from discussions which have expanded on the concept of 'media logic' to analyse the uneven power relations in the media's advances within sport during the twentieth century (Wenner, 1989). Recent studies focusing exclusively on the US media sport market include Kunz's (2020) examination of the political economy of the US sports market, taking a communications studies approach to mapping out changes in the US media market. While Johnson's (2021) study of sports on television provides a historically grounded account of the evolution of sport on US television, neither study makes reference to the sport of F1 on US television, an indication perhaps of the invisibility of the sport within US television up until this point, and something we argue in this book that has changed significantly in the last few years.

Fears about the intrusion of media institutions on sport have a long history, particularly among sport administrators who initially feared an existential threat to their sports from the development of television (Haynes, 2016). Academic research has therefore sought to explore and critique such concerns, drawing on social theories of the media to understand the media's influence on sport (Butterworth, 2021). Within such discussions, media sport scholars have also highlighted the cultural power of sport to shape and change media economies, organisations and practices (Rowe, 1999). These dynamic processes have been articulated further through the application of the theoretical concepts of 'mediatisation' and 'sportification' which account for more complex inter-relationships between sport and the media, where shifts in the balance of power between sport and the media are contingent on specific economic, political, social and cultural contexts (Frandsen, 2019). In the media-sport nexus the media can shape the fabric of sport experience and its meaning and significance. But sport can also shape the organisational structures, technological innovation and narrative representations within the media, which have resonance for the place of sport in popular culture more broadly. In F1, the interplay of an emergent motor sport from the 1950s, to its maturation as a global, hyper-commercialised television spectacle from the 1980s, therefore provides a specific case study in the complex economic and cultural power

relations in sport, which hitherto have been absent in the wider academic debate.

Sport and identity

One of the most significant contributions to wider social science and the humanities scholars in media and communications of sport or the sociology of sport have made has been in providing empirical knowledge on the relationships between sport and identity. Recognising the cultural importance of sport in people's lives, and the power dynamics of the representations of mediated sport have been highly productive.

One of the most productive areas in the field has been a focus on sport stars, which has featured heavily in work which has exposed how the relationship between sport and the media has changed over time as sport increasingly became commodified (Andrews, 2001) and the representation of the cultural figures of sport have been transformed and accelerated (Whannel, 2002). Evident inequalities in the coverage of sporting figures have driven investigation and critique on why such imbalances exist. Feminist scholars have produced detailed empirical knowledge on the heteronormative and masculinised representational biases and marginalisation of women in mainstream sports coverage (Cooky et al., 2013; Bruce, 2016). Such critiques have been expanded to new online sport outlets (Garcia & Profit, 2021) and the associated world of sport advertising (Posbergh et al., 2022). In spite of attempts by sport and media organisations to challenge the patriarchal structures and cultural stereotypes that permeate sports coverage (we discuss attempts by F1 to alter these narratives throughout the book), research has consistently revealed continuing empirical and ideological gaps in the coverage of women's and men's sports, which is particularly acute in the world of motor sport and F1 in particular (Matthew et al., 2016). It was only in January 2018, under the new commercial rights owners of F1, Liberty Media that the pre-race practice of the 'grid girls' parading around the paddock, promoting sponsors and teams was finally stopped, provoking a mixed reaction from UK media coverage (Tippett, 2020, 2023).

In relation to the representations of sport stars, F1 drivers are now framed by global mass communications as celebrities, which accelerates their fame, by producing media narratives which maintain the interest of global audiences and commercial interests. However, such commercial imperatives can create an ambiguity with other socio-cultural aspects of their personas, which frame them as heroes based on their deeds behind the wheel, their status as

national icons or their advocacy of wider cultural politics, including human rights activism. In this context, scholarly work on anti-racism campaigns in sport and sports media (Boykoff & Carrington, 2019), as well as knowledge on the post-colonial influence in framing contemporary sport (Carrington, 2010; Ariall, 2020) help situate emergent activism by sport stars, in both mainstream media interviews and increasingly across social media platforms.

Sport Journalisms

It is widely acknowledged that the professional practices and democratic function of journalism have been severely disrupted by the Internet and social media platforms in particular, to the extent that questions as to 'who is a journalist?' or 'what is journalism?' have come to pervade both industry and academic debate. As former editor of *The Guardian* Alan Rushbridger (2009: 19) has suggested about the place of journalism in the twenty-first century: 'We can probably agree it matters: it might be harder to agree any longer what journalism *is*.' Much information on websites and social media platforms has a quasi-journalistic function, which Rushbridger (2009: 19) notes, 'twist, complement, subvert or replace conventional journalism'.

In the digital world of sport, the scale and volume of such material is vast with every sport having an online presence reaching out to diverse audiences both global and local. The intermingling of legacy media sport structures – the written media and broadcasting – with the diffuse and disruptive online forms of digital communication has required new methodologies and theorisation to critically analyse the challenges and opportunities for sports coverage and sport journalism. Brett Hutchins and David Rowe (2012) in their landmark study *Sport Beyond Television* examined what they termed the 'rise of networked media sport'. Their analysis across sport journalism, sport broadcasting, sport blogging and sport computer games was the first sustained analysis of how the interrelationships between sport and the media were being transformed, often at breakneck speeds. The disrupters of established sport journalism's habitus revealed how the very 'structures and practices' of the profession were in 'flux', 'loose', 'contentious', 'fragile' and 'permeable' (Hutchins & Rowe, 2012: 150). Shaped by the network of networks of media sport, sport organisations, commercial interests, fans and governments the flow of information about sport has been radically altered since the late-1990s. Since 2012, the dial has arguably been turned up on their characterisation of sport journalism as a 'leaky craft' primarily due to advances in broadband enabled mobile telephony which has shifted the accessibility, speed and reach

of information from sport. Again, Hutchins (2012) was alert to the potential for smartphones and tablets to disrupt the 'media sport content economy' and one only has to think of how athletes use their social media as platforms to directly reach their audience to appreciate just how 'leaky' information flows in sport have become.

We concur with Hutchin's and Rowe's (and others) summary that sport as a form of content has proven to be a latchkey into the next generation of communications. Social media has transformed the everyday functioning of sport journalists. They are 'always on', reacting to unfolding events in the world of sport, constantly required to pass comment and join the conversation which elides the distinctions of information between sport, journalism and fans. Networked media sport, as Hutchins and Rowe envisaged, has arisen due to a number of processes which are shaped by markets, regulation, technologies and socio-cultural behaviours. The online distribution and consumption of sport content, its proprietorial ownership and circumvention, and the meaning of what sport is in the era of e-sports continue to require nuanced and interdisciplinary approaches to answer questions as to what is going on in the world of contemporary sport. We feel such questions are particularly apt in the networked media sport of F1.

Researching F1

Surprisingly, given the scale and international media profile of F1, the sport has until recently remained understudied in the broader sociology of sport field and the related communication and sport arena. Excellent new international research collections from across significant handbooks of sport and society (Wenner, 2023), sports journalism (Steen et al., 2021) and communication and sport (Butterworth, 2021) running to around 2250 pages collectively make but a handful of references to F1 or motorsport more generally. The most recent sustained academic work has tended to come from the business studies and sports marketing field with an edited collection by Naess and Chadwick (2023) examining the business, politics and wider social importance of motorsports, including F1. This impressive collection, while from time to time touching on the media and mediation of the sport of F1 has this as a peripheral focus of interest, rather than an area of sustained study. Another important addition to this area is the extensive collection of essays gathered together by Sturm et al. (2023). Running to almost 1000 pages, the

core focus of this work is on the history and politics of motorsport more gener-
ally, with chapters by Carrington (2023) on race, Evens et al. (2023) on media
ownership and Sturm (2023) on Formula 1 and television, the most pertinent
to this study.

David Hassan (2011a, 2011b) introduced a special issue of the *International
Journal of the History of Sport*, that focused on the global popularity of motor
sport, by noting the dearth of academic studies around the globalised motor-
sport field of which F1 of course constitutes but one part. This ground breaking
collection began to sketch a more historical academic approach to motorsport
and at times engaged with F1 in for example the work by O'Kane (2011)
which offered an historical account of the 'Triple Crown' of motor racing, The
Indianapolis 500, the Le Mans 24 Hours and the Monaco Grand Prix, which
since the inception of F1 world championship has been a constant in the rac-
ing calendar, but has of course been staging Grand Prix's since 1929. O'Kane
stresses the historical importance these three iconic races play in aspects of
American, French and European cultural identity. While the best full account
of the historical, cultural and sporting importance of the Monaco Grand Prix
remains the book by journalist Malcolm Folley (2017), O'Kane's research into
the importance in American national and local popular culture of the 'Indy
500' and the work of Shackleford (2011) and the history of NASCAR in the
US offer insight into the differing European and USA cultures of motorsport.
The former characterised by an initial European gentile amateurism, the lat-
ter informed by a more robust working-class, commercial culture. In so doing
they raise the issue of class, race and even gender and perhaps hint at reasons
why F1 has found competing against the indigenous motorsport culture of the
US so difficult over the years. As we note later in the book, this is of course a
situation that has dramatically changed in the last few years.

While de Melo's (2011) research provides a fascinating insight into the
early history of motorsport in Brazil (between 1908 and 1954), providing the
historical culture that will go to produce such F1 stars as Fittipladi, Piquet
and of course Senna. Yet despite this important collection, later published
as a book, Hassan's central argument about the paucity of academic research
into motor sport remains valid. As we note in the following chapter, with the
exception of the work of say Haynes and Robeers (2020) that provided an
historical analysis of the BBC's coverage of post war motorsport, the historical
relationship between the media and F1 also remains largely unexplored from
a media and communications studies perspective.

A notable exception is work by Mark Finn (2020, 2023) that attempts to take the concept of mediatisation, discussed earlier in the chapter, and apply it to studying aspects of motorsport, including Formula 1. As Finn argues:

> Most professional sports have a close connection with various forms of media, but few are as deeply reliant on media as motorsport. While fans of sports like tennis or football can actively participate in versions of their favourite sport on a casual basis, the high costs and potential dangers of motorsport mean that for the vast majority of fans it is the *mediated* experience. From the still photographs of the early days of the sport through to the multi-camera satellite broadcasts of today, motorsport has relied on media technologies to satisfy existing fans and potentially find new ones. (Finn, 2020: 973)

Finn reminds us of how deeply embedded the media are in the motorsport industry, not least through the key role of sponsorship (and the need for media exposure) as one of the financial underwriters of the sport of Formula 1, and the teams that compete at this elite tier of motorsport. In one sense this is not new, Whannel (1992) examined what he called the sporting triangle of sport, television and sponsorship and we (Boyle &Haynes, 2009) have talked about how television has been the financial underwriter of elite sport for a number of years.

What Finn highlights though is the additional role of gaming and licensed racing games in particular as an important way in both promoting the sport and opening Formula 1 to new younger audiences. The development since 2017 of an esports F1 race series was a significant recognition by the sport of its importance to be in this space, and as we argue later in the book, esports would prove to be an important substitute for some fans (and F1 drivers) during the Covid lockdown, when for a period actual Grand Prixes could not take place. Although for Witkowskie et al. (2021) this type of online motorsports activity also highlighted some central issues around the culture of esports arguing that:

> As media sports integrate esports into their profile, convoluted cultural affects and challenges unfold from participant safety and responsible marketing to proprietorship of content and choices surrounding the 'right' rules of play. (Witkowski et al., 2021: 10)

What is interesting about Finn's research, is the centrality that television maintains as both a key mediator of the sport and in its representation of the sport a key influencer on other mediated forms. Be that the live F1 track

experience (dominated by big screens relaying the television feed). The other area of note is the way in which Formula E (Robeers, 2019) has adopted interactive media technology, through things like FANBOOST, that allows fans to directly boost the electric power of the car of their favourite driver during a race (Finn, 2020: 947). This level of interplay has not been replicated in Formula 1, which as we noted in our introduction, currently has no requirement to further enhance the elements of sporting controversy already embedded in the sport and its media coverage.

With regard to media representation Sturm's (2014) examination of the media spectacle created by F1, captures well the pre-Media Liberty era of the mediated sport in terms of its tightly controlled media coverage and broadcasting criteria, and in particular its refusal to engage to any significant degree with 'new media'. Perceptively Sturm, writing in 2014 identifies the challenges of such a traditional approach being taken by the sport in terms of its media strategy. He notes that:

> Arguably, such an approach will remain problematic, if not futile, in an increasingly digitized media age.[] While Formula1.com is seemingly the obvious site for future 'official' global live visual streaming, such transformations may still be some way off. (Sturm, 2014: 73)

It is this transformation (2017-) that is examined throughout the book and specifically in Chapter Three. Sturm also captures a moment in the sport as the mostly Europe centred nature of the sport has changed and the global nature of the racing calendar is becoming normalised and indeed expanded.

Sturm's (2014, 2017) research positions the sport as a key part of the mega-media events sports culture and brings into sharp focus the extent to which the televised races sit at the centre of F1 media coverage and drive the dominant image and discourses that are centred around the sport. He reminds us that over 70 years since the start of the world championships, that F1 operates as a major sporting event, but also as a media event and media spectacle. What has become a highly commercial and technology driven sporting/business infrastructure is dependent on its television coverage. Through this Sturm argues that the sport:

> projects a glamorous and high-tech global spectacle of speed that evokes elitism, the exotic and an aura of expensive sophistication, often directly associated with its technologies, localities or assumed jet-set lifestyle. (Sturm, 2014: 80)

To what extent, this critique remains the case for the sport almost ten years on in terms of the media coverage is a theme within the book and specifically addressed in Chapter Four, but Sturm's work is an important and rare intervention into F1 analysis from a media and communications perspective.

One focus of this book is on the importance of spectacle in communicating aspects of a wider cultural identity, that can often be an important element of the ideological and commercial business model of the sport. Interestingly the work of Mark Lowes (2018) although initially coming from within communication and sport perspective is more concerned with the promotional aspect of the sports discourse. In particular how F1 grand prix events are promoted and mobilised by host cities as part of a wider strategy to position a city as a 'world class' sporting and cultural venue, characterised as part of a cosmopolitan network of global cities. Given this concern with what Low (2018: 215) calls 'urban placemarketing strategies' it is hence perhaps unsurprising that where the academy has engaged with the sport of F1, it tends to be from a marketing, business school perspective and often with a focus around the growth of F1 as a series of marketing global mega-events. It is this research that we examine in the next part of this chapter.

Marketing and Business Approaches to F1

There is a body of research into F1, that is broadly concerned with the economic impact, often on host cities or regional economies of staging a F1 Grand Prix. The work comes out of management and business schools, often concerned with regional or urban economic development and/or dedicated sports industry research units with a strong economic impact framing. As is often the case among such work, there is not always a shared consensus around the measuring of the economic benefits derived by host cities and countries in staging mega sporting events, although the focus tends to be around FIFA World Cups or the Olympic Games (summer and winter) research into the staging of F1 Grand Prix events also forms part of this wider body of literature. Work by Lui and Gratton (2010) was distinctive in that it chose to examine the (relatively positive) impact on the image of a city in staging of the Shanghai F1 Grand Prix, rather than taking a more economically driven model of analysis seen in the work of Kim et al. (2017) which argued there was a significant positive economic impact in staging the F1 Grand Prix on the city's economy. While Choe et al. (2017) framed their research around the 2011 Korean F1

Grand Prix arguing, also, that such events bring significant economic benefits to, in the case, the tourist economy in that country.

By way of contrast, work from Storm et al. (2020) examined European Grand Prix events staged between 1991 and 2017 to investigate the economic impact on European regional economies. They found that hosting such events did not impact positively on GDP, employment rates or even tourism in the regions they examined. The debate among economists is often around differing methodological approaches between what they call IO modelling, cost-benefit analysis (CBA) and panel data regression techniques. In simple terms, all models have their critics (and advocates) but the former tends not to include the actual costs involved in staging the event, while the latter will strip out the actual costs from any economic uplift. Indeed, Storm et al. (2020) go as far to argue that:

> The implications of our findings are that politicians, public authorities and other stakeholders should reconsider the argument that using public funds to host F1 races is a sound investment. (Storm et al., 2020: 834)

Comparative research by Ramasamy et al. (2022) examined the impact of staging major golfing, tennis and F1 events on patterns of international tourism and the ability of particular countries Canada, the UK and Australia to mobilise mega-sports events to boost the tourism economy. They concluded that while staging an F1 Grand Prix was extremely valuable to Montreal and the Canadian economy, indeed they argue it is the largest tourist event in that country generating a tourist spend of US$90million in its ability to attract international tourists. They also noted that:

> F1 is however not a significant attractor of international tourists in the other two countries [Australia and the UK]. (Ramasamy et al., 2022: 2092)

In other words, they argued that the economic impact of staging F1 races, in terms of attracting international tourists, varied from country to country. For the purposes of this research, what is of interest is the relative lack of interest in media coverage as part of the process, but also a recognition that outwith of the World Cup and the Olympics, the F1 season has developed into a truly unique international city focused event with a footprint well beyond its European origins. It also highlights that the growth of the sport, in for example the UAE, hosting its first Grand Prix in 2009 in Abu Dhabi is being

driven not solely by economic concerns, often the historic driver for cities and countries to host such events, but rather by wider geo-political concerns.

These issues were also highlighted by Ed Warner's (2018) research into the financial drivers of elite sport and how money continues to shape sports culture and industry. Warner concluded that,

> Sport is an expensive business, its economics distorted by the involvement of billionaires seeking playthings and aspirant nation states craving acceptance. These investors have raised the stakes across the sporting landscape. (Warner, 2018: 250)

Interestingly, this aspect has also recently been highlighted by Chadwick (2022) who has advocated a moving beyond the dominant utilitarian (often European in origin) and neoclassical (often North American in origin) approaches in the field of sports management. He argues that a new geopolitical approach is required in this academic field to both capture the new realities of wider shifts in the global power base of elite sports away from Europe and the USA, and to better understand the increasingly complex nature of the relationship between sport, geography, politics and economics. He defines this as:

> The way in which nations, states and other entities engage in, with, or through sport for geo-graphic and politico-economic reasons in order to build and exert power, and secure strategic advantages through the control of resources within and via networks of which sport is a constituent part. (Chadwick, 2022: 693)

He argues not for a complete jettisoning of traditional ways in which sport has been framed by this discipline, rather that 'new life is breathed into our community and its work by the new geopolitical economy of sport' (Chadwick, 2022: 700). He develops this argument further in the collection of essays (Chadwick et al., 2023) that focus on the geopolitical economy of sport. We are highly sympathetic to this approach that sees sport linked to issues such as international soft power and diplomacy and wider State economic and political policy. Yet even in this work the media can at times appear peripheral from the accounts of sports growing power and influence. As we noted earlier in this chapter, within media and communication studies, issues around the political economy of the media and the political and cultural importance of media representations have long been central to that discipline, and its engagement with sport as a cultural form. Broadening this approach (around political economy and media representations and power) to additionally focus on sports media in terms of the changing global geography of elite sports

(something that has been part of the mega-media events discourse in the past) is vital, we ague throughout the book, if we wish to understand the contemporary trajectory and evolution of a sport such as F1.

A rarity among much academic research into the world of F1 is to be found in the work of Jenkins et al. (2016). Their research benefits from having significant access to the key stakeholders within the sport (during the pre-Liberty Media period), both in terms of interviews with key F1 managers, but also with paddock access facilitated by Bernie Ecclestone (Jenkins et al., 2018: 1), no doubt aided by the fact that two of the authors Ken Pasternak and Richard West had extensive contacts within the corporate sector and in the case of West had held senior commercial roles with three F1 teams including McLaren and Williams. The research led by Professor Jenkins from Cranfield School of Management, is open about the limitations of reading across from this very specialised and particular sporting business, F1, into other areas and sectors of business and commerce. However, they also convincingly argue that key learnings around leadership in a highly complex, fast paced, multi-stakeholder competitive environment make such studies relevant and of interest to a wider business school audience and beyond. They also showcase the impact that practice and innovation in the sport can have as transferable skills into a range of sectors including the health and safety arenas.

The third edition of this research originally appeared in 2016, but even by this time, it was being noted that the level of media scrutiny that the sport was under was changing. Jenkins et al. note that:

> Formula 1 has always been an active and attractive target for media scrutiny. The level of public awareness and, perhaps from the teams' point of view, invasiveness, has been multiplied exponentially as more social network formats are being employed. Today not only does the large press corps that follow Formula 1 travelling show has its say, but so does any fan or detractor who wishes to post their views. (Jenkins et al., 2018: 51)

However as in much of the management studies in this area the media are often mentioned in passing only and are not the key focus of the study, rather it is the issue of individual and collective leadership, with the challenges imposed by the specific nature of a sport, that is part of a wider business complex. Other examples include the work of Elberse (2022a, 2022b) and her study into the key leadership lessons offered by the highly successful Mercedes F1 Team Principal Toto Wolff who (along with Susie Wolff) presented a master-class in leadership to students at the Harvard Business School in March 2022.

Aspects of leadership and innovation in motorsports can also be found in research around the electric racing world championship of Formula E. Research by Naess and Tjonndal (2021) from within the field of sports management offers a sustained examination of the role of innovation and leadership that has been so important in attempts to establish a greener and more sustainable motorsport culture through the Formula E series. By way of contrast it's F1's complicity in 'greenwashing' (along with others sports including football) that is the focus of Miller's (2016) call for environmental activitism. Ironically, since Miller's research, it is the former sport that has made the greater strides to become more environmentally responsible, with engine changes and an ongoing commitment set out in 2019 to be net carbon neutral by 2030 and to have introduced 100% sustainable fuel by 2026. From a science perspective, journalist and university academic Kit Chapman (2022) makes a compelling case around the extent to which the sport, and the technology and innovation that is embedded in its R & D has resulted in wider social benefits from car safety, to changes in medical practice and equipment in the treatment of trauma, noting also how it was the Mercedes F1 team that helped prevent London hospitals becoming overrun during the Covid pandemic, engineering and building 10,000 breathing aids in less than a month (Chapman, 2022: 13).

Economic Studies of F1

There has also been an interest in the sport of F1 from the discipline of economics. For example, research studies by Judde, Booth and Brooks (2013) and Schreyer and Torgler (2016) both use economic data modelling to explore aspects of competitive balance within the sport, the former around the impact of regulation changes on this, while the latter where more interested in outcome uncertainty around Grand Prixes and television audiences in Germany. Both studies, while coming to the issues from differing economic perspectives reached broadly similar conclusions. The more competitive balance can be achieved across the F1 paddock among the teams, the better for gross sponsorship exposure, the integrity of the sport and, perhaps most relevant for this study, that uncertainty of race outcome increases television audiences and wider interest in the sport. In short, the more the sport enhances competition between the teams, the better for television ratings and by association the value the sport can derive from media rights.

These issues are also picked up in one of the major economic studies of the sport of F1 by Paulo Mourao (2017) in his book into the economics of

motorsports and specifically Formula 1. This study sets out to provide an overview of the sport through the optics of an economist and in so doing makes the case of why such a study can benefit the sport, and also the wider field of sports economics and the economic studies more generally. Mourao (2017: 14) argues that 'Formula One is not only a market; it is a complex system of markets'. For economists, it offers a case study in the challenges of competitive balance within a sports market, a study of oligopolistic power in shaping a sport and associated industries, the importance for on-track success of mobilising human capital and how competition can generate positive externalities. The latter in the shape of shared knowledge, technology, practice and products that while forged through sporting competition, then directly impact on other non-sporting areas of the economy and wider society.

Mourao reminds us that in terms of media rights and audiences, 2008 saw the F1 world championship achieve global viewing figures of around 600 million, but that by 2017 these had fallen to around 450 million (Mourao, 2017: 78). Mourao's study (up to 2017) captures the sport on the cusp of change as the new owners reshape a sport that appears to be in relative decline (in terms of media/viewing popularity). Although driven by data and economic analysis, he astutely recognises the central importance of the more sociologically grounded aspects of culture and tradition in any sports enduring popularity. He notes that:

> Formula One creates tradition in families of fans – some families remember how a grandfather used to love watching Formula One races – in countries that repeatedly host Formula One races, in informal groups of friends, students, gamblers, and specialists, in new groups generated by today's social media, and in book reviews and discussions, and periodical articles about Formula One. [] Formula One attracts crowds. However, it is much more likely that teenagers will love Formula One if they watched races a few years ago, or if races take place in their countries. In sum, they are more likely to love Formula One if they live in a country with a Formula One tradition, an established Formula One culture. Therefore, countries having a history of races, drivers, champions, and constructors are likely to have races, competitive drivers, and constructors in the future. (Mourao, 2017: 254)

What Mourao (2017) couldn't predict was the direction of travel (with its focus on social media) the new owners of the commercial rights to F1, Liberty Media would take (see Chapter Three), nor the impact of the Netflix series *Drive to Survive* (see Chapter Five) on helping to create new pathways for fans to enter the sport. Nevertheless, their argument around the importance for the sport of establishing a culture or tradition, underpinned in Mourao's study

by economic analysis remains pertinent and is a strand that runs through this current research into the sport.

Insider Accounts of F1

Another area of insight in the business and culture of the sport comes from 'insider accounts' of F1 and its culture. These will come from those who have worked within the sport, as either managers, drivers, mechanics and of course journalists. As we have noted above, given the importance of the entrepreneurial and commercial aspects that has always played a part in the sport since the start of the world championship in the 1950s, particularly within its British evolution allied with the key role that innovative design has played in its growth, business school and management studies have been academic fields that have been most likely to engage with the sport. We would argue that sporting biographies of iconic British innovators such as Ken Tyrrell (Hamilton, 2002), creator of the Tyrrell Racing Organisation (1958–1998), Colin Chapman (Crombac, 2002) founder of Lotus Cars and Frank Williams (Hamilton, 2017) founder of the Williams Formula One Team (1977–present) all offer important accounts of the evolution of the sport and its culture and are examined in the next chapter of the book, with its focus on the historical development of the sport with the media.

Among the most insightful and thoughtful interventions from insiders are Mark Gallagher's *The Business of Winning* (2021) and Ross Brawn and Adam Parr's *Total Competition* (2017). The former book shares much in common with Jenkins et al. (2016) work, although Gallagher is an insider with around 40 years experience of the sport. He spent almost 20 years as senior executive with teams including Jordan, Jaguar and more recently Red Bull Racing. He also started out as a journalist covering the sport for a number of years, before moving into public relations and working with the title sponsors of the McLaren and Williams F1 teams before being headhunted by Eddie Jordan for his team (Interview with authors, 25 October, 2022). Gallagher's (2021) book and his subsequent work with Adrian Stalham (Stalham & Gallagher, 2023) are both aimed at illustrating the lessons that the business community can learn from F1 and does this while capturing the growing complexity and transformation of the sports business over the last few decades. As he notes:

To be successful, each Formula One team has to become a world-class engineering business, working to aerospace standards with a low-volume, prototype-manufacturing capability. The end product is produced by integrating technologies from sectors including automotive, aerospace and information technology. A Formula One car is effectively part jet fighter and part supercar, built and operating using digital technologies. (Gallagher, 2021: 4)

Brawn and Parr (2017: 2) describe F1 racing cars as 'upside-down jet fighters, with the downforce [2.5 tonnes at top speed] pushing the car into the ground'. Gallagher argues (2021: 12) that F1 'is at heart a sports entertainment business rooted in technology' and identifies the key leadership and managerial challenges faced in the sport, which he characterises as being around innovating within a fast paced environment, driven by data and performance analysis. Brawn and Parr's book (2017) is excellent on the challenging nature of the off track (and indeed sometimes on track) politics of the sport, and the managerial challenges of trying to align these with a range of technology, engineering and economic and financial constraints.

The sub-title of the book is 'lessons in strategy from Formula One' and in keeping with other insider accounts (for example from former driver David Coulthard (2018)) seeks to extrapolate key business lessons, from viewing strategy as being political, economic and technical, and crucially not conflating it with tactics. The book is based on a dialogue with Ross Brawn one of the most successful Technical Directors in the history of the sport and until 2023, Managing Director of F1 and identifies several key rules with regard to implementing strategy both in the sport and beyond. The importance of strategic focus and clarity, and a recognition not to conflate strategy with tactics (or operational delivery) is also a theme developed in Campbell's (2015) engagement with Formula One in his book *Winners and How They Succeed.* For him it's the relentless innovation and drive to achieve marginal gains, often, but not exclusively driven by data analysis, that sets the sport apart and those who lead and manage F1 teams.

Surprisingly few team principles tell their story (although we suspect this will change in the next few years as media interest in them continues to grow), perhaps that is because unlike former F1 team boss and media commentator Eddie Jordan (2008) (his autobiography ghosted by Maurice Hamilton) they do not have the rich hinterland or tales to tell that Jordan has, capturing F1 at a time when small, independent teams could still have a major impact on the F1 grid. An exception was the diary of a season by HaasF1 team principal and star of Netflix's series *Drive to Survive*, Gunter Steiner, Team Principal for

Haas F1 who published his thoughts on the pressures of running an F1 team in 2023 in *Surviving to Drive*. Steiner's book captured the rather manic lifestyle involved in being a team principal for a F1 team not competing at the top end of the grid (nor having the largest budgets or staff numbers as competitors) and a sport whose profile in the USA was exploding. Another exception is Nick Fry (2019) who recounts the remarkable story of how as Head of Honda F1 he bought the team (with Ross Brawn) from the Japanese manufacturers when they suddenly withdrew from the sport. Within a year as Brawn GP they won both the drivers and constructors championships and he continued as team principal when new owners Mercedes re-entered the sport in 2010 (before being replaced by Toto Wolff in 2013). Fry captures the politics of the sport and the highly commercial aspects of the sport, emphasising the centrality that corporate sponsorship plays in an engineering and technology driven sport. Max Mosley's (2015) autobiography also unpacks the complex internal politics of the sport that has been an integral part of its intrigue over the years and reinforces the extent to which, along with Ecclestone, that Mosley, President of the FIA from 1993 to 2009, helped reposition the sport as a significant international television property.

The historical role of the sports journalist was to provide the inside track for the fan of the sport. As noted and discussed at length elsewhere (Boyle, 2006), this perception has always involved an element of myth, and the particular challenges of being so close to an elite sport and its stars (necessary for access) can also compromise aspects of journalistic integrity as the fragile trust that access entails can be lost through a story that a star is unhappy with. As we discuss in Chapter Four, sports journalists and those that cover F1 are not all equal, and are shaped in part by the organisation they are working for at any particular time. Being a broadcast journalist for Sky Sports F1 entails a differing relationship to the sport than a sports writer (employed for their comment and opinion) working for a non-rights holding newspaper for example. This challenging environment is well captured by sports broadcast journalist Lee McKenzie (whose father Bob covered F1 between 1991 and 2014 for the Express group newspapers) who notes the particular journalistic challenges around F1.

> I have worked in and covered many sports from rugby to Wimbledon to the Olympic Games but F1 is unique in how we move around and work. When you cover rugby, you might only see some teams once or twice a season but in F1 we are together over twenty times a year and often we travel on the same charted flights. There are few times a year when the Sunday night or Monday is as exciting and as big an occasion

as the F1 when some of us let our hair down together, It's this unusual way of living that unites us. (McKenzie, 2022: 8)

McKenzie documents moments when this close relationship with the stars of the sport are built up over many years (in particular with Lewis Hamilton), is vital in terms of access, can be difficult when more hard-nosed questions that she asks can generate a media storm as a result. F1 with its 'travelling circus' globe hopping season encourages that sense of collective identity between journalists and the sport. Some, like McKenzie (2022) and Humphrey (2013) manage to be both 'insiders' and remain 'outsiders' in terms of understanding the difference between sports journalism and sports PR. Accounts of the sport from journalistic insiders such as Collings (2001), Walker (2003), Williams (1998), Henry (2003), and Eason (2019) display an ability to understand the culture of the sport and the business and offer these insights to the reader while still maintaining that journalistic edge that means they never stray into that most notorious arena of sports journalism, hagiography. While investigative journalists such as Lovell (2009) and Bower (2012) have attempted to make sense of key F1 figures such as Bernie Ecclestone and document his influence on the sports relationship with money, the media and commerce (see Chapter Two).

Other insider accounts of the sport from inside the paddock (Priestley, 2018; Matchett, 1995, 1999, 2004), offer a snapshot of the culture at the sport at differing times through different teams from the perspective of the mechanics. For Steve Matchett, a former Benetton F1 engineer who wrote about the pit lane culture and then developed a career as an F1 writer, this meant crossing the line, and changing the relationships he had with previous colleagues. As Matchett noted in 2004, 'Grand Prix people tend to keep themselves to themselves. They elect not to write of their profession' (Matchet, 2004: 223).

Although times may be changing. Adrian Newey (2017) the most distinguished and successful F1 car designer in the history of the sport has published his memoirs and remains a key contemporary player in the ongoing success of Red Bull Racing. While his passion for the design and engineering of a Formula One race car shines through his book, so too does the importance of winning to the teams he has worked for and the importance of pushing the formula rules to the absolute limit in the process of creating the best racing car for any season. He also captures the early days of the Red Bull Racing team who headhunted Newey from McLaren (they let him go before his contract

ended as McLaren did not view Red Bull as a serious F1 competitor) (Newey, 2017: 282).

F1 drivers have also told their stories (most with ghostwriters), many after they have retired with various degrees of insight offered to the reader about the culture of the sport and the ability to offer some compelling insight or reflection on the sport. Among examples of the more insightful autobiographies are those of Jackie Stewart (2009), Damon Hill (2016), David Coulthard (2008), Jenson Button (2018, 2019), Nigel Mansell (2015) and more recently by former Hass F1 driver Romain Grosjean (2021). All benefit from being frank, yet reflective and provide the reader with a sense of a sport that remains among the most dangerous in contemporary sport, that has continually evolved, often at a rapid pace over the years as well as offering a sense of how the pattern of drivers becoming media commentators, as media interest in the sport has grown, remains a common career trajectory for many. The last section of this chapter now turns to more recent media developments and in particular the rise in importance of the internet as a form of content distribution and its growing impact on sports content.

Sport and the Platform Age

In the selling of sports rights for many years there existed a relatively stable business to business (B2B) model. In the analogue age, a sport would sell its television and radio rights to a broadcaster for a fee and set time. Often these rights were around limited access to live sport and related highlights packages. In the UK until the late 1980s this meant dealing with the strictly limited market dominated by the mixed programming economy of the BBC, ITV and to a lesser extent Channel 4. In other words, sports fought for their place on the same channel as news, entertainment, drama, comedy and other television genre output, with certain national events protected by legislation in terms of being made widely available (Boyle, 2015). The advent of a more deregulated, or re-regulated broadcasting market saw UK Pay-Tv broadcasters such as Sky (and for a short time BSB and much later BT Sport), keen to secure live sporting exclusive content to drive subscribers and fill the hours of airtime they had through dedicated sports channels. For rights holders you now had a Free-To-Air (FTA) and Pay-Tv market potentially allowing you to split live and highlights rights packages and drive up revenues. Into this market a decade or so later came new players keen to use the internet as its

distribution platform and use sport to drive a new business model for sports content such as Setanta Sports. For some businesses the broadband infrastructure was simply not robust enough to sustain internet delivered television, but by 2010, this was no longer the case.

The incumbent Pay-Tv sports rights holders such as Sky in the 2000s now faced competition from regulators (the EU) keen to break up sporting monopolies (with the unintended consequence of driving up the cost of sport for the consumer) and technological change that saw a robust internet capable of sustaining sports distribution. When allied with the rise of mobile media as another option for consumers to engage with sporting content and the rise in competition from new, global players such as Netflix and Amazon, the last few years have seen a much more fluid environment for sports rights, with the possibility of a direct to consumer model (streaming live content via the internet, through a controlled platform) now a practical reality for sports rights holders, if it makes financial sense. There is another dimension to this in the digital age and that is the value of data, which under a Business to Business model is to all intents and purposes meant sport handing over potential fan data to another media organisation. Under a direct to consumer model, this data is retained by the sports themselves and has the potential to drive further areas of revenue as well as innovation in how the sport is represented and developed. What then do we mean by the platform age?

The Platform Economy

Flew (2021: ix) argues that we have seen in recent years is the 'phantomization of the internet' which he defines as 'the process through which online interactions and engagements are increasingly made to take place on a relatively small number of digital platforms'. He argues that from 1995 to 2005 we had the libertarian internet, open and chaotic, and that from 2006 to 2021 the platformed internet, and that we are now (2022-) entering a new era of the regulated internet.

There is some contestation over the definition of a platform (this is particularly well captured by Flew (2021: 41–71) and it is an inherently porous and often fast changing environment, with new business models being adopted apace. For the purposes of the sports economy, we refer to platforms that distribute sports related content, such as X (formely know as Twitter) but this is also a short form video platform for sports related content and sports chatter as well as user generated content. YouTube initially a platform for user generated video content, is now under Google a business that has a

range of relationships with major content creators. For some short form video content creators TikToK is now seen as a more important platform. Many of these platforms are underpinned by an advertising business model. While other platforms such as Amazon Prime, Netflix and Apple are curated and entertainment driven subscription services. Indeed, for some scholars (Poell et al., 2022: 6) these should not in fact be labelled platforms at all, but rather media or entertainment companies. The distinction they draw is that they are not accessible to third parties to, for example upload user generated content. They are commissioning and securing both exclusive content (often high-end drama and increasingly live sport, or non-live sports related content) needed to drive a subscription base while also windowing television and film content created by others. Amazon Prime has been at the forefront of using its platform to stream live sporting events from tennis to football in a strategy to augment its offering (and drive subscribers to other parts of the Amazon brand offering) and extend its brand awareness into new markets.

We accept there is a danger of catch all label obscuring the often nuanced and complex differences between various areas of the emerging media ecosystem. Lotz (2022: 185) also notes that it is a mistake to assume uniformity among the SVOD (subscription video on demand services) sector. The development of say Disney+ and AppleTV+ in 2019 and 2020 highlight that SVODs are as Lotz notes:

> No longer an emergent technology but now the focus of industries built on decades of creating content for linear ad-supported services. (Lotz, 2002: 187)

And other forms of content are also emerging, hence the rapid growth in the popularity of podcasting which has been a significant feature of the Formula One media landscape in the last few years. Formula One related podcasts have grown significantly in the last few years as new (and older) fans and media stakeholders have used this format to reach a growing audience. In 2022 for example there were over 50 UK based F1 related podcasts available and the number seems to be growing. Some of these are professionally F1 produced such as *Beyond the Grid* and *F1 Nation*, and sit on what some scholars would see not a platform (the official F1 website and media hub), but rather as an entertainment site. However, the F1 site makes clear you can also access these podcasts on other platforms and provides a link to Apple Podcasts, Google Podcast, Spotify and RSS.

As we discuss in Chapter Four when we investigate the role of journalism in the sport, these are F1 sanctioned podcasts offering presenter Tom Clarkson

with some great onsite access to key drivers and members of the F1 teams, but they do not offer a form of independent journalism. Rather these spaces echo a trend identified by Barden (2021) in his work around multiplatform sports journalism. Barden uses the example of Livewire Sport, a digital sports consultancy and content creator (in 2022 they became part of Two Circles, a company specialising in sports data and commercial development) and interviews its co-founder Pranav Soneji. Barden notes that:

> Soneji admits there is an obvious difference between working *on* sport (to deliver coverage of it in the traditional sense) and working *for* sport (that is, in a business relationship with the sport itself). 'It's creating content to serve a [commercial] purpose, it's not sports journalism as it's been traditionally understood. It's not journalism in terms of scrutiny, it's not impartial, it's not the fourth estate'. (Barden, 2021: 107)

This is an interesting, and growing area of journalistic activity. It does not fit the traditional public relations (PR) role performed by some ex-journalists, but nor is it, as noted above, traditional, uncomplicit journalism. Rather it sits in between these poles, and a theme developed in more detail later in the book (see chapters Four and Six).

While other podcasts are much more fan-based podcasts from the growing number of 'content creators' and might offer reflections from among certain F1 fans, others still are much more journalistically informed and potentially more critical of aspects of the sport and its governance. All of these can sit on the platforms mentioned above and also on YouTube that is clearly defined as a platform. As we discuss further in chapter Six, in so doing they offer at least the possibility of developing an audience (and for some perhaps offer a rather speculative career path) for some fans although as noted in other studies this can be an extremely challenging environment in which to build and sustain a career (Boyle, 2018; Brooke Duffy, 2017). Turvill (2022: 12) notes how revenues in the UK from podcasting will hit £64m a steep increase from the £37m of 2021. So, this form of on-demand radio content, of the users choosing is an area of growing importance for the sport.

It can all seem slightly confusing, and in some senses an over fixation with categorisation is not always helpful for the media analyst. What we want to do in this book is map out the interplay between various media forms and sports related content and investigate what this is telling us about the sports media relations in this more fluid digital age. As an aside, it is worth noting (and somewhat frustrating) that in Poell's et al. (2022) extensive and detailed study of platforms and cultural production, particularly strong with its focus

on cultural producers, the book does not refer to sport throughout the study, despite it being among the most popular cultural forms (rich with cultural producers) and an historic early adopter of new technology.

As Lobato (2019) has noted the rise in competition for television content delivered OTT (over the top, or via the internet) by these platforms has of course seen legacy broadcasting organisations accelerate their own platform-based distribution of their content and enhance their on-demand offering. In the UK we see examples being offered to either a license fee paying public (in the case of the BBC through the iPlayer platform) or underpinned by advertising (as in the case of ITV, with ITVX or Channel 4 through its streaming service All4). This is important as it brings a level of complexity to the offering, as when we discuss the streamers, we are also refereeing to 'legacy' media that are also in this OTT space. As Westerbeek and Karg (2022: 146) argue, sports content has been a key driver in this area and in so doing has 'provided opportunities for new models and new players to enter the market further complicating media strategy within sport'.

Kevin McCullagh, Asia-Pacific editor for the trade journal *SportBusiness* argues that the demise of linear television, not for the first time has been overstated and that while the sports-media landscape has become more complex, linear television remains important. He argues:

> And now it looks increasingly unlikely that streaming will kill the stars of the linear television age. Instead, what is emerging is a 'multi-polar' world, where streaming platforms, social media platforms, 'traditional' pay-television platforms, telcos, dedicated sports channel businesses, free-to-air commercial broadcasters, public service broadcasters and rights holders co-exist as significant sports video platforms. (McCullough, 2022: 16)

The complexity here will be that this will play out differently in differing media markets, regulatory regimes and across differing sports. For example, in the US market, ESPN, NBCUniversal and Paramount Global, all titans of the pay-television era, have developed their own streaming services, initially to sit alongside their pay-television offering, but in essence reaching out to differing audiences. In short rather than simply cede the market to indigenous streamers such as Amazon or YouTube (who in turn have become more interested in sports content) they are moving their brands and content into this market. Yet as we write in 2023, the single most valuable sports property in the US, the NFL remains on free-to-air linear television. As Evens and

Donders (2018: 250) argue in their study of the impact on platforms on the television industry.

> The outcome of the platform war, as part of the ongoing transformation of the television industry, reflects where structural power lies in the global media economy. Disruptive technology may be a strong force of change, but its impact has to be mediated by power structures and institutional relationships that have been in place several decades. Unable to disrupt the television business model from the outside, Netflix, Facebook and other services are turning to adopt the old logics of the television industry in order to change it from the inside. This strategy demonstrates how deeply entrenched industrial structures and practices are in existing structures of power and persistent relationships. The success of winning platforms therefore relies on the control of critical (infra) structures of power through which they exert power over the industry.

We would argue, as has Chalaby (2023) in his study of television and streaming and changes in the global value chains within the industry that, while streaming and platforms suggest *revolution*, in fact what we are seeing are strong elements of *evolution*. As Chalaby notes:

> The contours of the TV industry as it enters the digital economy become clearer: it has expanded from broadcasting to streaming, encompassing new delivery modes and payment models. The connection points between 'old' and 'new' television are multiple. New platforms and old networks differ in many respects, but they also hire from a similar talent pool, and share many suppliers from content producers to cloud services. (Chalaby, 2023: 4)

It is against this media and platform complexity that a global sport such as F1, as a content supplier positions itself and chapter Five examines in detail the impact on the value and distribution of this environment for the rights regime of the sport.

Conclusion

This then is the backdrop to our study, in which we have an interest in not just *the political economy of sport*, but its *media representations* and also the changing nature of the *sports audience in the age of platforms*, where everything is in flux and yet by taking a longer historical view, we see the extension of some pre-existing trends. What we have then is a process of evolution, rather than revolution. Formula 1, as a sport in transition, deeply embedded in wider

media and commercial industries, offers a compelling case study that allows us to navigate our way through these changes, while recognising the important elements of continuity that give sport its unique local, national and international appeal and cultural and commercial value.

Given the range of approaches we have noted to the sport above it is important to be clear that this research is rooted in a media and communication studies approach. By this we mean that we are concerned with understanding the political economy of the sport embedded within the contemporary media environment. We are also interested in mapping and understanding the range representations of the sport created by such a relationship and wish to position these within the reception of such content by audiences at a time of changing patterns of media consumption. Throughout this we view sport as an important cultural form deeply connected with the wider political, cultural and economic contours of the society that creates and sustains the sport. We do not advocate a media-centric view of the development of sport, rather that media development itself reflects wider political and economic orthodoxies and in turn has a significant impact in shaping the structure, ownership and narratives of sports culture.

It is well over a decade ago that David M. Carter (2011) was examining in detail the convergence between elite sports and the entertainment industry in the United States. What is striking about revisiting his research now, is that what Canter identified, a number of years ago, then read as a very specific case study of the sports-entertainment nexus in the USA, yet today feels broadly applicable to more and more elite sport in Europe and elsewhere in the world. The blurring of once distinctive European and North American models of sporting structure, governance and even form is a striking feature of the contemporary sporting landscape and a theme that runs through the book. As Wray Vamplew succinctly (2023: 3) argues in his book on the economics of sport, the US model through profit seeking entrepreneurs, sees sport primarily as a means to make money. While the one area missing from Canter's work was the growing influence of nation-states entering the sports environment through ownership and control of the sporting assets.

There is a battle over the meaning of international sport taking place. It feels like we are entering a new epoch in that long relationship between sport, media and identity and a study of F1 offers some insight into the ongoing direction of travel we are embarked on. But first let's turn to the importance of placing the sport of F1 and its media relationship within a longer historical context.

· 2 ·

RACING HISTORY: F1 AND THE MEDIA

These questions are the stuff of motor-racing, the fascinating equation between technical achievement and human skill and courage, which, to its devotees, makes it so much more than just another sport.

Raymond Baxter (1964: 119)

I believe that motorsport needs explaining more than other sports. Partly because most people haven't done it. Whereas with most other sports they have done it. And partly because the equipment itself, the technical aspects of the cars or motorcycles.

Murray Walker (Interview with the authors, 2008)

Raymond Baxter and Murray Walker were synonymous with communicating motor sport in the UK for more than six decades from the late-1940s. Both were passionate advocates of all forms of motor sport, at the same time appreciating the challenges broadcasters faced in covering motor racing to audiences who, more often than not, did not have a technical knowledge of cars but were captivated by the thrills and spills of drivers risking their lives to race around world renown circuits such as Silverstone, Monza, Monaco and Spa. This chapter places this study within the broader cultural, political and economic history of F1 since its inception in the early 1950s. It places the relationship with the media, and television in particular, which has been at the core of the sport since its inception within a broader historical media context. Drawing on original material from newspaper and magazine archives, newsreel archives and broadcasting archives, it maps out the various stages of media development that have shaped the history, structure and governance of the sport as it evolved from an amateur pursuit into the professional era of the 1960s and 1970s. The chapter also draws on previous oral history interviews with now deceased individuals conducted by the authors in the past who were

leading lights in the broadcasting of motor sport. It investigates the first re-invention of the sport in the mid-1970s when control of it is secured by Bernie Ecclestone, who used media rights to re-shape the sport and internationalise it while establishing a framework for its coverage by the media and journalists that would exist until his exit from the sport almost 40 years later. The chapter sets up the key historical antecedents of the relationship between F1 and the media that would see its re-invention over the last decade.

Motor Sport Press

Grand Prix, and later Formula 1, has enjoyed a long history of dedicated specialist press. As a sport built by motoring enthusiasts many of the pioneering journalists in the motoring press had long-standing careers and deep associations with racing and motoring more broadly. A good illustration of such longevity is the career of Bill Boddy editor of *Motor Sport* from 1936 to 1991. At the time of his death in 2011, Boddy was by far and away the longest serving editor of any publication in the UK media. His fascination for motor racing and Grand Prix began when he first visited Brooklands in 1926, and he published his first article on the history of the track for *Motor Sport* (formerly *The Brooklands Gazette*) in 1930 (Haynes, 2015). Boddy developed a career as a freelance motor journalist after a brief spell working in a motorcycle shop. His first editorial role came in 1933 as editor of *Brooklands Track and Air*, for which he also road-tested new cars as a passenger, since he did not then have a driving licence. In 1936, after a further spell as a freelance journalist, principally writing for *Motor Sport*, he was asked by the magazine's new owner, Wesley J. Tee, if he would edit the periodical. He agreed, and continued to edit the magazine for the next fifty-five years. As editor, he turned a near bankrupt magazine into a quirky, but leading periodical on motoring during the mid- to late twentieth century (Haynes, 2015).

While Boddy exemplified the journalist as enthusiast for motor sport, other journalists with no affiliation with the sport did manage to change wider perceptions of Formula 1 to audiences who previously had no knowledge of the emerging sport. Robert Daley was a former publicity director for the New York Giants and in the late-1950s and early-1960s became a features writer for the *New York Times*. He attended the Winter Olympic Games in Cortina in 1956 where he met the flamboyant aristocrat Alfonso Cabeza de Vaca y Leighton, the Marquis de Portago of Spain who was competing

in the bobsleigh (Spurgeon, 2015). de Portago was also a racing driver, and captivated by his lifestyle and elan, Daley remained in Italy to report on the Spaniard competing in the Mille Miglia in 1957. Tragically, de Portago and nine spectators were killed in a horrific crash, and Daley's report was never published (Baime, 2021). Nevertheless, he had become entranced by the stories of the drivers and the risks they took, so returned to Europe to report on the 1958 Grand Prix season. 'I wasn't interested in valves and camshafts and stuff, and never put anything about that stuff in the articles,' recounted Daley then aged 85 in an interview with the *New York Times*, 'I was just stunned with all of these guys getting killed' (Spurgeon, 2015). Daley scooped an interview with Enzo Ferrari, organised through American driver Phil Hill. 'He was known for never talking to journalists' Daley recalled, 'I have no idea why he talked to me' (Baime, 2021). Daley's profile of Ferrari and his cars appeared in the *New York Times in* June 1958, with the headline 'Ferrari: Speed-Bewitched Recluse.' Daley's subsequent reporting on Formula 1 and other motor sport from Europe between 1958 and 1961 transformed public recognition of the sport in the United States, introducing a new roster of driving heroes and the danger of a sport which was always close to disaster in the late-1950s and 1960s. Daley's homage to motor sport was captured in his book *The Cruel Sport* published in 1963 which became an instant classic for many fans of the sport. Daley himself moved on in his journalism career, but his brief sojourn into the world of Formula 1 proved transformational in terms of awakening American audiences to the sport.

In Europe, several motor racing journalists became synonymous with Formula One, travelling the world and building their careers in tandem with the development of the sport. Italian photo-journalist Franco Lini was one of the first journalists to travel to all Grand Prix races around the world (GPL, unknown). His knowledge and criticism of Italian motor racing led Enzo Ferrari to appoint him as the team manager of the Ferrari F1 team in 1966, arguably transforming the image of the team in that period. Swiss journalist Gerard 'Jabby' Crombac (*Autosport*, *Sport Auto*), alongside British journalists Alan Henry (*Motoring News*, *The Guardian*, *F1 Racing* and *Autocar*), Nigel Roabuck (*Autosport*, *Motor Sport*), and Maurice Hamilton (*The Observer*) were so well known within Grand Prix circles they were referred to as 'the Cartel'. Fellow motor racing journalist Richard Williams remarked this elite group of journalists were 'often teased for their anorak-level expertise but also admired for their readiness to share insights and historical knowledge'

(Williams, 2016). Their knowledge often came from direct involvement and friendships in motor racing.

Jabby Crombac was the son of a wealthy Swiss department store owner, and had mechanical knowledge and was the first outside the UK to race a Lotus Mark VI built by Colin Chapman, who became a lifelong friend (Donaldson, 2020). Crombac became *Autosport*'s first European Correspondent when the weekly newspaper was founded by Gregor Grant in 1950, and subsequently established *Sport Auto* for French motor racing enthusiasts in 1954. He also developed close friendships with drivers, most notably sharing a Paris apart- ment with Jim Clarke, which reflected the journalists' integral status in the sport's evolving popularity through the 1960s. As well as his journalism, he also held a position in the FIA.

Alan Henry began his journalistic career after complaining about *Autosport*'s coverage of the Brands Hatch grand prix in 1968. He joined *Motoring News* in 1970 launching a career spanning five decades and 650 grand prix races (Straw, 2016). Known as AH within the F1 paddock, his reports became 'must reads' among those within the sport, which McLaren boss Ron Dennis described as always 'knowledgeable, accurate, intrepid yet fair-minded' (Dennis, 2016). Henry test drove numerous Formula One cars in the 1970s and was awarded membership of the British Racing Drivers Club, both rarities for a motor racing journalist. According to Richard Williams, henry maintained a sardonic wit throughout his career, never in awe of what became a glamourous sport. Nevertheless, he was always thankful to be among the world of F1 which framed his professional career as a journalist. Commenting on the everyday stresses of constant travel within the world of F1, Henry wrote, 'It's true, this is one negative side of the job. But look where it takes you' (Williams, 2016).

Both Nigel Roabuck and Maurice Hamilton began their journalism careers in motor racing in the 1970s. Roabuck initially wrote freelance and was press officer for driver Graham Hill's Embassy F1 team in 1975, before becoming *Autosport*'s Grand Prix correspondent in 1976. Before F1 had regu- lar television coverage his much heralded weekly 'Fifth Column' brought rich detail and analysis of races and the lives of F1 drivers. Between 2007 and 2016 he was editor-in-chief of *Motor Sport*, before returning to his weekly column with *Autosport*. Hamilton, as a young motor racing fan from Northern Ireland always dreamed of being involved in the sport and found his way into jour- nalism in 1977 as assistant to freelance motor racing journalist Eoin Young, who had strong ties with Bruce McLaren founder of the F1 team. As Hamilton

recalled, 'I was immediately introduced to the top level, straight away. So, I wasn't doing this business of going through the cub reports and starting working away. I was there at the top. So I was very, very lucky to get that introduction from him' (Interview with authors, 3 June 2022). Proximity, to the relatively closeted world of F1, and the informality of relationships between the racing teams and the press in the 1970s and early-1980s, saw Hamilton's career develop rapidly. Eric Dimmock, *The Guardian*'s motor sport correspondent recommended Hamilton to replace him at the paper in 1979, and in spite of inexperience, he managed to forge a career in motor sport journalism with spells at *The Independent* (from 1986) and *The Observer* (from 1990).

Motor sport journalists throughout the formative decades of F1, from the 1950s through to the early-1980s, built ineffaceable bonds within the sport, but also with motor racing enthusiasts eager for insights into the personal, engineering, racing and political minutia of the global grand prix circuit. The gravitas they built in their journalism stemmed from years of building relationships with team managers, engineers and drivers. Before the changes brought by television and sponsorship, and subsequently more interest in motor sport from the popular tabloid press in the late-1980s and 1990s, journalists working in F1 had carte blanche to talk with and interview drivers, mechanics and team owners. Former BBC and ITV sport presenter Steve Rider recalled in his autobiography how in his early career as a sport news broadcaster with regional channel Anglia Television, his crew were able to head to the British Grand Prix in the early 1980s without prior announcement, pick their spot at the Woodcote chicane at Silverstone, only a few feet away from the circuit. 'This is the kind of access that these days would be denied by health and safety', remarked Rider, 'let alone by the impenetrable accreditation requirements of Bernie Ecclestone' (Rider, 2012: 17). As the commercial interests in F1 grew, so this unbridled access diminished.

Grand Prix Film and Newsreel

The evolution of Grand Prix motor racing coincided with innovations in film and the emergence of newsreel production in the late nineteenth century. Motor racing began to feature in topical films, the forerunner to newsreel, in the first decade of the twentieth century. The Gordon Bennett race held in Ireland in July 1903 is widely recognised as the first motor race to be filmed. Two films survive from Cecil Hepworth's Biograph Studios original filming of

the event conserved in the Northern Ireland Screen Archive and Pathe film archives. The films reveal the bespoke designs of cars from Britain, France (Panhard), Germany (Mercedes) and the United States, mainly the French Panhards or Mercedes cars parading along a street of onlookers behind cyclists; the second, a Pathe film has shots of cars setting off from a crowd, at top speed along dusty straight roads and manoeuvring around a sequence of bends. The event was run over a figure eight shaped closed circuit based around Athy, County Kildare. Cecil Hepworth's company, the Biograph Studios were commissioned to film the event. Hepworth did not come to Ireland for the race and it was likely that it was filmed by his assistant Louis de Clarke. It is believed this film may be a 'lost' part of the Biograph film. The Athy race had great significance, being the event from which all subsequent international motor sport evolved, right up to the current F1 Grand Prix series.

Oil companies have long had a commercial interest in motor racing, including F1, and they have funded the filming of the sport to both showcase their profiles in the sport, as well as foster deeper relationships with motor racing enthusiasts. Documentary luminaries such as John Grierson, who established the Shell Film Unit in 1934, used investment from oil companies to develop extensive catalogues of sponsored factual film, many capturing motor sport. Bill Mason had raced cars in hill climbs as a young man in the 1930s and in the post-war era drove his 1930s Bentley in vintage car races at circuits at Elstree, Gransden Lodge, Goodwood, Silverstone (*The Telegraph*, 2002). He joined the Shell Film Unit in 1943 working on films for the War Office, but much of his work for Shell up to 1956 focused on either aeroplanes or motorsport, including films on Le Mans, Mille Miglia, the Dutch TT and the British Grand Prix. As a freelance director for Shell, BP and other sponsors Mason became one of the most prolific motor racing film-makers in the immediate post-war period. His landmark film *Grand Prix* (1949), which the BFI described as a significant contribution to the sports film genre, 'set the benchmark for the multi-location, multi-camera coverage still used today' and his inter-cutting of racing and motor-racing fans proved hugely popular (Russell & Foxon, 2015). Mason later described how dangerous filming at Grand Prix race tracks could be: 'it was full of problems because there was very little safety regulations, one was very rightly nervous because the only spectator protection was a bit of rope, and they were making us have our cameras some way back, there was no sandbags or anything to keep behind them, they gave me a few straw bails' (ACCT, 1987). Nevertheless, Mason innovated how motor racing could be filmed, using multiple cameras around the race track and

creating panning shots using his own Bentley car with a cameraman lying on the front wing (Clarke, 2002). His documentary series *The History of Motor Racing* produced in the 1960s pulled together film under threat or considered lost, is a testament to early endeavours of pioneering filmmakers to capture the spirit and life-threatening dangers of early motor sport.

Because television did not take much interest in F1 until the late 1970s, film archives from the 1960s and 1970s remain a crucial aspect of F1s visual culture from the twentieth century. One of the largest archives of film from 1970 to 1981 with more than 450 hours of footage was initially conserved by Brunswick Films, a production company who had the rights to film around grand prix circuits and conduct driver interviews. These rights ended once Bernie Ecclestone's Formula One Management took control of all filming and video rights from 1981. FOM, under Liberty Media, took control of the Brunswick film archive in 2019 with the aim of digitising the films and making the 1970s footage available to F1 TV streaming service. Ian Holmes, Director of F1 Media Rights commented at the time of the acquisition:

> The enlargement of our archive will allow us to make available a lot more content so that our fans can access whenever and wherever they want to. Our focus is to put our fans at the center of the Formula 1 action and allow them to access and share our history. (Gilboy, 2019)

Bringing the film archive under the control of F1 gives the sport more control over the licensing and use of the footage, but also ensures the safeguarding of F1s heritage for future generations.

Radio Motorsport

Radio broadcasting has a long association with motorsport. The first notable radio broadcast on the subject of Grand Prix racing was in August 1926 in a thirty-minute talk entitled 'The Brooklands Grand Prix' by engineer, journalist and motoring enthusiast Mervyn O'Gorman. The talk was broadcast on the eve of Britain's first Grand Prix on 7th August 1926 at Brooklands race track, Surrey. Such accounts were typical of the inter-war period on BBC radio, with a knowledgeable expert with some journalistic experience brought into record their thoughts on specialist subjects. O'Gorman, who was a member of the Royal Automobile Club of Great Britain and Ireland, and went on to write the first version of the Highway Code, would have given his impressions of

cars and drivers expected to race in Britain's first Grand Prix. Brooklands had been built in 1907 as the world's first purpose-built banked racing track, and introducing the Grand Prix was viewed as a way to renew the fortunes of the track. An impression of the event was later reported in *Motor Magazine* (September 1926) which observed, 'A brighter scene would be hard to imagine; sunshine, dresses, sumptuous cars, grass, trees, advertisements, and lastly the little green and blue projectiles themselves, such is the picture retained in the mind of this great event.'

Interest in motor sport had grown during the inter-war years, and radio talks, eye-witness accounts and live commentaries began to emerge on radio during the period, supplementing the proliferation of motoring magazines and newsreel coverage of the sport. On 1st October 1927 the BBC carried an eye-witness report of the second British Grand Prix from Brooklands. On this occasion the BBC turned to a racing driver, 'Sammy' Davies, to provide the account of the race. Davies had not long returned from winning the 1927 Le Mans 24-hour race but was also the sports editor of the magazine *Autocar* and was therefore viewed as someone with both sporting and journalistic expertise. The balancing act of expertise in sport and expertise in broadcasting has remained a constant throughout the history of motor racing coverage. Motoring experts cannot always be relied upon to provide clear and mellifluous broadcasts to the non-expert listener or viewer. Similarly, broadcasters without a knowledge of the sport can be prone to errors in identification, history or wider context of a sport. The BBC's early coverage of motorsport had relied on staff commentators who covered a range of sports. Raymond Glendenning whose main sports were football, boxing and horse racing would occasionally be asked to commentate on motor racing, and would have the company of Max Robertson whose main sporting expertise was in tennis. It was not until 1950 that the BBC found its main voice of motor sport, Raymond Baxter, who following his wartime role as a fighter pilot had a period producing radio for the British Forces Network in Hamburg.

Radio provided the immediacy of motor racing, the atmospheric sounds of roaring motors passing the microphones evoked speed and excitement, even if listeners had to fully exercise their imaginations. Radio had become a feature of motoring itself, and in 1960 Stirling Moss entered the Tourist Trophy at Goodwood driving a production car and was able to listen to Raymond Baxter's BBC commentary on the car radio as he was actually leading the race (Williams, 2022; 237). Baxter had become the BBC's first motoring correspondent in 1950, a role he kept until 1966 covering twenty F1 races for

the BBC in that time, and a multitude of other motor racing programmes on radio and television. Baxter epitomised the 'gentleman broadcaster' with a rich distinctive middle-class voice and a polished sartorial style. In the 1950s Baxter was the principle link British audiences had to F1 in the home. The role of the radio commentator was to 'paint a picture' for the listener, and the combination of Baxter's in-depth technical knowledge of motorsport and his innate sensibility of what it was like to drive and race fast cars, enabled him to convey both what was happening in a race as well as the emotional thrill of racing. His commentary style was much admired by British racing drivers of the 1950s and 1960s because Baxter had experience of rally driving, frequently competing in hill climbs and the Monte Carlo Rally on behalf of the BBC, microphone by his side. Stirling Moss remarked in a documentary on Baxter's career that because of his wartime experience as an RAF fighter pilot 'he could feel the sort of things we could feel. I think because of his background' (BBC, 2006). This sense of jeopardy was apparent in Baxter's contribution to a BBC publication *Sports In View* edited by Peter Dimmock (1964). In a chapter on motor sport Baxter revealed the reality of F1 racing in the immediate post-war period: 'They may be fighting each other with every ounce of effort and determination they possess, but in a sense they are all on the same side – they all want to go on living' (Baxter, 1964: 120).

Baxter was directly involved in many innovations and firsts in the BBC's coverage of motorsport but often felt motor sport was on the periphery of the BBC's sports coverage in spite of its popularity. In his autobiography, Baxter recounts how in 1955 he persuaded the BBC to send him to cover the European Grand Prix from Monte Carlo, the BBC's first ever continental commentary of motor sport. Baxter did his commentary from his hotel balcony and travelled with his wife Sylvia who helped update the lap counts of the drivers. In an eventful race in which Stirling Moss's car retired in a cloud of smoke and the Italian Ascari plunged his car into the harbour, Baxter was able to go live on the BBC's Home Service to announce Trintignant had won the race for Ferrari amongst all the mayhem. Pleased with the broadcast on return to London he submitted his expenses but was told he could not claim the costs for his wife who had been integral to his commentary and correctly calling the eventual winner (Baxter, 2005: 161). It summed up the BBC's approach to Formula One which by the early-1960s was highly fragmented and uneven. The 1962 World Championship, for example, came down to a battle between Scotsman Jim Clark and Englishman Graham Hill, with the title to be decided in the final race of the season taking place at the Prince

George circuit in East London, South Africa. If we consider the blanket UK and international media coverage afforded the Abu Dhabi 2021 championship decider involving Hamilton and Verstappen almost 50 years later, it is sobering to note in 1962 BBC radio saw fit to offer 10 minutes of commentary to the UK audience of a sporting contest which no doubt would now be framed as the 'Battle of Britain'. Incidentally, Graham Hill won the South African GP and secured the first of his two world titles (Hamilton, 2022: 59).

Televising 'The Golden Age' of Grand Prix Racing

In an illustrated BBC publication celebrating the corporations seventieth anniversary covering sport there is a page dedicated to 'The golden age of British motorsport', celebrating the achievements of John Surtees, Graham Hill, Jim Clarke and Jackie Stewart in the 1960s. It is an imaginary and nostalgic view of the period, born of a national media narrative about pioneers of automotive engineering and the heroic drivers who signified an age of postwar modernity. In the UK, by the 1960s television was well on the way to becoming the dominant form of public information on the world and the constructor of a national sporting culture. Even with limited live exposure on television, public awareness of motor sport grew and by the 1970s motor racing had embraced a triangular commercial model of sport, television and sponsorship (Whannel, 1992).

Following the end of European hostilities in 1945 motor racing, like BBC television, sought to expand its facilities. The RAC promoted the transformation of redundant RAF airfields into racing tracks, Silverstone a prime example, to accommodate the appetite for the sport. Amid a more general post-war sporting boom the BBC were also keen to expand their coverage of motor sport, and sought opportunities for live transmission from motor racing competitions. An experimental transmission of a motor cycle race from the grass circuit at Brands Hatch in 1947 revealed the logistical and visual challenges of transmitting motor sport. Another barrier was the scheduling of races on Sunday's. In the 1950s the BBC had a strict policy of not transmitting sport on a Sunday effectively making many motor racing events off limits.

In January 1950 the BBC transmitted filmed highlights from Silverstone of the 1949 International Trophy sponsored by the *Daily Express*. For the remainder of the 1950s the BBC primarily relied on the use of filmed highlights

of Grand Prix races rather than live transmissions. Motor racing films, sometimes imported from America, France, Italy or Germany would regularly feature on the BBC's weekly topical sports programme *Sportsview*. Motor racing was such a popular feature on the programme that from 1958 to 1962 its presenter Peter Dimmock entered the Monte Carlo Rally, on one occasion in a London taxi driven by Tony Brooke (Haynes, 2016). However, there were some notable exceptions to filmed content. BBC cameras did return to Silverstone in 1953 for a series of broadcasts focused on the British Grand Prix. In the thirty-minute programme *Background To Sport: Motor Racing*, broadcast on a Thursday evening in July, the BBC's motoring correspondent Raymond Baxter introduced viewers to the preparations for the race ahead of live transmissions on the following Saturday afternoon. Coverage included a 500c.c. race in the morning and three visits to the British Grand Prix in the afternoon, interspersed with horse racing from Ascot.

In the *Radio Times* Baxter (1953: 43) explained the BBC hoped 'to bring some of the thrills of the circuit to a wider audience', which for the first time were covered on both radio and television. 'To the enthusiast there is no substitute for the battering roar of exhaust, and the thrilling combination of hot oil, hot rubber, and Continental cigarette smoke which is the bouquet of speed', wrote Baxter, 'But in our television pre-view on Thursday, we hope to explain some of the apparent intricacies of the game and introduce some of the personalities and machinery which make motor racing a sport and a spectacle unique in its appeal and character.' His report hints at the raw excitement he saw, and indeed experienced, in motor racing, which for most listeners and viewers was unknown and a world removed from everyday experience. Formative television transmissions from Silverstone brought a new audience to motor sport, a relationship which in the future became central to its growth and commercial success.

Baxter's report also reveals the importance of drivers as personalities. There is enough evidence from media archives from the 1950s and 1960s to illustrate how the notoriety and fame of drivers reflected a growing public fascination for the daring escapades of motor racing's elite drivers. Stirling Moss became a household name in the UK in the mid-1950s as he competed with the leading Italian driver Fangio. Moss won sixteen Grand Prix races through the 1950s and his challenge for the Drivers Championship (he was four times runner-up) began a golden age of British success in F1 which continued throughout the 1960s into the 1970s. As Maurice Hamilton (2020: 56) notes, 'He was at the peak of his powers, racing whatever he could, whenever he could.' In 1958

Moss combined racing with presenting regular filmed reports from Grand Prix for the BBC's *Sportsview* programme. It made him one of Britain's most recognisable sport stars of the period. Moss trailblazed the way for other British drivers to win the championship including: Mike Hawthorn (1958), Graham Hill (1962), Jim Clarke (1963 and 1965), John Surtees (1964) and Jackie Stewart (1969, 1971 and 1973).

This unprecedented success caught the popular imagination of the British public, reflected in motor racing's success in the BBC's *Sports Personality of the Year (SPOTY)* introduced in 1954. The trophy itself, a replica of an image orthicon outside broadcast camera, had originally been designed for a new motor racing hill climb series devised by Baxter and producer Bill Duncalf in 1948 called the *BBC Television Trophy* (Haynes and Robeers, 2019). The *SPOTY* award, voted for by BBC viewers, consistently featured motor racing throughout the 1950s, 60s and 70s signifying the emergent popularity of F1 as a spectator sport. The award was won by Surtees (1959), Moss (1961) and Stewart (1973), with runner-up awards for Moss (1957), Clarke (1963 and 1965), Hill (1968) and Hunt (1976). The Cooper motor racing team won the inaugural BBC Team of the Year award in 1960, followed by BRM motor racing in 1962. The fascination with the design of F1 led to the BBC bringing Hill's winning Lotus 49 car into the *SPOTY* studio in 1968, in order to showcase Colin Chapman's revolutionary stressed member engine design and distinctive high-wing aerofoil. To date, over the seven decades of *SPOTY*, F1 drivers have won the award on nine occasions, second only to athletics among the list of winners (eclipsing major sports such as football, rugby union and cricket).

As their fame grew, so the financial rewards for drivers were beginning to grow by the early-1960s. In 1964, BBC motorsport correspondent Raymond Baxter (1964: 120) noted that, 'The man who wins the Grand Prix Drivers' Championship of the World can expect to earn around £30,000 that year.' Baxter also noted that other leading drivers might earn half that amount, but compared to professional football players of the day the rewards were significantly greater in Grand Prix racing. However, the costs of running an F1 team travelling the world were high, and although Ferrari and Mercedes teams were financed by wealthy manufacturers, British teams needed to raise funds themselves.

A significant see-change in the commercial side of racing had begun to appear in 1964 following a deal struck between race organisers and the newly formed Formula 1 Constructors Association (F1CA) which negotiated

increased 'starting money' for its member teams to £800 per race (Moss and Carllson, 1964). Under the headline 'The End of Grand Prix Racing' the *Sunday Mirror* reported on the perceived impact the deal had for drivers as the commercial side of the sport moved towards the collective needs of the teams. The commercial tensions between drivers and teams continued in 1965 when Jim Clarke (Lotus) and Dan Gurney (Brabham) chose to drive in the Indianapolis 500 instead of the Monaco Grand Prix as the American fee was twice as much as an F1 World Champion could earn in a season (Hay, 1965).

The commercial underpinning of F1 did raise alarm among broadcasters of the sport, especially the BBC who had a strict policy against advertising. The prominence of brands on BBC cameras was to be avoided at all costs, but motor racing circuits were plastered with large advertising hoardings. Advertising at race tracks had been the norm since the 1930s, but by 1960 the strategic placing of adverts by oil companies, tyre manufacturers, newspapers, alcohol and cigarette brands were difficult for cameras to avoid. In 1963, the BBC's Chief of Programmes, Donald Baverstock, wrote to the Head of Sport, Brian Cowgill, to complain about 'blatant advertising which was visible for long periods of time on the screen in last Saturdays *Grandstand* from Brands Hatch' (BBC WAC/TV14/169). Brands Hatch had signed a long-term agreement with the BBC and there was a feeling amongst senior BBC managers this was being used to entice new advertisers to the race track. In 1964, an advert for Castrol oil had to be pulled from the BBC's promotional listings magazine, the *Radio Times*, because it named the BBC's *Grandstand* programme as an ideal way to watch the Grand Prix and avoid attending the race. *Grandstand* viewers could also receive a free mail order F1 book published by Castrol (BBC WAC TV14/169). The whiff of commercialism was too rich for the BBC to stomach. To compound matters, in November 1967 the RAC, the Society of Motor Manufacturers and Traders, the circuit owners and F1CA agreed that cars could carry full body advertising for the 1968 season (Wilson, 1967). Colin Chapman was ahead of other team owners in brokering sponsorship deals and in 1968 Graham Hill won the drivers' championship in the Gold Leaf Team Lotus car based on a £100,000 deal with Imperial tobacco which revolutionised the relationship between the sport and the tobacco industry (Bower, 2011: 26).

The issue of blatant advertising on F1 cars and drivers came to a head in 1976 when BBC executives pulled the plug on coverage of F1. The only sight viewers got of their driving heroes was at a The Grand Prix Night of the Stars, a variety show televised from the Royal Albert Hall which paraded fourteen

F1 drivers alongside Shirley Bassey and Lena Zavaroni. The blackout contin-ued in 1977, until the BBC relented to promises from teams and the FIA that advertising would be kept to 'acceptable levels' (*Daily Mirror*, 1978).

Reflecting on the 1960s, to many something of a 'golden age' of Formula One racing, John Cooper, founder of Cooper Formula One, remarked:

> 'Formula 1 was pretty cheap then. We'd build a chassis for £3000, a whole car for four grand. Like most teams, we used Climax engines, which were £1250 apiece, and we'd do at least two race weekends without stripping them down. So far as 'sponsor-ship' was concerned, in 1960 we got £10,000 from Esso, a couple of thousand from Dunlop, a grand from Champion, and that was the lot.' We are talking, of course, of a dozen years before Bernie Ecclestone took over F1, founding FOCA (the Formula One Constructors Association), which – although the word ordinarily made him quake – unionised the teams, on whose behalf Ecclestone dealt with race organisers. (Roabuck, 2020)

In the 1950s and 1960s television contracts were negotiated directly between the broadcasters and the race tracks, for what was essentially a 'facility fee' to access the venue. In 1959 the BBC paid the insignificant sum of £750 for a three-race deal with Brands Hatch. A decade later commentator Murray Walker was presenting live from the Monaco Grand Prix linked via Eurovision for the first time on *Grandstand* which would have been expensive for the BBC but the full value of television to promotors and the teams had yet to be fully realised.

The step change in television coverage began to take shape in the 1970s. Increased television coverage also increased newspaper interest in racing rivalries between teams and drivers such as James Hunt and Nicki Lauda. The BBC's editor of *Grandstand*, Jonathan Martin, had noticed the increased interest in the Hunt/Lauda rivalry, and in 1978 launched the F1 highlights programme *Grand Prix* on BBC 2 with the now famous theme tune The Chain by Fleetwood Mac. 'BBC 2 was developing as a channel and looking for con-tent', said Martin in an interview with Maurice Hamilton (2022: 79), 'That allowed me to push the door open and get *Ski Sunday* and *Grand Prix* on the air.' In short, the BBC provided the television coverage, while the sports print media began to colour in the on-track rivals and drivers. As the circulation battles between the London based tabloid press in the UK intensified in the late 1970s and early 1980s, sports journalism became more robust and celeb-rity focused, in so doing 'busting the club' that had existed between journalists and the sportspeople they wrote about (Boyle, 2006). The level of exposure of F1 as a sport on television would dramatically change in 1981 as Bernie

Ecclestone began to see the value of television for the sport, and the relationships with broadcasters began to shift.

The Ecclestone Years: The Creation of a Global Sport

In the autobiographical documentary series *Lucky* (2022), produced for Discovery +, the 92-year-old Bernie Ecclestone stares into the camera, dressed in a pristine white shirt in front of an aethereal white background, reflects on his life in F1 from the 1950s to 2017 and states: 'I always believed in television right from the start. The future was television.' In terms of what television could deliver for sport, Ecclestone shared a similar vision to the BBC's General Manager of Outside Broadcasting, Peter Dimmock, who strongly believed free-to-air television helped promote sport to a wide audience, which in turn benefitted their commercial interests. If a sport was not on television, it was invisible to anyone apart from the die-hard enthusiast.

Although they shared a vision for the value of television for sport, Dimmock later recalled Ecclestone was far from straight forward to deal with. 'I used to have to negotiate with Ecclestone. God he used to drive me mad. He'd agree things and then he'd ring me up and say, "Peter, I've been thinking about it but I would just like to change that."' Ecclestone would say, 'I've got to do my best for the sport' explained Dimmock, 'Well, it's not for the sport it's for Mr "bloody" Ecclestone!' (Interview with the authors, 2008). Dimmock, a seasoned rights negotiator, would not be alone in feeling bruised from his tussles with Ecclestone. 'Much of the media appear to dislike or at least distrust him', explained journalist Kevin Roberts many years later, 'but those who have worked closely with him talk of his integrity, loyalty and generosity' (Roberts, 2009: 26). As Ecclestone's biographer Tom Bower (2011: 21) explained, he learnt his methods of negotiation in the world of second-hand car sales, 'a market notorious for bluff and brutalisation'.

Ecclestone had been fascinated by motor racing from an early age, and from renovating used motorcycles in his teens to selling second-hand cars in London's Warren Street, he went on to race 500cc cars in his early twenties, mixing the thrills of the track as he built his car dealership in post-war austerity. He quit racing after a series of accidents, but returned to the sport in 1957 to manage F1 driver Stuart Lewis-Evans who he had first met while racing Formula 3 cars in 1951. Ecclestone left F1 in 1958 following the death

of Lewis-Evans following the explosion of his car during the Moroccan Grand Prix. A decade passed before he returned to manage another driver Jochen Rindt at Lotus, who also tragically died in a crash in Monza in 1970. Ecclestone was invited to manage the Brabham F1 team in 1971, which he bought for £100,000. This began an era of commercial influence F1 teams, crucially his stewardship of the Formula One Constructors Association (FOCA) with his legal adviser Max Mosley from which he took a stranglehold of negotiations for television rights and battled with Jean-Marie Balestre, president of the Federation Internationale du Sport Automobile (FISA), the Paris-based governing body of international motor sport. The so-called 'FISA-FOCA wars' were essentially the battleground for commercial control of the sport, which for many decades had been dominated by the manufacturers Ferrari, Renault and Alfa Romeo. The outcome of the dispute was the signing of the Concorde Agreement in 1981, a document drafted by Mosley which has underpinned the structure and commercial set up of F1 ever since.

Motor sport commentator, Murray Walker, whose voice became synonymous with F1 for many UK fans from the 1970s to early-2000s summarised how he saw Ecclestone's influence in the sport:

> You can't ignore the power and influence of Bernie Ecclestone as far as Formula One is concerned. Bernie has, single-handedly, in terms of leadership, admittedly with the help of very capable people, which were his people, transformed Formula One from being a sport largely for wealthy amateurs that the public didn't know about or care about very much, and which wasn't promoted,... and Bernie saw the commercial possibilities of it. (Interview with authors, 2008)

Throughout the 1980s Ecclestone extended his influence and control of F1 especially commercial control of television contracts. In 1982 Ecclestone established FOCA TV and struck deals with every circuit that his company would handle the television rights for every race. This foregrounded a deal with the European Broadcasting Union (EBU) which represented ninety-two national broadcasters across the continent who agreed to show entire races live, thereby guaranteeing sponsors at least two hours of exposure to millions of viewers. When the BBC refused to transmit inferior pictures from Belgium coverage at Spa, Ecclestone created FOCA's own television production centre at Chessington and set about investing in outside broadcast units to create higher quality coverage. This move upset members of the EBU, but as Bower (2011: 128) notes:

His tactics, throwing up problems but potentially profitable solutions, were almost by chance producing a strategy to transform a minority sport into a global attraction.

Learning from Mark McCormack sport marketing empire IMG, F1 removed the plethora of brands littering the periphery of circuits, and instead focused on a narrower roster of quality brands and hospitality which were managed in partnership with Allsport Management run by Patrick McNally. From 1985 Allsport's ran access to the paddock, making it more exclusive, attracting celebrities and the wealthy to attend the sport. When the second Concorde Agreement was signed in 1987, Ecclestone formed Formula One Promotions and Administration (FOPA), later renamed Formula One Management (FOM) to manage TV rights for the teams. FOPA received 49% of all television income. He acutely understood the long-and-well established relation there exists between television, sport and sponsorship, what Whannel (1992) called 'the sporting triangle'. He understood that by expanding the television audience by selling television rights across more international markets, he positioned the sport as a premier shop window for multi-national companies keen to maintain or even gain exposure across a range of global markets (Sturm, 2023). His unassailable leadership of F1 led Kevin Roberts (2009), editor of *Sport Business* to proclaim: 'Bernie Ecclestone, one of the few people on earth whose name rarely appears in print without the prefix Supremo, Svengali or Ring Master.'

As Damian Sturm (2023: 391) notes, from the 1990s F1 became 'explicitly corporate in its make-up, design and operation.' In 1991, Ecclestone's alliance with Mosley helped secure the latter's election as president of FISA. In 1993 Mosley became president of the FIA, absorbing FISA into the parent organisation 1993, which helped align the governing body's ambitions with those of Ecclestone and the F1 teams. Although disputes between the FIA and F1 teams continued, the hegemony of Ecclestone's grip on the commercial operations of F1 was unrivalled in any other sport. Journalist Mihir Bose argues that Ecclestone was among a group of entrepreneurs that began to change sport during this period, by recognising its often amateur governance structures and realising the commercial power that the expansion of television coverage offered. Bose suggests that:

He was the great pioneer of making a business out of sport, but unlike most of his contemporaries who came into sports with the same motives, he paid no homage whatsoever on the higher ethics of sport as enunciated by Thomas Hughes. He made

it clear that he saw sport purely as a way of making money, not as an aspiration for morality. (Bose, 2012: 350)

Ecclestone understood the product being sold: the drama and thrilling narratives created by drivers in cars which pushed the boundaries of speed on a race track. In *Lucky* (2022) he argued, to entice viewers to television, 'You just need one team with two drivers who both want to win'. In this context, the journalist Richard Williams (1998: 7) argues that by the 1980s the generation of Nelson Piquet, Alain Prost, Aryton Senna and Britain's Nigel Mansell had become the first generation of drivers to treat motor racing 'as a contact sport'. What he meant by this was that the rivalries and conflicts generated by these drivers was crucial for the sports sponsors and broadcasters in helping to create the narratives that positioned F1 as an increasingly global form of television entertainment, rather than simply a niche sport. For almost a decade this cast of characters, each with a delineated set of characteristics, in part nurtured by the sport and its attendant newspaper coverage, provided an open ended yearly international television soap opera, albeit one intrinsically more dangerous than working on television soap operas such as *Coronation Street* or *Dynasty*.

In the first decade of the 2000s F1 sought to expand its reach in terms of new Grand Prix in new territories in order to capture new audiences and expand the global fan-base for the sport. UAE, South Korea, Turkey, Singapore, India, China and Russia were all in the sights of F1. At the time, many thought America would be ripe to expand the global Grand Prix circuit, although Ecclestone remained largely unconvinced based on his understanding of American TV audiences and fans. 'We never had anything out of America' he argued, 'No sponsorship as such comes out of America and America has got its own way of presenting almost everything including sport' (Roberts, 2009: 28). Ecclestone was far more excited by the prospect of expansion in Asian and Arab states where innovations such as floodlit racing in Singapore in 2008 transformed the look and reach of the sport. 'It was a bit of a ballsy thing to do, to ask them to light up their bloody streets', said Ecclestone, 'Everyone said the same thing... that I was mad, the drivers wouldn't be able to see and that it would be a disaster. It wasn't' (Roberts, 2009: 28). The expansion of F1 carried a lot of financial risk for the nations that built new tracks (Turkey was introduced in 2005 but was dropped in 2012 until its reinstatement in 2020, only to be dropped again in 2022), but the carrot of hosting an elite sporting

brand with global reach and the potential commercial revenue that could follow persuaded governments and local investors to follow Ecclestone's vision.

What is curious about Ecclestone was his relationship to the sport can seem indifferent. Despite his origins as a driver (he recognised he wasn't good enough), his development into a team owner and finally his seizure of the reigns of power of F1 through initially controlling its media rights through the Formula One Constructors' Association (FOCA), it seems his main interest was building his own personal wealth. In many ways the most revealing aspect of Tom Bower's (2012) investigative book into Ecclestone was how he often left the Grand Prix well before the end of the race, taking off in his private Falcon jet and leaving behind the carnival he had set in motion. He would find out who won later on, a bit like the fan leaving the stadium early to avoid the traffic after the event.

From Free-to-air to pay-TV: BBC, ITV, Channel 4, Sky

With the exception of the British Grand Prix and the Monaco Grand Prix, usually transmitted live on the BBC's flagship sport programme *Grandstand*, most of its coverage consisted of recorded highlights of races on the half hour programme *Grand Prix*, with commentary by Murray Walker. From 1981 most European races were transmitted live via the Eurovision network, and Walker began to form a commentary duo with the ebullient if highly critical style of former World Champion James Hunt. Walker was initially concerned with the BBC's choice of Hunt, fearing it was the beginning of the end of his commentary career. Hunt was also notoriously late to appear in the commentary box, often after spending hours drinking in the hospitality tents of F1 teams. As Walker later recalled, 'My views on life were diametrically opposed to his. I was a pretty plonking straight-forward up-and-down bloke and here I was with this booze-swilling, cigarette-smoking, womanising, drug-taking chap who I associated with rudeness and being objectionable' (cited in Hamilton, 2022: 88).

The British F1 fans lapped up the incongruous double-act, with Walker's excitable commentary and Hunt's insightful critiques of drivers and teams, often picking up interesting information on the cars and team tactics prior to the race from the F1 paddock. In 1982 Walker retired from his career as an advertising executive, and went from being a motor racing enthusiast who

was an occasional broadcaster, to become a full-time broadcaster travelling the world to cover F1 following F1's new television deals for live coverage of every grand prix. His high pitched, high-octane commentary style endeared him to millions of fans and made him synonymous with F1 as a sport. The *Guardian* journalist Frank Keating (2021) eulogised: 'the passionate yawp and yowl emanating from Walker's commentary box was an almost onomatopeic accompaniment to the snarling beasts hurtling past at 200 mph'. Jonathan Martin, Head of BBC Sport in the 1980s, claimed F1 was the hardest sport to commentate on. As Walker explained:

> When you're looking at Formula One as a viewer you're seeing the cars go round, there's twenty-two of them, spread out over a three-and-a half-mile circuit. Some of them make pit stops, some of them haven't, there is an enormous amount of tactical and strategical information to communicate to the public that you can't divine by just looking at the picture. So you've got to work all that out in your head while you're telling them about what is on the picture, and it is an extremely complicated thing to do. (Interview with the authors, 2008)

Always standing to deliver his commentary, mainly due to his excitable energy for motor racing, led to adoration from F1 fans, who celebrated his exuberance for the sport as well as his gaffes and slips of the tongue known as 'Murrayisms' ('This leading car is absolutely unique – except, of course, for the one immediately behind it, which is identical'). Walker's fame was further elevated by his relationships with leading drivers, in particular James Hunt, Nigel Mansell and Damon Hill (with whom he lampooned his commentary style in a TV advert for Pizza Hut). In an interview with the authors in 2008, we asked Walker if he ever felt it was his role to engage in the politics of F1. Walker had an unequivocal answer:

> It wasn't something I felt I couldn't do, or shouldn't do. I used to as a commentator to try not to get involved with the politics of the sport and to take sides. Because if you take sides you make enemies. If you make enemies you can't do the job. If you're critical, if you say "Joe Bloggs is a bloody useless driver, he's in the wrong gear and he's breaking at the wrong point". First of all, how can I know that? I haven't done it myself. Martin Brundle could say that. James Hunt could say that. James Hunt did say that. So I never criticised drivers for their skill or for their lack of skill. Or application or whatever. (Interview with the authors, 2008)

Walker's answer is diplomatic in the extreme, because the politics of F1 from the late-1970s to the present day have been riven with disputes.

In 1993, television cameras had captured the tragic deaths of both Roland Ratzenberger and Ayrton Senna at Imola. The horror of Senna's crash and the chaos which subsequently unfolded live on television prompted new disputes over the safety of F1, with Max Mosely claiming drivers 'were driving at 170 mph in an unprotected petrol bath' (Bower, 2011: 167). As journalist Malcolm Folley noted, that as television and sponsorship money flowed into the sport in the 1980s and 1990s:

> It would require a hard heart to begrudge racing drivers for being well rewarded for participation in a sport where death can arrive at the next corner. (Folley, 2017: 27)

The crash that killed the iconic and revered Senna also occurred live on television coverage of the Grand Prix. As Maurice Hamilton notes:

> In one afternoon, the false sense of security was demolished instantly by the death of one of the best know names in global sport [] This was the decade ahead of social media's accelerating influence and its demands for answers before there have been sensible and measured questions. In May 1994, the media was about to dictate policy in a manner never before experienced by those in charge. (Hamilton, 2020: 171)

The media outrage around Senna's death resulted in a number of technical changes being introduced by the sport in an attempt to improve safety. But the tragedy also highlighted that while F1 was happy with the money they received from television, a growing media scrutiny of the sport was also going to be something that would come with the increased profile of the sport as an international spectacle.

In the macabre spectacle of the 1993 season, television ratings for F1 around the world increased. An emergent rivalry between Michael Schumacher driving for Benetton and Damon Hill driving for Williams propelled F1 into the spotlight as television viewing figures soared in spite of the two deaths earlier in the season. Further drama ensued with pit disputes, crashes and a refuelling accident that seriously injured a Benetton mechanic, all seen live on television. According to Tom Bower (2011: 174) the renewed spectacle of F1 rivalries and dangerous action had potentially magnified the income that could be generated by broadcasting, and Ecclestone was in a prime position to leverage enormous income from the global demand for television coverage of F1 rivalries and incident. By 1993 drivers were earning huge salaries from the sport, up to $12m per annum, but few had realised the wealth flowing to Ecclestone from television rights. When his salary was revealed as £29.7m in 1993 he pronounced, 'The teams know that if I'm making a buck, they

are making a buck and then everyone is happy' (Bower, 2011: 175). In 2008, Murray Walker reflected back on Ecclestone's manipulation of the sport's rivalries and television deal-making thus: 'If Bernie Ecclestone hadn't made Formula One what it is now, then the television companies would not be interested in showing it. It would still be a sort of peripheral sport' (Interview with the authors, 2008).

In 1996 Murray Walker himself became the centre of the battle to televise F1 when ITV snatched the rights from the BBC for £65million over five years, nearly ten times what the BBC had previously paid, and way beyond its sport rights budget would stretch. The BBC's head of sport Jonathan Martin had been left completely in the dark and deeply upset that the Corporations promotion of F1 had meant little in Ecclestone's hard-nosed approach to business. In Portugal, Ecclestone hosted a party for the BBC team to thank them for nearly 20 years of coverage, and presented Walker with a silver trophy. The *Daily Mirror* set up a campaign to save the treasured Walker as 'the voice of motor racing', but fans need not have worried, he was soon signed by ITV Sport for whom he commentated until his retirement in 2001 aged 77. No sooner had ITV brokered the deal the new British star of F1, Damon Hill, was unceremoniously ditched by the Williams team. When news of this got out, there was anger in a number of quarters not least from ITV. As Richard Williams noted, for ITV: 'Hill's continuing rivalry with Michael Schumacher represented a key strand of the narrative of the grand prix soap opera' (Williams, 1998: 196/7).

Bower (2011) suggests 1996 was a watershed in Ecclestone's negotiation of television rights with commercial broadcasters in Europe. Indeed, on the production side, F1 began to lead the way in digital outside broadcast techniques through its investment in F1 Digital+, an innovative multi-feed service which introduced high-definition coverage, interactivity for viewers, onboard cameras, dedicated pit lane coverage, additional racing coverage lower down the grid and live lap time data overlaying the coverage. The innovation in new digital cameras and editing facilities run by former Brabham engineer Eddie Baker was costly, using two Boeing 747 cargo planes to ship the masses of equipment to each race to be housed in a temporary facility nicknamed 'Bakersville' by the F1 community. For the first time F1 began to explore the commercial potential of pay-TV, which was transforming television sport across Europe, especially in the UK with Premier League football driving subscription revenue for BSkyB. FOCA brokered deals with Kirch Gruppe for its subscription service DF1 in Germany, Austria and Switzerland, Canal

Plus in France and TELE+, Italy's first subscription channel founded by Silvio Berlusconi. These deals had followed a period of power plays by Ecclestone who had become acutely aware of how fundamentally important television had become to the commercial success of the sport and his growing empire as its impresario. His salary in 1996 had grown to £54m, making him the highest paid executive in Britain.

F1 Digital+ launched briefly in the UK in February 2002 charging Sky's digital subscribers an additional £12 per race, but by the summer of that year its take-up had been nothing short of a disaster, with audiences as low as 9,000 viewers compared to an average audience of 3 million on ITV1's free-to-air broadcast (Milmo, 2002). Fears grew among F1's manufacturers Mercedes and BMW that a move to pay-TV would shrink audiences to an unsustainable level, especially for sponsors whose brands had thrived under F1's free-to-air broadcast deals. The pay-per-view (PPV) service in Germany, France, Italy, Spain and the UK was entirely dropped by Ecclestone at the end of the 2002 season due to escalating costs and poor audiences. In many ways, the service was ahead of its time in terms of the market it aimed to reach, digital television was still in its infancy across Europe and the concept of PPV disliked by consumers.

In 2004 ITV renewed its contract for F1 for a further five years which enabled the broadcaster to cement its commitment to the sport and plan enhanced coverage across its new digital channels ITV1, 2 and 3. In the media press ITV's Head of Sport, Brian Barwick, emphasised the enhanced nature of the channels coverage, with revamped, punchy opening titles, and opportunities to focus on British driving talent with David Coulthard, Jenson Button, Justin Wilson and Ralph Firman. The innovations in production of F1 were revelatory, and in 2004 FOM took over digital production from every circuit removing the inconsistent quality from host broadcasters. Digital production enabled F1 to re-introduce the innovations of F1 Digital+, including high-definition cameras, on-board coverage, lap data and many more cameras on the circuit and pit lane (Benson, 2002). The main challenge for broadcasters was the dominance of Schumacher and Ferrari in the driver and manufacturer championships, which had turned some viewers away from the sport. In spite of the downturn, Martin Lowde, ITV's director of sponsorship was bullish about F1's appeal to audiences, stating, '40 million people in the UK watched formula one on ITV1 and crucially for advertisers it attracts an average 41% share of young, upmarket male viewers' (Day, 2003). Nevertheless, in 2003 Toyota pulled out of their £25m sponsorship of ITV's F1 programming, and

the broadcaster's deal for the 2004 season with *The Daily Telegraph* was considerably reduced deal for £4.5m (Deans, 2004).

In 2008, ITV announced a new sponsorship deal with Sony and enhanced their coverage further in 2008 with the launch of a broadband F1 offering which would stream Friday practice sessions, the first time they had been televised (Sweney, 2008). However, in a dramatic shift of strategy, ITV initiated a break clause in their contract for F1 in order to compete for television rights for UEFA Champions League football which brought a much more lucrative prime-time audience for advertisers. The financial crisis had dramatically hit ITV's advertising revenues, and in spite of a growing audience for F1 ITV had to focus its resources and football was king (Rider, 2012). Ecclestone quickly struck a deal to return F1 to the BBC from 2009 for £40 million per season, who were keen to capitalise on British viewer interest in its emergent F1 hero Lewis Hamilton (Gibson, 2008).

The BBC's coverage of F1 enabled a reprise of its landmark F1 bass riff theme tune from The Chain, they brought fresh presenter talent in Jake Humphries to front the coverage and appeal to younger viewers, and employed racing expertise with Eddie Jordan, David Coulthard and Martin Brundle who came across from ITV. Viewing figures for F1 soared on the BBC with 8.5 million viewers watching the 2011 Canadian Grand Prix as new rivalries between Hamilton, Massa and Vettel renewed interest in the sport. Although public pronouncements from head of BBC Sport Roger Mosey were upbeat, according to Steve Rider, who had fronted ITV's F1 coverage, behind-the-scenes the costs of producing coverage, estimated at around £9 million, sent a shudder through BBC executives (Rider, 2012). The BBC's licence fee settlement had been frozen by David Cameron's government following the financial crisis in 2008, which was also part of an ideological move to reduce the influence of the broadcaster in public life in favour of more commercial media interests (Barwise, 2022).

In spite of continuing popularity of the BBC's coverage, the financial pressures on the broadcaster's sports rights portfolio and production costs drove it to make significant savings and in July 2011 F1 announced a new collaborative five-year television deal between the BBC and pay-TV broadcaster Sky Sports. Again, the abrupt transformation in F1's television coverage in the UK came as a surprise for many, including presenters such as Brundle who tweeted, 'BBC/Sky/F1 2012+. Found out last night, no idea how it will work yet I'm out of contract, will calmly work through options Not impressed' (Nelson, 2015). The dual-network approach in the UK was a significant

departure for F1, with Sky becoming the dominant television partner and agreeing to create a new dedicated channel to F1 which could deliver rich, in-depth pre and post-race coverage that a free-to-air broadcaster such as the BBC simply could not afford. Reflecting back on F1's decision to move behind a paywall, Sky News F1 correspondent Craig Slater explained that making a sport like F1 a premium content can increase its desirability among audiences, as has been seen with Premier League football:

> I do think an interesting point in the journey was that maybe, ahead of some of the exploitation by social media, was going behind the paywall for Sky was a big moment. There was a lot of nervousness that we encountered about it. A lot of those involved in F1 didn't like the idea. Team bosses, even journalists, reckoning it would reduce eyeballs watching the top number which would have an impact on sponsorship and so on, and just make the sport less visible, full stop. And it's hard to argue against a lot of that, but I think possibly social media has filled some of that void. And I think the other, there's some other aspects to going behind the paywall, especially the way modern sport works and maybe football is the chief forerunner of it that I think. (Interview with the authors, 6 December 2022)

In the UK the free-to-air component of the dual-network approach has taken several twists and turns from 2012 as broadcasters coped with playing second-fiddle to their pay-TV partner. In 2015 the BBC stepped away from televising F1 as the cost of coverage became too great following further real-term cuts in its licence fee settlement with the Conservative government. Channel 4 picked up the BBC's remaining three-year contract for free-to-air coverage from 2016, covering ten races live without advertising breaks, and adopting the BBC theme tune The Chain. Channel 4 extended their contract for F1 in a sub-licensing agreement with Sky from 2019 to broadcast race highlights and the British Grand Prix live. The revised deal effectively removed live and extended racing coverage to subscription television, with Channel 4's coverage also forbidden to interview drivers in the paddock or hold the grid 'walkabout' prior to the races.

Conclusion

Like many sports, the history of F1 is intricately connected to its media coverage. As a commercial operation serving the needs of teams, spectators and sponsors F1 heavily relies on its exposure across all forms of media, which as we have seen has changed in form and volume since 1950. There is scope for

much richer academic histories of this relationship, which currently resides in the biographies and autobiographies of journalists and broadcasters of motor sport, or the critiques of investigative sport reporters. Fans of F1 are also deeply connected to these histories, whether through access to media archives or in following the latest deals being struck to cover the sport on television and other platforms.

As we go on to discuss in chapter Three, the partnership of pay-TV channels such as Sky and F1 has been vindicated by the commercial success of the sport, particularly since the change of ownership under Liberty Media from 2016. Although our history has focused on the UK context, partly because the business of F1 has long resided in the UK under the entrepreneurship of Bernie Ecclestone and FOM, F1's relationship with the media has been global from the beginning. Whether it is the newsreel film footage of pioneers such as Fangio or niche online media obsessions with Ferrari by the Italian digital publisher *Edimotive Srl*, F1 fans have generated an appetite for F1 news which has sustained its commercial success. Television has been the key driver of that obsession, and F1's concentration of its production and licensing of races has turned it into a definitive global sport.

· 3 ·

DIGITAL F1 AND REINVENTING SPORT

We are in a new era which has a different philosophy; a different approach which effec-
tively says we should all be working very strongly together to lift the sport to the highest
possible level.

Ross Brawn, Managing and Technical Director of Formula One in Hamilton, M.
(2020) *Formula 1: The Official History,* London: Welbeck, page 11.

The comment from Ross Brawn above signals that change would be the order of the day under the new owners of F1, Liberty Media. Brawn was tasked with leading a review of the technical regulations governing the sport in order to increase the quality and excitement of the on-track racing. It also signals a moment of change in the sport. This chapter drawing on original fieldwork research sets out to examine this re-invention of F1 in the digital age. It maps out the key changes taking place across the media and communication sectors and how these are mobilised by the new owners of F1 Liberty Media to re-think the sport, its relationship with investors, sponsors, fans and most crucially the media. The development of social media strategy and a more comprehensive digital framework help re-position the sport as it seeks a new digital audience, while attempting to retain its legacy audience. It also examines the political and economic context as the sport increases its global reach and in so doing highlights the growing importance of the geo-politics of sporting discourse as the media sport environment is disrupted by the growth of platforms and new media players.

Liberty Media: Creating an Entertainment Brand

Sport thrives on competition, on an element of jeopardy. The irony of this is that as more capital comes into sport, it often seeks to eliminate risk and uncertainty from sports culture, seemingly oblivious to the fact that these elements are often what make it a compelling 'media product' in the first place. For F1, the 1990s began to see a narrowing in the technical aspects and even the aesthetic looks of F1 cars. Part of this was driven by the advent of a more computer driven focus on technical development, and the increased competition to secure that vital lifeblood of support for teams, commercial sponsorship. As an aside, it is interesting to note how one of the most important and significant car designers in F1 history Adrian Newey (2017), has retained some of the more analogue elements in his working practices, despite the onslaught of digital technology and computer based design that has flooded, what has become a high-tech industry.

The need for F1 and its media coverage to compete for an audience in the 'attention economy' was something recognised as far back as the late 1990s by sportswriter Richard Williams. What interested him was how this need to compete with other forms of popular cultural activity, might change F1. With admirable accuracy he suggested that:

> The nature of motor racing has changed greatly and will perhaps change even faster in the coming years, under pressure from television and the need to compete for attention with virtual-reality games. The question is: how can the sport increase its levels of safety while maintaining the tension derived from the knowledge that its contestants are taking part in a profoundly perilous activity?. (Williams, 1998: 280)

Almost twenty years on from this observation, the challenge of rekindling media and fan interest in the sport of F1 was taken up a new player securing effective control of the sport, through acquiring the commercial rights to the sport.

Liberty Media entered the sport on the 23 January 2017 paying $4.68 billion dollars to secure the commercial rights to Formula One (F1) from CVC Capital and its controlling executive Bernie Ecclestone (Evens et al., 2023). As a media organisation, embedded in the digital transformation of the media industries they enter with a particular strategy to grow the sport, specifically in the USA. Mark Gallagher, F1 business analyst argues that the timing was crucial for the sport:

Formula One's core business model needed to evolve, and in selling to a company like Liberty, CVC and Ecclestone place it in the hands of a company that better understood the fast-changing media landscape. The absence of a succession plan [in the sport] had long been a concern. A new regime was required to take the sport onto the next level, developing the product for the 21st century. (Gallagher, 2021: 7)

Over the years the sport had held races and had media coverage in the USA, but had never broken the stranglehold of the major American sports or indeed the motorsport sector in the USA. An American media company was always going to see this as fertile ground to expand the profile, audience and of course the commercial value of the sport in what remains the biggest sports media market in the world. Former executive vice-chairman of 21st Century Fox, Chase Carey became the first CEO of the new era and remained in post in this first crucial stage in the transformation of sport until September 2020, when he would be replaced with the current CEO and former Head of Motorsports at Ferrari, Stefano Domenicali. Along with Sean Bratches (Managing Director, F1 Commercial Operations) who had over 25 years experience as senior executive at the sports cable company ESPN, they set about restructuring the business.

Carey had no background in the sport, but as a senior and experienced media executive he understood what was needed to grow the media value and profile of a sport. In effect Liberty Media undertook, at considerable cost the challenge of rebooting a sport that was no longer fit for the digital age. One of their key appointments in 2017 was Ellie Norman, recruited as Global Director of Marking and Communications. Norman's background was in media, marketing and sports. She was clear about why Liberty Media has been interested in F1, and what were the challenges facing the sport.

When I was going through the interview process and meeting Sean (Bratches) and Chase (Carey) and starting to understand from Liberty why they'd been driven to make the acquisition, it very much stemmed from recognising that Bernie and CVC had built a great business but actually from their perspective it had been underutilised and there was far more potential within Formula 1. I think from the USA point of view you can own a team franchise, but you couldn't go and buy an entire league in sport. So that was a great opportunity, with global appeal and a fan based and an awful lot of opportunity there to really grow the sport. My specific role going into that was really to understand the ecosystem that had existed and still exists to this day and recognising where the primary commercial revenue can come from, which is your media rights, your sponsorship and, in the case of Formula 1, promoters, and countries that want to host a Formula 1 race. At that time in 2017 I think the sport could have been positioned as boring, losing interest, not relevant anymore. In an age

of electric vehicles, it's like a dirty sport, with an ageing fanbase, people moving away from the sport and therefore my remit was to say, 'Well how do I grow the fanbase? How do I bring relevancy back to Formula 1 and to grow the fanbase and attract a new fan for the sport but importantly, without alienating the core to the fanbase?' (Interview with authors, 28 November, 2022)

Given the closed structure of the sport (ten teams, twenty drivers on the grid, with no relegation for those that finish last in the constructors championship), one can see how the North American sports franchise model appealed to a US media content company such as Liberty Media.

One of the first things they did was commission a major piece of research into who F1 fans were and the perceptions of the sport. Drawing on data from 14,000 surveyed fans across seven key markets in North and South America, Asia and Europe, the research looked at perceptions of the sport right across differing fan demographics from being an avid fan of Formula 1 to the casual fan, from the general sports fan right the way through to not being a fan of the sport and augmented this data with in-depth interviews. Norman recalls that what clearly emerged from the research was a view of the sport as:

essentially an elitist billionaire's boys club and that was fantastic to then have as almost like a problem statement to fix. At the same time if you were to type into Google Formula 1, the three things that would show up would be boring, not a sport and dying and so it was actually setting out a really clear problem, never straightforward, but you really know what is it that we have to start to understand and then to address. Whether that was through all of the changes to the sporting regulations, technical regulations and all of the work that Ross Brawn and the FIA led on the new cars that you see in 2022, right the way through into the digital transformation and actually creating digital products and experiences to better serve fans as well as just opening up social media, communications, esports, and bringing in grid kids. It's just, 'How do we bring more people into our world?' And importantly through marketing and communications where are those opportunities that take Formula 1 out of its own echo chamber and really show up with where we think our target audience is and what are they passionate about?. (Interview with authors, 28 November, 2022)

Ross Brawn has a long history in the sport as a successful Technical Director and Team Principal working with a number of teams that have successfully won world championships. Despite retiring from the sport in 2013, he returned in early 2017 at the behest of the new F1 rights owners Liberty Media as initially Managing Director, Motor Sports, the Formula One Group and led an in-depth review of the sport, with a focus specifically on the technical side of the sport with a view to improve on track racing. In so doing it would

contribute to the longer-term purpose of growing and expanding the sport for commercial reasons. In 2020 he noted that:

> The philosophy of Liberty Media is that we're in this for commercial reasons, but we are willing to invest the money to make the sport as great as it can be. We are not a venture capital company with the single intention of extracting the maximum profit from the sport. We are making a healthy profit-but we are putting it back in. (Hamilton, 2022: 11)

Aside for the barb at the previous owners of the sport, the private equity firm CVC Capital who indeed were never going to be in the sport for the long term, Brawn's return to the sport signalled that major change was being instigated.

Underpinning the audience research carried out by IPSOS MORI was a recognition that the sport knew relatively little about the differing types of fans that engaged with it specifically through television and other platforms. We expand on the developing patterns of fandom in more detail in chapter Six, but it is important to note that the F1 experience in 2017, in many ways mirrored the lack of data that many sports and sporting clubs have with regard to their fanbase.

A key element of this, as we have noted earlier in the book, is that the traditional sports media model has been one of a B2B relationship, where a sport, such as F1 is involved in a transactional relationship with the media. In other words, it sells the media rights to the sport in particular media markets to a media organisation, such as in the UK Sky Sports. Or de-bundles the rights (for example radio rights) and sells to a number of organisations, however the media have always been willing to pay more for some element of exclusivity. In so doing the sport is in effect handing over the data about those television (or radio) audiences to the media organisation, and for years this model has worked for many sports as the money received was usually upfront, guaranteed and offered a degree of medium-term financial stability to the sport. Of course, the value of these rights differed between elite or top-tier sports and other less popular sports and also between differing media markets. What this meant was that while sporting clubs or indeed F1 teams may have some knowledge of their specific fans base (and we would argue that until relatively recently, certainly in Europe this depth of knowledge has been uneven at best among sports clubs), the sports as a whole, be it football leagues, governing bodies or F1 had limited or relatively crude notions of the depth, desire and demographics of the mediated audience engaging with their sports.

However when a media organisation, actually aware of the value of data secures the rights, through ownership of an entire sport such as F1, then a much improved detailed data driven and differentiated knowledge of the media audience was always going to be a central part of any commercial strategy to grow the sport, and by default its commercial value to the shareholders of the company.

Ellie Norman, on becoming Global Head of Marketing and Communications of F1 quickly realised that the way the commercial side of the business had been run under Ecclestone, was, not to put to fine a point on it, minimalist. She notes that:

> the surprise was to see how much aspects of it were like a cottage industry and that sounds perhaps a little harsh and doesn't take away from actually what Bernie built which was an incredible business. But as a marketing person the surprises were, there wasn't the infrastructure either from a research point of view, in understanding your fan base. Not actually having a database any of those things in place and yet the success of the business had very much been approached through a Business to Business lens or actually as an IP business. So, that was surprising. (Interview with authors, 28 November, 2022)

In resource terms, another surprise for Norman was that there wasn't an actual marketing department, so an intensive, but financially restrained period of recruitment was undertaken. Norman recalls that:

> I remember being told, right so you are headcount number 1 in marketing and comms. You've got a blank sheet of paper, there's no team but here's a headcount of 12 and here's a budget of X and when we're talking about a budget of X we are literally talking less than 1% of what you would normally have.[], the one thing that we had to really do was to signal change and I was bringing in 12 people in that first year with the skill set of how do we rebrand and build a brand built on fan engagement as a primary objective or ours. That started with bringing in a head of customer marketing fan engagement and putting in place all of the databases what was required and I would say, were fairly sophisticated for motorsport. We wanted notifications that really brought fans much closer to the sport but always through the lens of, 'We're not here to sell, we're here to tell stories and to get you engaged with the sport.' (Interview with authors, 28 November, 2022)

The next area of growth was around the need to build digital products and experiences and know who the F1 fans were so that the sport can foster a closer relationship with them. Thus the initial focus was very much on the commercial side of the business, and only then was attention paid to the

development of the media relations and wider public relations aspects of F1. This initial focus on building the commercial side, did no go unnoticed by the F1 journalists tasked with reporting the sport.

Ironically, given that opening up the paddock to allow more media access would be one of the key changes instigated under the new regime, the immediate impact for many journalists was in fact the opposite. Rebecca Clancy, is F1 correspondent for *The Times* and notes that when Liberty Media initially took over, they appeared to largely forget about the sports media, by way of contrast with the previous CEO, Bernie Ecclestone. She argues that:

> But Liberty Media, when they came in which was when I started, the news shut down. It felt like they decided that they wanted to just stand back, see how it was all going, they didn't want to talk to us. There was absolutely no news in between races at all, generating news was impossible basically. And it was very, very closed down. Chase Carey, who was the chairman and CEO and didn't really understand our function. They have now but they hadn't previously hired anyone decent in PR so they had no one to guide them and advise them on how to do it. So, that was really difficult at the start because you just didn't know what they stood for, what they were doing, things would leak out as they do because they would talk to the teams and the teams, obviously, we still had relationships with. But it was very much a closed book at the start. (Interview with authors, 31 May, 2022)

What is clear, is that for the new owners, getting the commercial side of the business in order was their priority, rather than developing media relationships. This is acknowledged by Liam Parker, Director of Communications and Corporate Relations at F1 who joined the communications team in 2019. He notes that:

> When I first came in it was still only a few years into the Liberty ownership. They were focused on getting the commercial side of the business right, focusing on building the teams in that area. Communications to the extent it had a role was, without being negative to anyone that's done it before, kind of old school, a transition from the kind of Bernie era where, as I understand it, Bernie never had press people, he did his own media. So, there wasn't a huge amount of proactivity. There was a lot of the kind of no comment to any journalistic enquiries regardless of what they were. It was a very kind of combative relationship with the media and over time that's now evolved into a greater proactivity, a greater openness to different media and by different media I'm kind of talking more the mainstream, the consumer, the lifestyle, the online blog space as well as the core traditional sports media.

Parker argues that this strategic focus on clear external communication has increased in recent years. He suggests:

Under Stefan [Domenicali, CEO, Formula One Group, who replaced Chase in September, 2020] I think it's been supercharged as communication is very important to him. Now the role is to be even more proactive, even more collaborative with the teams. Everything used to operate separately but one of the approaches I wanted to do was to get all the teams together and say, 'This is where our target market is, this is what we're trying to do.' As a result, we can help support the teams' access opportunities in the US, in Asia, in Europe, that they might not necessarily have the resource or the contacts to do so. So, that's evolved. (Interview with authors, 27, January, 2023)

This step change in media relations is examined in more detail in the following chapter.

There were however other media concerns about the new owners and the fact that they appeared deeply rooted in the North American sports franchise model, one that seeks to rigorously manage risk in sport, not least for the franchise holders. Craig Slater, is Sky Sports F1 news reporter and suggests that:

My worry was when the Americans took it over that they might make it all a bit monotone. They might try, and that's Chase Carey and Liberty Media to create this American franchise system where everyone was kind of the same, and it wouldn't have the quirkiness of the sport as it had been. Maybe some characters would be lost and you need to have that, and that's a difficult thing to engineer, isn't it? I think you don't really like rebels. You want to control things if you're in charge of a sport. But you need the unexpected. (Interview with authors, 6 December, 2022)

Interestingly, as we discuss in chapter Five, in part it would be the success of Netflix's *Drive to Survive* series (initiated by F1's Sean Bratches), that would help offset this concern, through its focus on a range of characters, drawn from drivers and team principals from across the paddock. For others the new approach from Liberty Media manifested itself in a broader cultural sense. Andrew Benson, has many years experience as an F1 sports journalist and is now the Chief F1 writer for BBC Sport. He argues that:

There's a change in approach, in the sense that the sport as a whole has become more corporate and more professional. Run like you would imagine a multi-national organisation to be run rather than one person's personal fiefdom which is the way it was fundamentally run in Ecclestone's time. (Interview with authors, 22 September, 2022)

We have seen in the previous chapter the key role played by Bernie Ecclestone in transforming and commercialising the sport, from the 1980s into the 2000s. This was underpinned by a relatively small number of key deals, all of which were financially underwritten by television rights deals, which in turn

facilitated controlled exposure across an international audience. As noted above, Ecclestone ran a tight (and small) team of key people in what was in essence an analogue business in what had become a digital environment. Under Carey, Norman and others this changed dramatically between 2017 and 2020.

The Liberty Vision: The Rise of F1TV and Media Rights

The Formula One Group sits within the Liberty Media Corporation and wholly owns Formula One which has the exclusive commercial rights for the FIA Formula One World Championship. From the outset the goal was to grow the reach of the sport to a new younger audience and drive up revenues, through the three pillars of the staging of the Grand Prix races (19 when Liberty took over, 23 in 2023 with a view to growing to 25 a year); media rights and sponsorship. In his final presentation to shareholders, F1 CEO Chase Carey summed up the vision and the impact of the new owners in 2020. He noted that:

> Since Liberty Media took over custodianship of Formula 1, we have transformed how we go to market with more open and collaborative ways of working, a solutions-focused attitude to new opportunities, and a commitment to have our fans at the heart of everything we do. (Liberty Media, 2020)

The issue of the growth of new fans and the lowering of the average age of the F1 television fan in the USA (it was 59 in 2017) was a particular focus. By 2022, the sport was growing across the US media landscape, with that country the fastest growing market for F1 social media content (up 40% from 2021). While on ESPN, ESPN2 and ABC the 2022 F1 season averaged 1.21 million viewers per race which was up 28% from the 2021 record of 949,000 average viewers. *The Athletic* (23 November, 2022) noted that twelve of the 22 races set U.S. television event viewership records with the Miami Grand Prix the most-watched F1 event ever in the USA, while the biggest increases in 'key demographics' were among young viewers and women. This changing F1 fan is discussed in more depth in Chapter Six.

F1's Chase Carey also reflected in his corporate strategy presentation in 2020 that:

We have built a 21st century organisation that supports the repositioning of F1 into an Entertainment and Media company with our first ever Marketing, Digital, Strategy and Research divisions, expanded teams managing our key revenue streams and a dedicated Motorsports function led by Ross Brawn, that are using state-of-the-art technology to develop regulations alongside the FIA to facilitate great racing. (Liberty Media, 2020)

Strategically, both on and off the track the new owners are reshaping the business, with the biggest on-track changes being the new regulations (developed in part by Brawn and the FIA) designed to improve the closeness of on track racing and introduced in the 2022 season. These included a ground effect floor on the cars, to increase down force, which along with changes on the front and rear wings of the car and new 18inch tyres were made to increase the likelihood of wheel-to-wheel racing and the ability of drivers to closely follow the car in front. While the introduction in 2021 of a cost cap on what teams could spend on their cars during a season ($145m was the COVID impacted figure, originally it was going to be $175m) again with a view to making the ten teams more competitive up and down the grid. In previous years the top teams of Mercedes, Red Bull Racing and Ferrari could be spending $400m, compared to teams at the back of the grid on a budget of $130m. There was also a sustained focus on the importance of media rights and social media strategy.

Ian Holmes, Director of Media Rights and Content Creation at F1, worked with Ecclestone for around 15 years and was central in the selling of television rights under this regime. He notes that historically F1 had been among one of the last top tier sports to move to Pay-Tv with the launch in the UK of Sky Sports dedicated F1 channel in 2012 (at which point some free-to-air BBC coverage remained). Deals with Pay-Tv platforms in major European markets such as Germany and Italy quickly followed. The reason for this late shift (live English Premier League football had moved to Pay-Tv as far back as 1992) was that the previous focus of the sport had been on building sponsorship revenue through wide exposure on free-to-air TV. A tipping point was reached when the revenue from Pay-Tv for the rights to broadcast the races significantly outstripped sponsorship revenue plus FTA revenues. Craig Slater, F1 reporter for Sky Sports F1 channel reflects on the shift of the sport into the Pay-Tv space:

I do think an interesting point in the journey was going behind the paywall, for Sky was a big moment. There was a lot of nervousness that we encountered about this. A lot of those involved in F1 didn't like the idea. Team bosses, even journalists, reckoning it would reduce eyeballs watching the top number. Which would have an

impact on sponsorship and so on, and just make the sport less visible, full stop. Hard to argue against a lot of that, but I think possibly social media has filled some of that void. And I think the other, there's some other aspects to going behind the paywall, especially the way modern sport works and maybe football is the chief forerunner of that I think. An unexpected by product of going behind the paywall in in football's case was that sizing football as something desirable worth paying for, and it's somehow raised its desirability, subtly. It's something that you would pay for rather than just get for nothing. And I think, funnily enough, I think that did happen via the sky process a little bit with one thing, and the odds the audience is reduced significantly in terms of the bottom line figures, but partly because of the advertising campaigns. (Interview with authors, 6 December, 2022)

In 2023, sponsorship revenues for F1 make up around 15% of its of its income. Sponsors remain important (not least for the teams themselves), but percentage-wise make less of a contribution than they once did.

Under the new owners rights are no longer unbundled and sold across differing media platforms. For example, in the UK, Sky Sports secure the rights and then use these across a range of platforms including streaming. The sport used to sell mobile rights, but the advent of streaming across mutiple screens make these obsolete, the content is simply part of the digital rights package that is available to viewers either through screens and platforms they pay for directly though subscriptions or indirectly through advertising (or a combination of both). They also recognise that there are legacy media that are now also streamers (in the UK for example Channel 4 with its All4 platform or the BBC with its iPlayer) and 'pure streamers' such as Viaplay, AppleTV and DAZN who have built their business solely around internet delivered content.

F1 launched its own direct to consumer OTT service F1 TV in 2018 and F1 TV Pro, the latter being a full-service commercial stream offering live races as its centre piece. This is not available in all markets (for example the UK), but in 2023 it is available in 89 countries and after a difficult initial start-up period has become an important part of the F1 content offering. F1's Ian Holmes outlines why streaming matters to the sport and what F1TV Pro adds to the fan experience:

There are consumption opportunities that streamers are better placed to deliver because of the nature of the technology. In the same way free to air television really has one channel (you might have a red button option), however satellite television has multiple channels and streaming just takes it to the next stage. Ultimately the streamer has endless depths of coverage it can put together, such as with our own streaming service F1 TV Pro. You've got the international feed, you've got the pit lane channel, you've got data channels, you've got all 20 onboards. You couldn't

do that on a free to air traditional way, you'd struggle to justify it on satellite but on a streaming service it's relatively, easy. For Formula 1 there is an added component that is interesting, because as a sports right, as a product, what we lack is breadth of content. We're not like the Premier League that has X hundred games a season, X thousand hours, we have 23 events this year. What we do have is the depth of interesting, relevant coverage. An onboard channel is interesting. The international feed is most relevant and you could have endless other channels that are additive. So, a streaming service does help us better cover the sport because it is easier. So, when we do a streaming deal, it can use those raw ingredients where F1TV Pro can offer multiple channels of coverage and that's good for Formula 1 because what we lack in terms of a number of events we gain in terms of the depth of coverage. (Interview with authors, 10 January, 2023)

In having their own OTT platform with F1 TV Pro, it gives F1 leverage in local negotiations, where they can make a value judgement to launch it as a standalone service if they fail to secure a local deal, or hold it back in some markets when they have a deal with a dominant Pay-Tv player offering the sport (e.g. Sky in the UK with an F1 deal until 2029 or Italy and Germany with Sky/F1 deals until 2025), but in other markets such as the French it could be sold in partnership via free-to-air or a local Pay-Tv service such as CanalPlus with a deal running to 2029.

What emerges is an increasingly complex global picture of rights, where there is not a one size fits all model. In 2023, F1 rights are sold in over 180 territories, working with over 60 broadcasters. Ian Holmes at F1 is clear that while this is complex, there are significant advantages to the promotion of the sport in working with local broadcasters, with F1 providing the international feed to them. He argues:

regardless of the market the local operator is going to be much better promoting our sport to their customers than we would. We'd need a mammoth worldwide marketing budget to try and replicate what our partners do so brilliantly in their respective markets. So, I think it's important we say that it's not Formula 1's destination to not sell our rights to a third party and to go it alone, that's not the case. Yes, you never say never but that's definitely not the case in the short and medium term. Long term is too far away to worry about because the industry changes so quickly. (Interview with authors, 10 January, 2023)

Holmes acknowledges that, 'we had not moved into social media and digital' (Interview with authors, 10 January, 2023) and that one of the first tasks under Liberty Media was to recruit extensively to the team, which had no social media staff, no real marketing team and was under resourced and ill-equipped

to undertake the transformation of the F1 brand that Liberty Media saw as crucial to their investment. At the core of the proposition was the central driving philosophy that F1 was not a sporting brand but rather an entertainment brand, and it needed to be marketed and repositioned as such among a new and younger audience.

To this end F1 have invested in their website and across their social media offering mobilising short form content significantly more effectively. This is a process kick started under Ellie Norman (2017–2021) and being built on year on year. In 2022, F1 was the fastest growing global sport on social media, year on year, with the USA being the fastest growing market with a 40% increase, while there was a 30% growth across all platforms. At the core of the strategic thinking is a rights balancing act, with the idea that exclusivity is not always the best in generating value, and that some sharing of rights often helps build and sustain the wider ecosystem. In other words, their content strategy is closely aligned with their marketing vision with a view to entice new fans in (through social media and short form content) but also reaching segments of fans with the right particular content for them. As Ian Holmes notes:

> it's still a complicated sport and we've got to make sure that the content offering to the fans and certainly new fans, is digestible. Hopefully you want them to become full fat fans and sit down on a Sunday at six in the morning and watch the Japanese Grand Prix. Now not everyone's going to do that, so we need to make sure that there is an offering for them to help them on their journey. Some of them won't ever get to that point which is not a problem. As long as we keep them within our ecosystem and hopefully feed and develop their interest. I think our licensees are very much part of that process and it's not about us educating them. They do it with other sports, so rather we are educating each other. (Interview with authors, 10 January, 2023)

F1, then in recent years has opened up social media encouraging all teams and drivers to engage in this media space. The BBC's Chief F1 correspondent Andrew Benson reflects that:

> in terms of Ecclestone versus Liberty, it's just a completely different mindset. Ecclestone set about digital TV not as a means of increasing Formula 1s exposure but as a way of increasing his income. Liberty took a different view, they decided that to increase their income, they needed to increase their exposure. So, it's almost like a completely inverted way of looking at how to approach the publicization of the sport. (Interview with authors, 22 September, 2022)

Hence for the teams this was important and marked a change that impacted on their own communications capacity and sense of direction. Bradley Lord,

Chief Communications Officer at Mercedes-AGM Petronas F1 Team also recalls that the change of ownership opened up communications opportunities for both the team and the sport through the increasing use of social media and influencers to connect to fans. This had structural implications as well for the communication teams, as life became busier as they produced content across a range of platforms. For example, over the last ten years the size of the Mercedes F1 communications team has grown from four, to twenty-two (Interview with authors, 1 December, 2022).

The growth in the social media profile of the sport has been significant, for example F1's YouTube platform has grown its subscription base from below 2 million in 2020 to 9.12 million in June 2023, with more than half of these subscribers are under the age of 35. Instagram has also grown with 23 million followers on the F1 site in June 2023, up almost 3 million from the previous year.

Not all developments have been successful however. In 2020 they launched *F1* the official Formula One magazine, a glossy print edition that lasted around 18 months before closing. The rebooted version of this approach appeared in 2023, as *F1 Unlocked*, to all intents and purposes an online F1 magazine (without the print costs) was launched through the F1 website. Brandon Snow, Formula One Group Managing Director of Commercial Affairs, views the new magazine like product as a platform, rather than a traditional magazine, giving behind the scenes access and exclusive content free to those who subscribe (which is free). The shift from print to online, perhaps never better illustrated here as well as a clear strategic vision of where the younger (and not just this demographic) audience are accessing their media content.

Interestingly, issues with rights and IP do still exist at times between F1, the teams and other broadcasters. As Stuart Morrison, Head of Communications at MoneyGram Haas F1 Team recalls:

> We were trying to do a deal with HBO Real Sports, they want to do a piece on us, in and around the American Grand Prix and it was all coming together and I'd had Formula 1 involved but ultimately it still fell apart because of the media rights access that they were prepared to give. They were prepared to give something but it wasn't quite enough to make HBO Real Sports comfortable to put the piece together. It was literally down to the number of seconds of footage that could be used and what exactly was being filmed. And so, in one respect yes, F1 are very much still active in terms of protecting the rights of their broadcast partners. But on the other hand, they understood that getting this out and getting the feature on us for 15 minutes on HBO Real Sports, is huge … And it was just one of those things that it fell by the wayside. Which was frustrating but, the dialogue at least happened. Whereas in the old days

it would have been a case of either no or yes, they can have it if they give us £250 thousand for every minute of footage that they use. Which obviously kills most deals dead in the water. So, there's still that element but I know there's other things that they're working for next year as well media wise that we'll benefit from so, I really enjoy the relationship with those guys. It's good, it's a positive relationship and not everything is necessarily done right but it's never going to be perfect. (Interview with authors, 5 December, 2022)

Thus, while IP issues are still very much core to the business, it is also clear that there is a greater openness from F1 to work with the teams, where possible and to look to develop mutually beneficial media exposure, particularly in the US market.

Boom Time in the Business of F1

As we discuss further in chapter Six, the growth in spectator numbers at live Grand Prix weekends has also been impressive for the sport. The post Covid bounce back or pent up spectator demand has been a factor, but clearly there are other trends in play, including the expansion of the younger base across social platforms. In its review of 2021, F1 reported that:

Once again Formula 1 was the fastest growing major sports league on the planet in terms of follower growth in 2021. We now have 49.1m total followers and have seen the highest engagement rate with social posts compared to other major sports in 2021. In 2021, followers (across Facebook, Twitter (now X), Instagram, YouTube, Tiktok, Snapchat, Twitch and Chinese social platforms) were up 40% to 49.1m, video views up 50% to 7bn and total engagement up 74% to 1.5bn. Additionally, total video views across F1.com, the F1 app and social media were up 44% vs 2020 to 7.04bn, unique users were up +63% to 113m and page views were up +23% to 1.6bn. In China we saw very strong digital growth with followers on Chinese platforms (Weibo, WeChat, Toutiao and Douyin) up 39% to 2.7m. The results mean that Formula 1 is outperforming other major sports in the digital arena. The digital share of total minutes consumed (across broadcast and digital) has grown from 10% in 2020 to 16% in 2021. (F1, 2022)

These figures, while originally starting from a low base, as noted earlier in the chapter, are still hugely impressive, both in their global reach and in the level of engagement.

While Liberty Media were initially slow to change the relationship between F1 and the journalists reporting and covering the sport on the issue of social media, they have become more pro-active. Stuart Morrison, Head of

Communications at MoneyGram Haas F1 Team recalls the immediate impact on the paddock.

> I did the 2016 season which was still the Bernie era and then like the morning of the first test in 2017, in pre-season, we were told you can film the car for social media. And everybody was just like, what we're actually allowed to film the cars like rolling out the garage and going down to the pit-lane and actually use video content on socials? Nobody knew what to do which is now led to this boom of videography because once that genie was out the bottle, you're not getting it back in. So, immediately there was a dynamic shift under Liberty Media who understood that we needed to utilise social media as a further way of engagement. You know, Bernie couldn't get his head around social media or any way to monetise it. So, he just kind of buried his head in the sand as far as that was concerned, his business model was all about protecting the media rights for the broadcasters who were the rights holders and be damned with everything else. (Interview with authors, 5 December, 2022)

Stefano Domenicali, CEO of Formula One Group who replaced Chase Carey for the start of the 2021 season, recognises the challenge of growing the sport, while not alienating many of the pre-existing audience. He is keen to break with the Ecclestone era or 'the need to have discontinuity from what has happened before' (Allen, 2022). Speaking at the *Financial Times/Motorsport Network Business of F1 forum* in Monaco in 2022 Domenicali argued that for F1 Group:

> Thinking about the bigger future means that we need to be respectful of what has been Formula 1, but entering new markets that potentially will enable us to grow; not only financially, but in terms of awareness and passion for the sport. We're talking about a sport that needs to have the element of emotion; we want to focus the main attention on the track. So great racing, making sure that the drivers, who represent for us the jewels, have the chance to fight between themselves, opening up the possibility through social media to have a chance to see them. It's important to get in touch with the new generation. We need to create different narratives for different kinds of fans. I don't think there's ever been an influx of new sponsor money coming into the sport like this since tobacco advertising was banned in the mid-2000s. Pretty much every F1 team you speak to, they're almost turning sponsors away now. (Allen, 2022)

In many ways the digital vision of F1 is encapsulated in these observations. Recognising that sport, to be compelling needs emotion and the emotional investment of the audience. He highlights the importance of the drivers, as the front of house icons of the sport, the importance of social media in creating the perception that you can get up close and personal with them, and

the idea of creating differing narratives for distinct audiences. Something we explore in more detail in the following two chapters.

The influx of new sponsors is also a key area of growth for the sport. Many of the key sponsors are now technology companies, or increasingly crypto-currency sponsors. We would argue the latter have in many ways becomes increasingly important financial underwriters of many of the teams sponsorship revenues in the last few years, with 11 different brands now involved in F1 team sponsorship. For example, Mercedes-AGM, under Totto Wolff (a cryptocurrency enthusiast) have a deal with FTX, a cryptocurrency exchange worth $27million per year, while Red Bull Racing enjoy a five year 2022–2027 deal with Bybit (another crypto exchange platform) worth $50million per season (*BusinessF1*, 2022, July: 22).

The dovetailing of the expansion of the audience for the sport in the US, the world's largest sports media market and the wider direction of travel and its importance to the business side of the sport is unquestionable. The 2022 edition of the annual SportBusiness *Motorsport Data Snapshot* which captures sponsorship relationships across motorsport highlighted the growth in USA based sponsors in the F1 sector. It noted that between 2020 and 2022 the number of sponsors of F1 teams headquartered in the USA grew from 97 to 161.

This represented a 66% increase since 2019, with McLaren Racing alone increasing the number of US based sponsors from 15 in 2020 to 26 by 2022. McLaren Racing Chief Executive Zak Brown is very clear this is not just a growth in the volume of sponsors, but also their value to the McLaren business. He argues:

> Over the years you'd hear someone say: 'Yeah Formula 1, but…' And the buts were: it's not big in America and it doesn't have youth. And that's where esports have been great and that's where the growth of Formula 1 in America has been outstanding. Incrementally, the sport's rate card, if you like, has probably gone up 25 to 50 per cent and continues to grow. If I look at some of the relationships that we have in place that we signed three years ago, what would they look like next time around? There would probably be a 50-per-cent increase. That's because the demand is there, and the growth of the sport is there. (Cronin, 2022)

This shift serves to emphasis the financial and commercial importance of the US market to the future of the once Euro-centric sport. Stuart Morrison, Head of Communications at MoneyGram Haas F1 Team, the only team with a US owner in Gene Haas, recognises that Liberty Media has changed the narrative around the sport in the US. He notes that:

Liberty Media is an American company so they were always going to do something that would try and drive business to the backyard. But the acceleration of it, the fact that now, a, we have the Miami Grand Prix and then next year (2023) we've got Las Vegas. And the fact that they've changed the business model so Formula 1 is the promoter of its own race. That's kind of stuck in the craw of some other promoters because that obviously is a threat to them that if Formula 1 says, we don't really need to bargain as much with you guys anymore; because we can run this show ourselves. But it shows the financial commitment that Liberty are prepared to put in. And I think that the good thing is for next year (2023), you have an American team, you have an American driver coming on board with Logan Sargant, whether he moves the needle or not; probably not. But those 3 races plus the success of Netflix's *Drive to Survive*, and the beauty of the races and we as a team are obviously looking closely at how do we manage each race?. (Interview with the authors, 5 December, 2022)

A further metric indicating the growth in this market is that Disney owned ESPN platform which carries F1 races in the US extended its contract with F1 until the end of 2025, paying around $90million for a three deal, where previously they had payed around $5m a season. The key change in the deal sees ESPN and ABC carrying a number of races while ESPN+ the streaming service will show a number of the (expanded) races on its platform. With three USA based races in the 2023 season, including the Las Vegas November 2023 Grand Prix, and under pressure from Amazon and Comcast bids, Disney were keen to capitalise on the growth of the sports popularity in this media market.

The commercial benefits for the sport of growing its profile in the US continue to be evident, with the announcement in 2023 of the return of the Ford motor company to the sport (it severed links in 2004), with the announcement that it would be working with Red Bull Racing in a strategic partnership with its powertrain business. As motorsport industry expert and commentator Mark Gallagher argued:

Aside from the Netflix *Drive to Survive* effect and F1's surging growth in the United States, the sport's commercial landscape has seldom been more attractive. Revenue is up, costs are controlled and the decade-old hybrid powertrain technology is set for another major shift in 2026. That bigger energy recovery system and battery, mated to an engine no longer running on fossil fuel, can only be attractive to a company heavily committed to electric vehicles and decarbonisation. (Gallagher, 2023: 19)

In so doing it reminds us of the sports long intertwined relationship and history with major car and engine manufacturers, and the importance for the sport of its decision to end using fossil fuels to power its racing cars by 2026.

Media and the Geo-Politics of F1

'If human rights was the criterion for Formula One races, we would only have them in Belgium and Switzerland in the future.

Bernie Ecclestone, then F1 Rights Holder, quoted in Bose (2012: 6).

As mentioned earlier in the book sport, given its symbolic as well as political and economic profile has always been immersed in politics both national and international as reflected in the rather acerbic view expressed by Bernie Ecclestone. The 'keep politics out of sport' has often been coded language for 'keep the politics of sport as they are'. The expansion of the F1 world championship into new markets and countries driven by Ecclestone in the last twenty years has at times thrown into stark relief the ethical issues that sport can face when rubbing up against wider geo-political considerations.

What we would argue has changed is the wider public's awareness of this dilemma (and ability to articulate this on social media), and an increasing willingness of parts of the media to actually acknowledge this tension. The term 'sportswashing' or reputation laundering is a newish term for an idea that has actually been around since sport began to become intertwined with the media in the late 19th and early 20th century. Some sports such as rugby union, boxing and the Olympics itself have long histories of staging events in compromised political situations, where various regimes (often dictatorships) have showcased sporting events as an example to the wider world of the 'normality' of these countries.

F1 have been staging Grand Prix rounds of the world championship in for example, Argentina (1953–1981), Portugal (1958–1960), Spain (1951–1975) and South Africa (1960–1985) during eras of political dictatorships, with little or no media questioning of these decisions. Today we would call it states mobilising sport as part of a process of 'sportswashing', then it was more likely to be reported as sport has nothing to do with politics, or as is more often the case, sport is simply following the money.

In more recent times F1 have created new rounds of the world championship in Bahrain (2004), Abu Dhabi (2009), Azerbaijan (2016), Qatar (2021) and Saudi Arabia (2021). There have also been Grand Prix rounds held in China (2004) and Russia (2014–2021). All these states, have paid substantial amounts of money, with Qatar and Saudi Arabia both

committing to ten year deals worth £450m to the sport, to be allowed to stage these F1 events, promote the races and their cities and countries to an international audience despite growing concerns about their human rights record, the role of women in society and often ongoing political and civil unrest (Chadwick et al., 2023).

Journalist Mihir Bose (2012: 5) notes how the Arab spring uprising had spread to Bahrain in 2011 calling into question the Grand Prix. He recalls that only Red Bull's Marc Webber among the drivers acknowledged the wider moral question of racing there, otherwise there was radio silence from the paddock. Fast forward to March 2022 and the Saudi Arabian Grand Prix being held at the Jeddah Corniche circuit sees Thursday practice being interrupted by a missile strike on an Aramco oil depot about ten miles from the track. There then follows a series of meetings between the drivers, the teams the Head of F1 and track officials about the safety of continuing.

All this is played in real time on social media as journalists and social media influencers reported live from outside the meetings. There was also a meeting of the Grand Prix Drivers Association (basically the drivers' union) that lasted for well over four hours, during which time social media was reporting the race was off, then it was back on with nobody knowing what the race status was until after that extraordinary meeting that the drivers held, with some reluctantly agreeing to continue despite safety fears. The race eventually did take place, but by way of contrast to over a decade earlier, we saw a growing trend for drivers to speak out more around such events, often using their social media accounts to do so. Also, social media, the Twitter (now X) platform specifically, acted as a news feed for both journalists and fans around the world who were able to follow in real time the movements in the story late into the night if they so wished.

The Drivers

A significant factor for the sport has been the advent a cluster of drivers (all in their early 20s) many of whom have grown up racing each other in other Formulas or through karting. Drivers such as Max Verstappen, Charles Leclerc, Pierre Gasly, Lando Norris, George Russell and Alex Albon are the digital drivers, who have grown up as digital natives and use social media in a differing way to the previous generation of F1 drivers. David Coulthard, former F1 driver and now, among other things Channel 4 F1 commentator (his co-owned media production company supply the

Channel 4 coverage) has an interesting perspective on these drivers. He suggests that:

> I think the modern era is full of talented, committed, spatially aware, media-aware, fan-aware, socially-aware drivers. Some tend to be more engaged on the social media platforms, but what tends to happen over time is that you see a lot of young drivers come in, bright-eyed and bushy tailed, then certain things fade because they just can't handle everything. I think that phenomenon during lock-down, where a lot of them were gamin on-line and publicly doing so, if that where to happen again in five years you won't see the same people doing it, because they'll value their privacy. As you be come more publicly recognised your privacy becomes an evermore important part of how you live. (Gallagher, 2022: 52/53)

We focus in more detail in chapter Six later in the book about the role of social media in attracting and engaging with a new generation of F1 fans, and role played by the drivers in using social media in this process. It is worth noting what Coulthard highlights as the challenge of sustaining this private/public persona as your career develops, the dangers of a perceived lack of authenticity if this aspect of the drivers brand is then handed over to a professional social media team who tweet for example on your behalf (a common feature of social media management practice among for example English Premiership footballers) and the possible fan backlash that it can then foster among followers.

On track, the two major changes instigated by Liberty Media have been around the changing regulations, aimed at improving the on-track racing and the team cost cap, again aimed at longer term increasing competition between the teams up and down the grid. For the teams, the continuing technological evolution of the sport also offers real organisational challenges. As Bradley Lord, Chief Communications Officer at Mercedes-AGM PetronasF1 Team notes:

> I think we are in the midst of a real structural shift in the sport in terms of the introduction of the budget cap and the limitations it produces therefore in the resource that can be spent on the technical and operational side of the company. We've seen a large growth in the support areas in order to cope with this; it is creating business opportunities. There is the opportunity to commercialise and deploy engineering capability and project management capability in non F1 areas. Working with INEOS Britania, we're embedded into their technical effort for the next America's Cup. So, that's seeing growth and a diversification of our business model. Yet all our energies have to be on supporting the ultimate purpose which is winning in F1. (Interview with authors, 1 December, 2022).

The sporting jury remains out on the ability of the changes to increase on track competitiveness and create a greater media spectacle, the success of which will be crucial in maintaining the sports upward trajectory in its popularity. What is beyond doubt is that five years after Liberty Media secured control of F1, off the track the commercial and organisational infrastructure of the business side of the F1 industry is booming.

Conclusion

The longevity with which Ecclestone controlled F1 is unlikely to be seen again. Just over five years after securing control, there is already talk within business elites about the future of Liberty Media (a hugely complex structured business under John Malone, now in his early 1980s) and by association its Formula One Group. Having bought it as we noted for $4.4 billion (with around $3 billion of debt) in late 2016, by 2022 its valuation on the Nasdaq and OTC markets in the US was around $13.4 billion. The trade magazine *BusinessF1* (2022, July: 23) reported in 2022 that the Saudi Arabian Public Investment Fund (PIF) of that country had made overtures to Liberty Media about buying the Formula One Group, to add to its growing global sports portfolio. While their interest appeared to have waned somewhat with their focus in 2022 seemingly on creating the new LIV breakaway golf tour they funded and fronted through Greg Norman, it is indicative that the global control of the sport, for so long in the domain of one man, remains ultimately uncertain, and subject to the whims of global capital, the political and cultural aspirations of States and media entrepreneurs.

What this chapter has identified is the significant organisational and sporting changes that Liberty Media have implemented as they have transformed the sport in the last few years. As a media content company, owning an entire sports league (rather than the traditional model of individual team ownership) it wants to reposition the sport as a media and entertainment brand, with an eye to growing significantly in that biggest sports media market, the US. The following chapter examines the impact of this process on the media representations of the sport and those involved and the impact on those traditional cultural intermediaries of sport: journalists and broadcasters.

· 4 ·

TELLING THE STORY: F1, JOURNALISM & MEDIA REPRESENTATIONS

Until the Seventies, grand prix racing was reported as if it were no different from rowing or polo, more of a gentleman's recreation than a sport. The battles between Niki Lauda and James Hunt began to change that, impelled by the increasing coverage on television. Gradually a modus operandi *emerged: television provided the pictures while newspapers supplied the characters.*

Richard Williams (1998), *Racers*, pp. 25–26.

Sportswriter Richard Williams' elegantly written observational story of a year in the world of a Formula One season, Damon Hill's championship year of 1996, reveals how television transformed the sport into mass entertainment. 'While television coverage provides the bare bones of the narrative structure' he wrote, 'the newspaper journalists, led by the representatives of the tabloids, add the flesh of characterisation and motive' (Williams, 1998: 2). If the iconic design of the cars provided the screen imagery of grand prix racing, he argued, the narrative meaning and significance of the sport was played out on the pages of tabloid newspapers, focused on driver celebrity and rivalries. Williams reminds us that F1 has long been a multi-media experience, framing the drama and creating the racing rivalries to engage the fans. More than two decades later, television still provides the dominant visual narrative of the sport, however tabloid newspapers are no longer the arbiters of the dominant narratives coming out of the sport, and journalists now compete with the voices of drivers, teams and fans in a far more complex communications ecology.

This chapter focuses specifically on the relationship between journalism, journalists and the F1 circuit and how this more complex communications

ecology impacts on these relationships. Drawing on original material and interviews with key stakeholders the chapter examines the importance of story-telling and the construction of narratives around the F1 season. It explores how leading F1 journalists built their careers around the sport, and how entry into the profession and their practices have changed over time. It places motor sport journalism within the context of the battle to control both access and the public narratives of F1, in a highly concentrated and politicised sport. It examines issues of media relations in terms of access to drivers, teams, promoters, owners and the FIA, investigating the interplay of journalists with a growing array of communications managers and public relations executives. An aspect of this control includes a hierarchy of media relations across different media outlets, and we explore how this is managed and the impact it has on the stories that emerge from the sport. The chapter also foregrounds the restructuring of these relationships as the digital distribution of content has mushroomed, particularly the impact social media platforms have on the circulation of information. It also examines the range of issues related to inclusion and diversity in F1 journalism, issues of journalism ethics in covering motor sport and the challenges faced by F1 journalists in their attempt to cover a travelling global sport. Finally, we explore how the representations that exist around F1 are shifting and changing as social media profiles and brand management have become more important among the drivers, the teams and the organisers of the sport.

Getting onto the Grid: Becoming an F1 Journalist

As with other forms of journalism there are many routes into a career as a motor sport journalist. For some it is born of a passion for motor sport in the first instance, and a desire to get as close to the action as is humanly possible without actually being part of the racing. As discussed in Chapter Two regarding the career of Raymond Baxter, in some cases experience in motor racing feeds the urge and informs unique insights to write or broadcast from the sport, where former drivers become insiders who, metaphorically at least, step outside the racing bubble to inform a wider audience of an otherwise closeted world. However, motor racing is a niche participation sport, and only a small minority experience the thrills of elite motor racing. For many journalists their careers follow a more structured path of journalism education or

training. For some this may be related to a passion for sport and a desire to become a sport journalist, but for many developing their craft, learning to write comes first and sport is consequential.

For all the journalists, broadcasters and communications professionals we interviewed the route to becoming an F1 journalist involved elements of luck and happenstance. Rarely was the professional journey into F1 journalism by design or straight-forward, rather journalists followed their instincts of the kind of career they wanted, developed their craft, and moved quickly when an opening appeared to their chosen career. In Chapter Two we noted how Maurice Hamilton had pursued his career in motor sport journalism without any formal training as an understudy to *Autocar* columnist Eoin Young. Hamilton had developed a passion for motor sport from his father who had taken him to see the Monoco Grand Prix in 1973, igniting a desire for involvement in the sport, for which journalism became his way in. In the 1970s and 1980s the freedom to move in to writing about motor sport was more open, even within national newspapers. As Hamilton remembered:

> *The Guardian* sports editor, as were *The Daily Telegraph*, *The Times*, etc all the rest, they knew everything about football and they knew all about the popular sports and they knew who was who and who was doing what, but things such as motor sport, ice skating and stuff like that were minority sports in their view. At that time and they knew nothing about who was who. So Eoin said, 'They're going to ask me, can I recommend somebody because they don't know. So, I'm going to recommend you and you're going to come with me and we're going to do the job'. (Interview with the authors 3 June, 2022)

Before long, Hamilton was the motor racing correspondent for *The Guardian*, and his lifelong career in sportswriting had taken off, almost from nothing. Other journalist we interviewed revealed a similar lifelong interest in motor sport, but the development of their skills and knowledge as a journalist was fundamental to creating an opening in F1 media. Ben Anderson, then editor of magazine *GP Racing*, and now Group F1 Editor at the online paltform *The Race* and *WTF1* Editor in Chief, had been socialised into motor sport from the age of seven by his father, an engineer, who raced kit cars. By the age of eleven, Anderson began to race go-karts and he also reported on the race meetings for *Karting Magazine*. As he recalls:

> I decided to volunteer to start writing reports for the Kart Club, if you like. So, I'd been in some of the races, this is when I got to about 16, and I'd report on the other

ones. You know fill in the gaps, watch the finals, what have you. (Interview with the authors, 31 May, 2022)

Having gained confidence as a writer Anderson completed a formal UK NCTJ accredited journalism education before taking up his first journalism position on the news desk at the *Surrey Mirror*. Keen to progress his career to a national level Anderson realised he needed to specialise and turned to his knowledge of go-kart racing as a way in to sport reporting. To his surprise, as a recently graduated journalist, in 2008 he successfully applied for the post of editorial assistant with *Autosport*. He continued to work within Motorsport Network titles, including editor of *F1 Racing* from 2018, which subsequently became *GP Racing* in 2019, before moving in 2023 to become Group F1 Editor at *The Race* (www.the-race.com) one of the largest F1 platforms for news and journalism about motorsport.

Anderson's trajectory into motor sport journalism in the early-2000s is mirrored by others who had an interest in F1 but began their careers in other areas of journalism such as news. Rebecca Clancy, motor sport correspondent for *The Times*, began her early career in business reporting but in her early thirties felt she was at a professional 'cross-roads'. Clancy recalled a conversation with her editor at *The Times*:

> I just said, 'Look, I want to be a sports journalist, what's the reality? I've always loved F1. If you tell me to sit on the news desk for a year and then I'd get F1, you know I'd do it.' And two days earlier, the F1 correspondent had announced he was retiring, but privately, sort of internally. I had about seven months of interviews, and that was it, and then I got the job. (Interview with the authors, 31 May, 2022)

The departing F1 correspondent of *The Times*, Kevin Eason, introduced Clancy to the key people in the industry at the season finale in Abu Dhabi in 2016, which helped her orientation into the role. Nevertheless, finding your feet in a constantly moving F1 circuit is a challenge to the uninitiated. As Clancy remarked, 'I described my first year of Formula 1 as walking into 20 new offices and having to learn where to get the water, where the toilet is, it was that kind of experience.' As one of the few women working as an F1 correspondent for a national newspaper Clancy also faced sexist discrimination from some of her male peers. Sexism and blocked opportunities for female sport journalists is well documented in academic research, which has focussed on the lack of visibility of female sport journalists in the press (Franks and O'Neil, 2016) and the lack of acceptance amongst male peers (Hardin and Shain, 2006). In the

heavily masculinised world of motor sport, Clancy acknowledges she occupies a unique position in UK print media:

> I'm the first woman on Fleet Street to do my job, I'm the only woman to still do my job. I'm the only woman who writes in the English language. There's another woman who writes in German and one in French and we're it. (Interview with the authors, 31 May, 2022)

Clancy revealed in her first season in F1 her male peers mistook her for a hostess and asked for some wine. A couple of seasons into her career in F1 she discovered some of her male peers had placed a bet as to who would be the first to have sex with her. Sexual harassment in any workplace is intolerable, but in the masculine domain of F1 media gender-based discrimination has neither been investigated nor condemned. In spite of the sexism Clancy experienced from some of her male peers in the press corps, she has developed her career and professional status as a leading motor sport journalist for a major national newspaper, gaining respect among the F1 teams and drivers. 'When I was pregnant with my son,' she notes, 'Mercedes for example came up to me and said, "Whatever you need." Because we're not cared for very well in the media, we're not looked after by the FIA they are useless. 'Come to us for catering whenever you need it' (Interview with authors, 31 May, 2022).

The unique habitus of the world of motor sport, which is a melting pot of the talented, creative, opportunistic and privileged (from either wealth or nepotism) is a heady mix in which journalists have to work. Several of those we interviewed mentioned F1 is populated by very intelligent people brought together by an obsessive dedication to the sport. But it is also littered by the stars of the entertainment world, the guests of corporate sponsors, and an entourage of wannabes and hangers-on who want to be part of the F1 circus. How journalists and media professionals enter this world, and orientate themselves within it, reveals much about the degree of importance a newspaper title or news outlet regards F1 in a wider portfolio of sport coverage. This arguably may be changing as the media environment of F1 continues to grow exponentially and the outlets and opportunities to communicate from the sport also increase. But in some areas of the sport news media the decision whether or not to employ a dedicated F1 correspondent is financially and editorially challenging. The volatility of media economics, caused by the disruption of social media platforms as rival information sources, therefore shapes the landscape in which motor sport journalists enter and sustain a career in covering F1.

When Comment Was Free: F1 Media Relations of the Past

As we noted in chapter Two, one of the effects of the highly competitive commercial environment that existed between the UK tabloid press, driven by under pressure editors, and the need for sporting exclusives driven by conflict, scandal and celebrity angst, was the erosion of trust between elite sportspeople and journalists. In interviews with journalists who had been around the F1 paddock since the 1970s and 1980s, it was clear the media relations and the access journalists had to drivers were significantly different in that era. Maurice Hamilton revealed how easy it was to get meaningful time with a driver, with no intermediary such as a PR agent to get in the way:

> If you wanted to speak to a driver, what you did was you would hang about the paddock car park or the entrance gate and you'd see him coming in and you'd just go up to him and say, James Hunt for example, 'James, listen,' he knew who you were. You weren't great mates but he knew who you were and you were a national newspaper, so therefore you were worth talking to in that respect. [] In those days, they didn't appear to just refer to public relations as we now know it. The PR officer, press officer, didn't exist. There weren't any. (Interview with the authors, 3 June, 2022)

The ability to more or less get access to all areas of the race track is one of the major differences of the late-20th century compared to how things developed once communications and press officers began to manage and take tighter control of who could go where on a race weekend. As Hamilton explained:

> It was very open, and you were on good terms with everybody. You could chat away as they walked along the pit lane. You could talk any time you liked. Similarly with team owners – Colin Chapman less so because he was a god and I was terrified of him – but people like Teddy Mayer at McLaren or Ken Tyrrell for example, go and chat to Ken at any time, any time about anything. (Interview with the authors, 3 June, 2022)

Hamilton talked of a time where journalists would turn up at a drivers' motorhome and huddle round to ask the questions they needed for the follow-up story they would submit for the Tuesday editions. 'We all had different thoughts and so it was really quite good,' he recalled, 'the tabloids would have a different line, they were reporting a more personal angle. I might be more interested in how did the chassis set up work.' He would also build relationships with mechanics who would provide off the record insights on how

particular cars were running. 'Now there's security, you can't get near them', said Hamilton, 'Now they're not allowed to talk to you, the mechanics are terrified' (Interview with authors, 3 June, 2022).

Mark Gallagher, began his career as a journalist before going on to manage or advise on press and marketing relations as an executive for several F1 teams from the 1980s onward, concurs with Hamilton's recollection of an easy going F1 paddock. 'Back in the day,' suggests Gallagher, 'journalists like Bob McKenzie; Lee McKenzie's [current Channel 4, F1 broadcast journalist] father at the *Daily Express*, [] would have a strong personal relationship with the press officers, the team principals, the drivers.' Building such relations was viewed as key in ensuring a journalist had a follow-up story having filled Monday's newspaper with their race report. 'Stan Piecha in *The Sun* would do the same thing', he argued, 'Stan would do his Monday morning 'Mansell blows out the championship', you know, whatever the Mansell story would be, and then he would do a follow up piece on Tuesday (Interview with the authors, 25 October, 2022).

In a similar vein, former Chief Sportwriter with *The Guardian*, Richard Williams explained how he would borrow one of the tabards from a press photographer to access areas of a circuit usually out of bounds for journalists: 'you could get a photographer's tabard and go and watch which I used to do in practice a lot and go out on to the circuit to watch' (Interview with authors, 31 May, 2022). James Bareham, who worked in F1 as a photographer for *F1 Racing* as well as Toyota Formula One in the late-1990s and early-2000s, explained there were two kinds of press accreditation, one for the season and another for individual races. A 'hard pass' were difficult to obtain, and many freelance photographers would get a single pass for each race. Bareham explained how transgressing this system brought heavy sanction. 'It was made clear that it could be taken away.' he said, 'You're well aware you're very much under licence.' In addition, even among photographers, there were different degrees of photographer access. 'There were the people who have the jacket, that could get the waistcoat, the brown waistcoat official jacket,' he explained. 'So you can have access to areas that other photographers cannot have. So, in a way, it's very feudal. There's a hierarchy and getting into a pit lane pass was the inner sanctum' (Interview with authors, 21 October, 2022).

Ben Hunt, F1 correspondent with the largest selling tabloid newspaper in the UK *The Sun* corroborated the idea that accreditation could be lost for doing or saying the wrong thing in the eyes of either the FIA or F1 senior management, particularly during the Ecclestone era. 'Under the previous

regime there was a fear that your pass could be taken away from you for negative reporting', he remarked, 'You know, there was always the fear of Bernie pulling you to one side, and all of a sudden you'd arrive in China, Singapore, somewhere on the other side of the world, Australia – try to get in, and your pass wouldn't work' (Interview with authors, 15 September, 2022). The threat from Ecclestone may have been in jest, but there is a sense that the ability to be critical of F1 has relaxed somewhat under the Liberty regime.

The influence of sponsors and marketing communications interests in managing the image of F1 also began to transform the availability of drivers. Maurice Hamilton suggests that the deals struck by John Player Special (JPS) with Lotus F1 in the 1970s was the beginning of what became the corporate control of drivers and their relationship with the media. JPS employed the marketing agency Championship Sporting Specialists (CSS) run by Barrie Gill, a pioneer of sports marketing and sponsorship in the UK. Gill had been a journalist and BBC commentator on motor sport, prior to moving to the Ford Motor Company to oversee its sponsorship. Gill formed CSS in 1973 and exploited the growing television exposure and appeal of F1 for commercial sponsors, initially working closely with James Hunt. As drivers became more of a commercial currency within sport, so the control of their media appearances and marketing responsibilities began to consolidate.

The increased television coverage and commercial investment from sponsors intensified the interest in F1 from popular news titles. Ben Hunt, motor racing correspondent for *The Sun* newspaper, recalled much greater interest from Europe's 'tabloid style journalists' when he began reporting on F1 in the early-2000s. 'The tabloid reporting is very different to what I'm seeing now with online,' he states, 'online sites like ESPN, *MotorSport*, *AutoSport*, Crash.net, and various different others.' The style of reporting was far more focused on drivers as stars with a story to tell. 'We were, as journalists, trying to bring stuff to life, chase stories,' he suggests, 'sometimes the questioning was awkward, uncomfortable for the drivers, but it did keep them on their toes' (Interview with authors, 15 September, 2022). In chasing exclusive stories, which magnified character traits and rivalries with other drivers, the tabloid approach eroded any element of trust. Media relations were increasingly replaced by a more corrosive and abrasive relationship that began to see the growth of sporting public relations and media management practices previously more common in the television industry or in the highly commercial world of US sport.

Journalist and sportswriter Richard Williams recalls how F1 drivers such as Damon Hill became collateral damage in this ongoing war between sections of the popular press and elite sports stars. As a result, they had to learn to deal with a new level of media pressure and exposure (often employing external PR and media relations expertise, in Hill's case that of Mary Spillane, to help him in the process). Williams argues Hill was subject to:

> The destructive force exerted on prominent British sportsmen by newspapers whose editors demand stories of conflict in which all emotions are heightened until they are caricatures of the original impulse [] Damon Hill it seemed to me had done nothing to be dragged into this cartoon world. (Williams, 1998: 132)

We've written before (Boyle, 2006) about the lack of trust between elite sportspeople and journalists, particularly in the UK and how this intensified with the growing commercial rivalry between popular newspapers. Writing in his autobiography former F1 driver (1994–2008) and current Channel 4 F1 commentator David Coulthard notes that by then:

> The sport has changed drastically, even several times during my career. Being a Formula 1 driver in the current era is a very disciplined job and there isn't an awful lot of room for outrageous behaviour. You hear a lot of talk of the paddock being bereft of so many personalities these days. Huge corporate sponsorships mean drivers have to play safe; they can't go criticising every rival or womanising in public or smoking forty-a-day. You have to tow the company line. (Coulthard, 2008: 300)

This experience was particularly acute for British F1 drivers who had to deal with newspaper environment in which sports stars had by the 1990s and early 2000s firmly crossed into the news sections, rather than simply being discussed in the sports section of the paper. As noted elsewhere (Boyle, 2006), this process was not new, but for British F1 drivers such as the 2009 World Champion Jenson Button who raced between 2000 and 2017, the media attention was difficult to deal with. In his autobiography (Button, 2018) he recalls how sensational tabloid headlines often misrepresented the story that had been written by the news (rather than sports) journalist, with the press often taking little accountability for the impact of the story. Button reflects that:

> The net effect of all this, of course, that you get scarred and end up doing what I did, which was to close down, and from that it bred a situation where the fan gets nothing but a procession of robot racing drivers who are afraid to say anything. Which is rubbish for the sport. People bemoan a 'lack of characters' in the sports (sic). Well they are there, but they keep it hidden from the press.

> Nowadays we have Twitter [now X]. People in my position can have their say direct to the fans without the filter of the newspaper and magazines adding the wrong emphasis, taking things out of context and every other trick in the book to make you look bad. Twitter probably came along too late to benefit me personally. I was no longer such a target by then: I'd thrown up enough barriers and developed strategies to ward off the worst of the press intrusion anyway. (Button, 2018: 145)

The decline in printed news media circulation has had an acute impact on how many newspapers send a correspondent to a race. Mark Gallagher, has operated both as an F1 newspaper journalist and as an F1 team executive and argues that there has been a dramatic change in both the number of journalists at a race and in the style of reporting. 'I came into the sport at a time when Fleet Street as we used to call it, used to send journalists to every race,' he said, 'I mean, you would literally have *The Sun*, *The Mirror*, *The Telegraph*, *The Times*, *The Guardian*.' Gallagher noted how that has diminished. 'Now I realise that it's slightly to do with the aftermath of Covid', he remarked, 'But I can tell you first hand that a number of people have said to me that one of the results of Covid is that a lot of editors, a lot of broadcasters, a lot of media owners have felt that you don't need to send people to events any more because it's quite expensive and, why don't we just cut costs and cover it remotely?' (Interview with authors, 25 October, 2022). Not being at races removes serendipity of discovering a story as it happens on the race track. It also removes opportunities to have 'off the record' conversations with drivers and teams. According to Gallagher, this has transformed what journalists can write about:

> You can build relationships and as I learned from people like the late great Murray Walker, you know, it's a conversation with a team principal over a cup of tea or it's meeting a driver in the departure lounge at the airport; there's where the richness of relationships are really developed. And when you lose that you lose something in terms of how the sport is communicated to audiences. (Interview with the authors, 25 October, 2022)

Transformations in both the digital media environment and a shift during Covid to online reporting has provided new opportunities for how F1 makes itself available to the media, as well as the working practices of journalists. We now move on to discuss precisely how these changes have affected access and control to information in F1 during a race weekend.

The Race Weekend: Access and Control

According to Liam Parker, Director of Communications and Corporate Relations at Formula 1, legacy media remain important to reaching motor sport's core audience.

> So, in keeping the core constituency of media on side, engaged, briefed up across things is a really important part of what we do and I think that's the same for the teams but at the same time we can keep them happy by reaching others and the concrete thing with Formula 1 is the media accreditation system which the FIA run. (Interview with the authors, 27 January, 2023)

The perception within the sport that the legacy media remain important is shared among a number of the communication teams we spoke with on the F1 grid, including by Bradley Lord, Chief Communications Officer, at Mercedes-AMG PETRONAS F1 Team. He argues that:

> I think they remain crucially important. If I compare smaller motorsports series we've been involved in where all of that media pack were effectively cheerleaders for the series; I believe having a robust and critical third-party media, as annoying and difficult as it can be to handle at times, is important because it lends us validity and credibility. (Interview with authors, 1 December, 2022)

The FIA manage the accreditation process for the F1 season which is open only to journalists and photographers. Broadcasters, who are rights holders and therefore considered commercial partners, have their accreditation managed directly by the Formula One Group (F1G). The principles of accreditation are strict and clearly set out in the FIA press guidelines published annually on their website (FIA, 2022 <https://www.fia.com/media-center/media_ac creditation>). People with wider affiliations to publishers, marketing agencies, social-media managers or influencers are not eligible for accreditation. National Press Officers, affiliated to the FIA, manage local accreditation for the national media of circuits hosting an F1 race. The accreditation is organised online to a published schedule of application, with permanent annual accreditation issued before the season start in January. Local, single race accreditation is usually settled a month prior to each race. The accreditation process follows strict criteria as to what constitutes a news outlet, and accredited news organisations are expected to provide substantive coverage of a race weekend from the Thursday to the following Monday or Tuesday. Monthly publications are expected to have significant editorial pieces focused on F1

which take up a major portion of their content. Websites have to be professionally run, dedicated to sport news content, in which specific F1 content is featured and delivered free of charge to the public. They are expected to provide audited traffic figures which show a minimum 100,000 unique users per month of their F1 content. There are also strict guidelines on the use of licensed material on websites, such as video archive.

Once accreditation has been received journalists with permanent accreditation have to commit to attending a minimum of fourteen races per year and submit evidence of their reporting. However, the costs of travel, not least the short supply of affordable hotel accommodation in the vicinity of some race tracks, has meant that journalists and their editors have to manage expenditure in very strategic ways. The BBC's chief F1 correspondent Andrew Benson explained the scenario for how journalists plan their season:

> You don't have to be at all the Grand Prix to cover all the Grand Prix. So, lots of journalists are saying, "well I can't attend all races" because a lot of the journalists in Formula 1 are freelance; a lot of them aren't but a significant number are. And you're talking about close to £50,000 to cover a season, just in terms of expenses before you've started to make any income at all if you're going to do all 24 races. If you start thinking about flights, hotels, hire cars, all the rest of it. So, that's one aspect that's becoming problematic for the media covering Formula 1. And then pushing into the cost thing is also the popularity issue. So, lots of the host cities have seen the growing population of Formula 1 and basically, they're pushing the hotel prices up for everybody over the course of a Grand Prix weekend. And that just makes it even more financially unsustainable for lots of people. (Interview with authors, 22 September, 2022)

On any given race weekend F1 could have upto four hundred journalists and photographers staying in local hotels. If you add in television crews from at least ten countries, with some broadcasters like Sky sending a crew of upto fifty production staff to cover a race, availability of hotel rooms becomes a major issue. Media outlets will negotiate reduced rates for regularly using hotels for their staff, which, at the same time, undercuts the potential rates many fans of F1 are happy to pay to attend the races. Host cities therefore face a conflict of interest of wanting the world's media to report on their city as an attractive backdrop to F1 and a tourist destination, at the same time maximalising the revenues from a race weekend, which may push the cost of travel beyond the budgets of most journalists. As Andrew Benson acknowledges:

They want people to write about how cool it is to go to the Austin Grand Prix or the Vegas Grand Prix or the Miami Grand Prix or whatever. And if you're not in Miami or Austin because you can't afford it then you can't do that, can you? And so, they're kind of shooting themselves in the foot on that level. So, that's an issue that hasn't been faced by Formula 1 as a sport in general. (Interview with authors, 22 September, 2022)

Ben Hunt, F1 correspondent with *The Sun* concurred with the general view of interviewees that booking hotels is considerably trickier in recent years, particularly post-Covid as numbers of spectators have increased. 'If you look at Monza, there were over 300,000 – I think 336,000 over the four days,' he suggested, 'whereas pre-Covid best levels, so 2019, it was 200,000. So you're looking at an extra 130,000 people through the gates' (Interview with authors, 15 September, 2022). The logistics of international travel, finance and spending a considerable time away from home are all familiar pressures to any sport journalist of international tours, such as golf, tennis or motor sport, but the rapid increase in spectator interest in F1 has created some acute pressure points for host cities.

The FIA organise the press conferences for the written press and web-based journalists, followed by the F1G television pen, or the 'TV bullring' as it is called, in which the drivers move around being interviewed for various television rights holders. Historically the media day would take place on a Thursday, with Practice on a Friday, Practice and Qualifying on a Saturday and Sunday race day. However, for the 2022 season the media access slots were shifted to a Friday morning which disrupted the pattern of reporting for both newspaper outlets and broadcasters. BBC F1 correspondent Andrew Benson explained the ways in which the race weekend has changed for journalists:

All the teams fundamentally operate in the same way. [] Thursday is media day. All their drivers have their slots with the media, whether it be TV or written. Then Friday they don't do anything apart from talk to Formula One cameras after practice. Saturday, there is the top three press conference. (Interview with the authors, 22 September, 2022)

In 2022 the timetable for the weekend also shifted to later in the day, primarily to accommodate North American audiences. As Benson explained:

Because of American TV, Liberty want to make as much of the weekend accessible to as many people in America as they possibly can. They've now changed the timetable so that on Friday, for example, first practice often doesn't start till 1:00 o'clock in the afternoon. Now they've shortened both the session to an hour but there's still

a two-hour gap between them, so that will finish at 2:00. Then you've got the next practice starting at 4:00, finishing at 5:00 or sometimes it might be 5:00 finishing at 6:00 and the same on Saturday for qualifying. (Interview with the authors, 22 September, 2022)

The shifting of media days and the timing of practice meant that during the 2022 season F1 struggled to meet the full demand for interviews from the media, squeezing the time drivers were available in the 'mixed zone' with other racing commitments. 'All these things have happened all at once,' suggested Benson, 'and Formula 1 as a sport is still wrestling with what's the right approach to all of this.' For broadcast news outlets, such as Sky Sport News in the UK, scheduling media days on Thursday's helped get F1 stories ahead of other weekend sport news, especially Premier League football. Indeed, for a TV rights holder like Sky its sports news channel is used to cross promote and build interest for a race weekend across the week. As Sky Sport journalist Craig Slater explained:

We almost go on the Sunday before and try and find material to preview from the Monday. Increasingly, what we realised pretty quickly, the teams couldn't really supply us anything on the early days of the week. [] Though I think that the English do try and get a driver on screen on the Wednesday. If we can't, I'll regularly contact all of the teams before I'm going to an event to say do you have a partner event? Is there anything that we can work together on? I can get some content, you can maybe get a bit of exposure. (Interview with the authors, 6 December, 2022)

For the written media, the FIA introduced a new 'written media zone' adjacent to the TV pen. The roped area was initially introduced during 2021 season at the height of Covid to maintain distance between drivers and anyone out with the racing 'bubble'. The zone has been maintained, but has had some consequences for how journalists gain access for interviews which has turned into something of a scrum monopolised by those luckiest enough to be near to the drivers. As Rebecca Clancy from *The Times* explained:

We just stand in a huddle and it's a hell. [] It's really difficult because you don't get anything from the drivers whereas previously [] we used to go into the hospitality. You would have ten drivers on a Thursday in the FIA press conference, and those ten who weren't in the press conference, each team would do proper media. You would get into their hospitality, you would look the driver in the eye, it was well organised, there was space, we would develop a rapport with them. We've basically lost that at the moment. (Interview with the authors, 31 May, 2022)

The other dimension of this arrangement is that journalists from every outlet are all hearing the same thing, so the opportunity for exclusive quotes or stories is negligeable.

Access to drivers is the most managed and transformed aspect of media relations in recent years. Maurice Hamilton noted that a driver's day is now full with scheduled technical briefings and other Team responsibilities that there are only small windows of opportunity for them to do media interviews, usually now more than ten minutes long. 'Not necessarily the driver's fault,' he says, 'they're part of the structure. The young guys coming though are told this is what you do, this is the way it is.' Other journalists we interviewed concur that access to drivers has changed over time, mainly because they are so incredibly busy. 'They're all shepherded about from one meeting to another throughout the day', notes Benson, who also suggested 'off the record' chats with drivers are less frequent than they used to be and would be something F1 teams discourage. 'The teams still are the gatekeepers,' explained Ben Anderson, 'if you want to do certain things with them that they like and they like what you're about, they like your audience or your ideas then they might facilitate you doing other stuff onsite or off (Interview with authors, 31 May, 2022). We would conclude from these observations that F1 drivers live a cosseted existence when on the circuit, with their own individual press officer or 'minder' working in collaboration with team communications. Their willingness to conduct interviews beyond the managed media zones is highly limited, and dependent on personal relationships with journalists. 'You're only allowed to step into hospitality if you're invited in and that's not going to change,' said Clancy. She also noted that some journalists build relationships through corporate sponsors of teams or particular individuals. 'Lewis [Hamilton]'s PR woman is dating a journalist from ESPN,' Clancy observed, 'somehow he ends up with three interviews a year, but it's not through Mercedes, it's through the sponsors' (Interview with authors, 31 May, 2022).

The main upshot of limited access and the reliance on press conferences where all the written media are assembled, is that the written media find it difficult to get a unique story or insight into a driver or a particular race. The obligations drivers have to TV rights holders and commercial sponsors places further pressures on the sporting press to produce stories that have not already been covered by broadcast media or the online platforms of sponsors. In a move to open up access, instigated by the FIA, F1G and the teams, the media (both print, web and television) can move across to the pitlane where the cars get pushed out and the media can look at the cars being raced that weekend.

Communications Directors from the teams are on hand to answer any media queries. Along with access to pitstop practice this is seen as an attempt by the sport to improve the connection journalists can have to teams and their cars.

Compared to other elite sports the apparent access to the key sporting protagonists in F1 minutes before the start of a Grand Prix is startling. For example, on the grid, just before the drivers get into their cars, the area is a hive of activity as engineers make last minute adjustments or seek to maintain the status of the car, so that it is in peak condition. While VIP guests and TV crews mingle with drivers and team members, while getting up close and personal with the cars on the grid. This tradition stretches back to more innocent media times in the sport, and despite attempts to limit the numbers wandering around the pre-race grid, it remains impressively chaotic, giving both the viewer and the media access that would be unimaginable 10 minutes before the start of say a major football event.

Former F1 driver turned broadcaster and media entrepreneur David Coulthard recounts the post-race media duties required of an F1 driver who has finished on the winners podium and been presented with their trophies.

> You then take part in two English-language press conferences; the first for broadcast media, which these days can mean TV, radio and digital or streaming media, typically quite a short affair. Each of the top three drivers has to provide a quote about how the race went, usually in response to two questions from the FIA-appointed moderator, while the race winner is then asked to give another quote in his native tongue. This is followed by the print media conference, which is rather more drawn out as individual journalists can ask specific questions in order to add a little more depth to the story of the race. (Coulthard, 2018: 27/28)

The other drivers who have not made the top three decant to the 'media pen', where rights holding digital and streaming media journalists can capture a brief comment and that all important visual footage content for their platforms often appearing as clipped quotes on their social media. Former F1 Word Champion Jenson Button described it as:

> like an enclosure at a farm park, except with Formula One drivers instead of goats, surrounded by journalists waving microphones at you. (Button, 2018: 281)

For most of the drivers this is then followed by a meet and greet with sponsors, guests of the team and thanking the myriad of team members including the pit engineers who have kept the car on the road. The team debrief then takes place involving drivers, senior technical staff including designers and

engineers, team principal and strategists, engine and tyre suppliers and indeed anybody else that might help in making sense of what has happened in the Grand Prix. With competing demands on a driver's time, F1 and teams are continuously seeking ways to manage media access efficiently. One outcome of managing which media outlet or platform gains access to which part of the circuit, teams and drivers, and when such access occurs, has created a structure hierarchy of media relations.

Access All Areas? Media Hierarchies and Representations

As rights holders TV broadcasters have the most privileged access on the racing circuit. While all media are important and are accommodated, TV rights holders are effectively leading commercial partners, and are therefore able to dictate the terms of access they require to cover the sport, deliver attractive productions to their audiences, and showcase the commercial brands associated with F1, teams and circuit promoters. TV images, therefore, deliver far more than simple race coverage, they become the premium mode for communicating the wider experience of an F1 race. As we shall discuss in chapter Five, in the age of streaming, rights deals have been transformed again as cameras gain access all areas to capture the F1 season as it unfolds.

In the UK, Sky's partnership with F1 has transformed the number of hours and depth of dedicated coverage of the sport through its dedicated F1 channel launched in 2012. When Sky took on the rights to F1 their approach focused on the opportunity to exploit their behind-the-scenes access and obtaining exclusives. Prior to the launch of the dedicated channel Barney Francis, managing director of Sky Sports, announced the channel would 'tell the whole story of the season, from every grand prix, from start to finish' (Plunkett, 2011). Francis continued, 'We have big plans for live shows and a rich lineup of Formula One programmes; getting to the drivers, exploring the technology and lapping up the drama.' Craig Slater, F1 correspondent for Sky Sport News explained Sky's original focus on additional programming, 'In the early days it was very much about the channel and the extra programming and the documentaries.' He continued, 'Actually, I think we as a channel, we're still a little bit old fashioned. We'd make more programmes and nice programmes, and that would be the way that Sky would prosper.'

In hindsight, Slater argued that Sky F1 has moved away from this more traditional model of programme-making, to focus on the opinion leaders, the former drivers who make up the majority of Sky F1 presenters and can draw on their experience to bring insight, opinion and critique. 'In the last few years, it's what did Martin Brundle think of this? What did Jensen do about that?' he explained, 'In the Court of public opinion being one of the, you know, the main character witnesses, [] it's occupying that space to a greater extent. I think we've been a little bit slow to do that' (Interview with authors, 6 December, 2022). Slater's observation about Sky's change in emphasis, from 'nice pro-grammes' to being 'the main character witnesses' is arguably a response to the increasing visibility of comments from current and former drivers across social media platforms. We would argue that the rise in importance of social media in the last decade or so, has changed the dynamic and become a key factor in both policing behaviour, but paradoxically allowing drivers to take greater control of the narratives that surround them. In so doing it has allowed the drivers (and the teams) to reach out to a wider audience, many of whom sim-ply do not read print newspapers.

In the face of blanket television broadcasting of F1 from rights holders like Sky Sports and the ubiquitous personal commentary by drivers in social media sharing their lives both on and off the race track, traditional sport news media find themselves well down the pecking order of story exclusives. As Ben Hunt explained:

> We always used to work hand in hand with TV, but there's now an appetite for the TV companies who … we can say Sky – you know, they came in, they paid a lot of money for the rights, and as a result they felt that they were entitled to perhaps more than they were being offered. And F1, being F1 under the previous regime and current regime, have been very accommodating. There's nothing wrong with that, but the only problem I found is that it has come at the expense of the written press, so we can use that term to reflect online and print. (Interview with the authors, 15 September, 2022)

Hunt revealed he has become increasingly frustrated in the way in which news stories that may first appear in print are recycled with no acknowledg-ment within the TV domain:

> I'm also finding that a lot of our online newspaper written press content is now being made available to TV commercial rights holders, and obviously they're pumping out the content as well. So, we don't really have much exclusive access which is a little bit disappointing. (Interview with authors, 15 September, 2022)

For legacy news media such as the BBC how they leverage their more limited access to F1 has required rethinking how their audience consumes its content. The BBC were previously the UK's free-to-air TV rights holder in partnership with Sky Sports until 2015, a decision precipitated by the need to save costs following a freeze in the Corporation's funding. The BBC's reporting on F1 has shifted to live digital coverage online with commentary, expert analysis and audience interaction. In spite of the loss of many premium rights to live sport to pay-TV the BBC has managed to maintain a level of audience loyalty to its radio commentaries and significant traffic via its sport website and apps. Andrew Benson acknowledges that while Sky's role as the principal rights holder provides the subscription channel with more exclusive access to the paddock, the BBC's online audiences for F1 have greater reach:

> The BBC Sport website has a huge audience; bigger than most TV channels. Way bigger than Sky's for example, just to give you an idea, my race reports regularly get high hundreds of thousands of unit users. And if it's a really big news story or a really big dramatic race; there will be well over a million unit users. And that's just UK figures you can add 25 to 33% for global audience to that. So, if you compare that, for example, to Sky's UK audience, it's at least as big as, if not bigger than Sky's UK TV audience. And the BBC is a powerful brand in itself, and the BBC website is a powerful outlet. Or at least it's influential and high profile, put it that way. So, the teams respond as you would expect to that. So, I'm quite privileged in that way. (Interview with the authors, 22 September 2022)

Benson acknowledged that 'broadcasters are definitely ranked higher than written media' and that where there is high demand for interviews and drivers will select only a few by ranking media outlets by perceived importance. 'Fundamentally they're using the media to expose their brand as they would see it,' said Benson. 'Which has its complications for the job from the media's perspective so you can understand why they're going to rank the importance of outlets as far as they're concerned.' The quality of access dictated by such ranking has a significant influence on the quality of media representation any media outlet can produce. Established broadcast media, by and large, can have an expectation to be higher up the pecking order of access, which allows them to create richer editorial content.

Another area where legacy media outlets are being challenged is through online motor sport outlets, including blogs and podcasts with large social media followings. Liam Parker, Director of Communications at Formula 1, explained that with the broadening spectrum of online outlets F1 are keen to support fledgling media alongside established titles. Although websites might

not have the finances to send people to every race, F1 still wants to offer them opportunities, particularly on Thursday's when cars are not on the track, to gain accreditation and perhaps present the sport to new audiences in different ways. However, such access comes with caveats, that the content being produced is new and fresh and not simply recycling the coverage of established journalists and broadcasters. As Parker explained:

> I've always been a believer in if they're writing about Formula 1, and its balanced and fair, we should be fair and accommodating and offering them opportunities. But it's the websites that appear that nick our TV feed. You know, skim stuff off other websites and, you know, the journalist that has spent time at the races and they report it as their own rather than attributing it to Anita Rankine at *Racing News 365* and those things become a problem because we have to jump on them because they are infringements of copyright. (Interview with the authors, 23 January, 2023)

This more open approach to emergent F1 online media outlets, which tend to develop devoted fanbases, with a younger demographic profile, is recognised for its potential to support the growth of the sport. However, balancing the propriety rights of broadcast partners with the needs of new social media focused outlets requires clear boundaries, and Parker suggests they would prefer to have a conversation with websites first to approve the use of certain content rather than constantly enforce copyright from infringement.

F1 is also seeking to be more accommodating to a broader spectrum of news media and lifestyle magazine outlets showing an interest in F1 which has mainly been due to the popularity created by the Netflix series *Drive to Survive*. As Parker argued:

> The FIA accredited media are there but there's more space, there's more opportunity and we've been looking to get *GQ*, *Cosmopolitan*, *Vanity Fair*, *The Athletic*, *Wall Street Journal*, people who don't come to every race accredited at our events but would be meaningful substance. So, I don't know, the *Wall Street Journal* will come and sit down with my boss and take it and they'll feel they've got some worthwhile action out of it and we are pushing constantly to make sure that the accreditation system works better with those, you know, what you would call kind of up-and-coming websites. (Interview with the authors, 23 January, 2023)

Throughout most of its history F1 has fostered an image of an elite sport. The patina of glamour associated with the expensive technologies of the cars, the global superstar lifestyles of the drivers and the exclusivity of some of its race locations, with the Monaco Grand Prix its prime jewel, have helped set F1 apart in popular culture from many other sports. This sense of elitism

and glamour underpins much of the representation of the sport but belies the hinterland of professional engineering and analytical expertise behind it. The series *Drive to Survive* has lifted some of the veil of secrecy behind the scenes, but as we shall discuss in chapter Five its narrative representation of F1 is created with an accent on character portraits and rivalries.

One of our interviewees, James Bareham, spent over a decade in F1 as a photographer working for *F1 Racing*, Toyota and the FIA. Unlike press photographers producing action shots from racing, his job was focused on editorial images for commercial partners or in-house media labelled 'sponsored' or 'branded' content. Working for the FIA gave him access to take images most other media would not usually gain access to.

> I covered for the FIA, so I was in the weighing rooms I was in with the scrutineers. I was with, I think, Charlie, who is the race director, Charlie Whiting [F1 Race Director 1997–2019]. But it was like portraits of him, portraits of the doctor, the medical car, the pace car. All of these things, and the weighing was really controversial, because I was in the weighing room and it had never been covered. That's completely off. The cars come in. So do the drivers. And I remember Ralph Schumacher got very upset, didn't know why I was there, and I was going to take a picture of him on the scales. (Interview with the authors, 21 October, 2022)

In the Ecclestone era of control media access to the inner sanctum of F1, such as the drivers briefing ahead of a race, was incredibly rare. Indeed, press access remains restricted in such domains, but one of the major changes that has occurred are personal thoughts and images from behind the scenes of F1 from the drivers and teams themselves delivered on their social media channels. The use of social media by drivers has disrupted the hierarchy of access to news and images, short-circuiting how information comes out of F1. In terms of photography Bareham is clear how the arrival of smart phones with cameras changed the meaning of the image in F1:

> Social media and smartphone photography has changed photography as a whole, but is also changed the way that people look at images. And if you go back to what the journalists were saying about, they don't have the access anymore. They also don't have the attention. Because if you think about even back, you know, 90s, early 2000s, most of the pictures that you saw from Formula One were taken by professional photographers. And anybody that wasn't a professional photographer were so far away that you weren't interested in seeing those pictures. But now social media is not interested in just who took a picture, but literally who is the person in the picture? Do I know those people? What's that angle?. (Interview with the authors, 21 October, 2022)

Bareham recognises the power of imagery around F1 has completely transformed from the editorial control of media outlets to the sharing of images from thousands of race goers who are more interested in images of people they know at the race – family or friends – or a selfie with a famous driver. This is a fundamental shift in the kind of imagery in circulation from F1, which has democratised the production and distribution of content, as well as transformed informal form of such vernacular photography.

The disintermediation of information from sport has transformed the speed at which news can circulate directly from drivers or the teams without any need for journalists as intermediaries. Rebecca Clancy neatly summarised how social media has transformed the relationships between the media and teams:

> So, when Liberty came in, you'll know this, they praised themselves on their increase in social media presence but the baseline was zero. And they allowed teams to start filming content, to basically have a Twitter [now X] account, social media, and certainly it started actually with the drivers, I would say, they found a way around us. And they could get their message, Lewis Hamilton, definitely feels like this, Max Verstappen feels like this. They can get their message direct to the fans, so why do they need to talk to us? And the teams who pander to their every word even though they're paid huge sums of money in their contract stating that they have to do media. And the FIA regulations state that they have to do media, they try to get out of it as much as humanly possible. (Interview with the authors, 31 May, 2022)

Many journalists noted frustration with how drivers or teams released information on social media, usually X (formely know as Twitter) or Instagram, that stands as the final communication on particular events. When questioned further on information released on social media drivers can be reluctant to expand on the detail, preferring to let comments or images posted on social media to be the final point of communication. Sky Sports broadcast journalist Craig Slater illustrated how drivers can shape the news agenda by their use of social media:

> I remember one occasion when I think it was Lewis Hamilton had been either investigated in New Zealand for making a video while being on a motorbike and he posted a message on his Instagram about it. I think in his press conference afterwards he referred a few times, 'Well, you've seen my post'. Which infuriated a lot of the traditional journalists who wanted to hear an answer that wasn't mediated. There were one or two times that a driver would say, 'Well, they've posted on this and they're not going to say anything further on the matter. So we'd rather they wouldn't speak.' (Interview with the authors, 6 December, 2022)

Similarly, the frequency of communications via social media can influence the experience of fans at a race or watching on television. 'You have an update from a team three or four times a race individually, aside from whatever you're getting on commentary' Slater remarked, 'So it's a much more immersive experience now than it has been.' these changes have occurred simultaneously with the decline in the sales of traditional newspapers, which have to transition into more multimedia entities. As Slater explained the changes he has seen since Sky Sports first invested in F1:

> When we first got the rights in 2012, there was still quite a strong Fleet Street group. All the daily papers had an F1 correspondent and they were quite vigorous. They felt quite empowered and felt the teams needed them to get their message across. So that enabled them in turn to be able to dictate the terms on which they would be questioned and so on. That has changed, in the teams now they do have their own outlets. What they don't necessarily have [] is the level of trust that the independent media would have. So you will find them still going to an Andrew Benson or to a Sky Sports or maybe to a Rebecca Clancy, if they have a story and they want it to be seen as something which people should care about. Independent. But there was a time when it looked as though the teams felt they could control their own image far more easily than they ever had in the past, which I think the media took a little while to get to grips with, and some weren't able to. (Interview with the authors, 6 December, 2022)

We would argue that the rise in importance of social media in the last decade or so, has cut across the value of traditional news media and accounts of a race. By the time a newspaper hits the shelves, or even its website, the main story of a race has been covered from multiple perspectives by broadcasters and online. This has changed the dynamic and become a key factor in both policing behaviour, but paradoxically allowing drivers to take greater control of the narratives that surround them. In so doing it has allowed the drivers (and the teams) to reach out to a wider audience, many of whom simply do not read print newspapers

Conclusion

As we discuss in the next chapter, there is widespread perception that the media audience for the sport has changed since the success of the Netflix series *Drive to Survive*. For some this had led to a dumbing down of the sport taking place as it attempts to provide more entertainment for the new audience, perhaps less interested in the technical side of the sport and more in the

human interest and celebrity angle. An example of this is the Martin Brundle 'gridwalk', which of course predates 2023, but appears if one follows it on social media to have got more chaotic. This segment of the television coverage is where former F1 driver and Sky Sports commentator Brundle, followed by a camera, walks down the grid shortly before the start of the race dodging among the cars, drivers, engineers and increasingly VIPs who have been given access to this area trying to catch a few words with them before quickly moving on, up and down the grid.

However, we think this is an example of how the post Netflix effect narrative is getting imposed on contemporary events in the sport. In other words, the Martin Brundle 'gridwalk' has always been chaotic, look at the example from the Monaco Grand Prix of 2004 (available on YouTube). At this time the commercial public service broadcaster ITV held the UK F1 contract, and the format remains identical to the 2023 Sky Sports F1 grid walks. In 2004, we have Brundle struggling through a packed Monaco grid, talking (through an interpreter) with a certain Roman Abramovich (who had just bought Chelsea Football Club the previous year), who is there as guest of Formula One chief Bernie Ecclestone who is encouraging the Russian to get involved in F1. The difference between 2004 and 2023 grid walks is social media, which allows a platform such as X (formely know as Twitter) to share clips from the walk, making sure it is seen by a much larger (often non F1) audience, and facilitating comments and feedback on this from those on the platform, in a manner impossible in 2004, where some newspaper reporting of the event would be the extent of media coverage. This process of *amplification* is crucial in understanding how the sport is able to extend its band awareness among a social media audience not necessarily watching the live broadcast.

There is also a strong element of personnel continuity in terms of the television coverage. Sky Sports F1 is crucial as they supply the international feed on race day, and are speaking not just to a UK audience, but a global one. While in the UK, Channel 4 provide the delayed FTA highlights and carry one live race per season. When the BBC secured the F1 rights back in 2009, the television team consisted of Jake Humphries (now owner of Whisper Group who supply Channel 4's F1 coverage), David Coulthard (now Channel 4 F1 presenter), Martin Brundle (now on Sky Sports F1), Ted Kravitz (now on Sky Sports F1) and Lee McKenzie (now on Channel 4 F1). BBC radio race commentary in 2009 was provided by David Croft (now the Sky Sports F1 lead commentator). Given the changes in the sport and its coverage, this is a remarkable level of continuity in terms of broadcast media personnel. Indeed,

the tight knit feeling of the group, specifically among rights holding broadcast journalists and F1 drivers and other team members, as they travel from race to race is well captured by Channel 4's Lee McKenzie (2022:8) in her reflections of working in the industry. What emerges from this chapter is that journalists working beyond this circle, enjoy less easy access and is increased competition to stay on the inside of the sport.

The next chapter examines in more detail the Netflix impact on the sport, changes in the media rights regime and the growing relationship between F1 and the USA media market.

· 5 ·

STREAMING F1, MEDIA RIGHTS AND THE NETFLIX EFFECT

Broadcasting the sport of Formula One in the 21st century is changing rapidly after the ascendance of Netflix's 'Drive to Survive'. Every conversation in the paddock in 2022 seems to be dominated by the influence of Drive to Survive.

BusinessF1 (2022) Car Crash Television, Vol 7. No 7, page 50.

By setting the world of top-tier international racing to the familiar beats of prestige reality TV, the series, now in its fourth season, has heightened the drama and minted a new class of driver celebrities. That's been great for business-and occasionally complicated for competition.

Adler, D. (2022) Netflix, *Drive to Survive*, and the New Cult of F1 Fandom, *Vanity Fair*, April.

F1 journalists and magazine feature writers covering the sport have been keen to highlight and report on the impact that the Netflix series *Drive to Survive* has had on Formula 1. From the specialised business and industry magazine *BusinessF1* through to more general publications such as *Vanity Fair*, the series has been discussed and profiled as part of the changing contemporary image of the sport. This chapter drawing on original research examines the impact the streamers are having on the sport both as new competition in terms of media rights, but also as conduits for related sports content such as the Netflix's *Drive to Survive* documentary series. As noted at the top of this chapter, it has been credited with increasing the profile of the sport in the USA and also among a differing audience demographic for F1 content. How accurate are these assumptions? And how is Liberty Media as the F1 rights owner shaping the strategy of the sport in this more fluid environment? In examining this

area, what insights are offered into the changing nature of the sports-media relationship and what we understand by sport in the platform age.

Streaming Competition

The advent of streamers such as Amazon and Netflix have increased the demand for television content and sports have benefited in no small part. In short, as we argued in chapter Three, streaming in its self is just a technology and delivery system, what it has done is increase competition in the sports rights market, as traditional broadcasters become streamers (in the UK, the BBC and its iPlayer platform) while pure streamers such as Amazon Prime Video have entered the sports rights market. 2023 saw global spend on sports rights up 64% year on year as almost $8.5 billion was spent, underpinned by NFL deals with Amazon and YouTube.

We are in the midst of a sea change in how sports rights will be sold and delivered, with more potential players in the market for particular live sports rights, although even in 2023 these are often locked into longer rights cycles and remain tightly controlled (and policed by rights holders). As we illustrated in chapter Three, the possible delivery of sports content by a sports rights owned OTT platform (such as F1TV Pro) has also given increased leverage to rights holders in negotiations with other platforms and broadcasters. However, the perception that we are in the midst of significant movement of all sports rights away from traditional FTA and Pay-Tv broadcasters can be overstated and this process will play out differently in differing markets driven by a range of particular economic, cultural and political market factors. Chalaby (2023) in his overview of the global value chain of the television industry reminds us of the strong elements of continuity as well as the change and disruption being brought by the streamers.

In the UK for example, Sky the dominant Pay-Tv player and sports rights holder is itself both a Pay-Tv operator and also a streamer with its Sky-lite NOW TV streaming platform augmented by the full fat streaming service Sky Stream. Its offerings and packages will continue to evolve as it responds to a fast-moving audience, but the arrival of pure business-to-consumer sports delivery is still a work in progress, as major media organisations retain the ability to offer significant financial return to sporting rights holders while absolving those sports of the risks involved in going to alone it reach the viewer. There are two modes of streaming, video-on-demand (VoD) and live

streaming (often involving sports content). Hence, not all streamers want live content, and those that do may not want live sport, just yet. Thus, the secondary sports market has grown significantly in recent years not least in the area of the sports documentary or docu-series.

The Sports Documentary: *Drive to Survive*

The sports documentary is not a new form of television or cinematic content. Indeed, when placed within the wider documentary tradition, Ian McDonald, writing over 15 years ago could note that:

> Sport documentaries constitute a significant part of the documentary tradition. Yet they remain on the fringes of the nascent discipline of documentary studies. Sport documentaries have made a significant contribution to the critique of sport and society. Yet as a genre of documentary, and as part of the visual-media sports cultural complex that includes television and fiction films, they have received scant regard from cultural critics, sociologists, and historians in sport studies. (McDonald, 2007: 208)

What has evolved over the last decade or so is a significant increase in the volume and profile of the sports documentary driven by a number of factors. These include; more platforms and outlets looking to generate sports related content for a particular audience, sometimes this is to augment their live sport offering (in the UK an example is both BT Sport and Sky Sports) or as in the case of Netflix allowing them a sports related offering without the investment in live sports rights. The *30 for 30* series commissioned to celebrate the 30 years of ESPN in 2009 was an important moment in the form's recent history as it connected the form to a new generation of film makers and a new audience for the sports documentary. In addition, there is a growing legacy recognising the value of sports history (or in the case of ESPN its own sports documentary tradition) facilitated by a significant televisual sports archive and a growing recognition of the ability of sports related narratives to both illuminate wider aspects of society and also act as a conduit for an examination of sports celebrity. Often these documentaries will have a cinematic release, before forming part of the offering of a range of platforms. Or they will form part of a series, such as Amazon's *All or Nothing* portfolio, which follows a team such as Juventus or Arsenal for a season. It is also worth noting that the pandemic and the initial halting of live sport (F1 closed down for ninety days, before re-emerging as a fan free television spectacle) helped accelerate

the desire for sports related content to fill this void, with increasing profile for sports documentaries part of this process.

What is understood by the term documentary has also evolved over the years and now embraces many televisual codes and conventions. Stylistic aspects of the fly-on-the-wall type documentary can often be seen in what are actually highly constructed, and sometimes re-staged events for the documentary team. This is not a new phenomenon, Robert Flaherty, one of the pioneers of documentary film went to great lengths to recreate and stage aspects of his famous *Nanook of the North* (1922) documentary set in the Canadian Artic, mobilising techniques that we would be today classed as docudrama or even docu-fiction, rather than simply documentary. Similar techniques were used by Flaherty's contemporary John Grierson in the UK, who termed the phrase 'documentary' and also recognised the social and political power of the form to shift social attitudes. In other words, the documentary form has always been a highly contested arena in terms of issues of veracity and authenticity. In more recent years the rise of reality television and multiple cross over genres have further stretched the definitional waterfront of the term. Central in the production of these documentaries are the issues of access and editorial control with the traditional understanding that the project is underpinned by the creative vision of the documentary maker. How have these issues played out in the Netflix series *Drive to Survive* (2019-)?

Origins

Series One of *Drive to Survive* appeared on Netflix in 2019, and in ten episodes of around 40–45 mins told the story of the 2018 F1 World Championship. It was watched by around 50 of Netflix's then 200 million subscribers and became a top ten hit for Netflix in all its major media markets. We look at its structure in more detail later in the chapter, but first we turn to its origins.

The take-over of the sport by Liberty Media, discussed earlier in the book in chapter Three is the catalyst for the series. One of the key appointments on taking over the sport was Sean Bratches, who had been charged with running the commercial aspects of the sport as F1 Managing Director of Commercial Operations. Bratches had been surprised on taking on the role to find little or no legacy infrastructure in the business which had been run by Bernie Ecclestone in a particularly esoteric manner. Bratches who had spent 27 years at the sports network ESPN rising to become Executive Vice President told the *New York Times* that on arriving in London on taking up his new F1 commercial post:

I realised there *was* no business. There was no sponsorship group, no media rights. There was nothing there. (Schoenfeld, 2022: 42)

Bratches was keen to develop the commercial side of the sport and through his television contacts was aware that the streamer Amazon Video had approached the F1 Mercedes team with a view to producing a short series for its platform. Bratches was keen that any series cover the whole sport and used his ESPN contacts book to approach former colleague Erik Barmack now Vice President, International Original at Netflix with the idea to showcase the sport through a behind the scenes type series. Ellie Norman was Head of Marketing and Communications at F1 and recalls how the opportunities to grow awareness of the sport, particularly in the US market outweighed the considerable contractual challenges in getting agreement from all the stake-holders across the grid. She notes that:

Sean Bratches actually had been like, 'Right we're going to do this' and it won't surprise you to know that there have been a number of approaches with ideas for similar documentary or content opportunities and then the Netflix one came on the table. We had a couple of other opportunities. Senior leadership team sat down and from a marketing perspective we know that the US is a strategic growth priority opportunity as it is for a lot of sports and you're like, hold on Netflix fantastic story-tellers, particularly Long Form. Three hundred million members, high penetration within the US. It's like, this is a little bit of a no brainer. So, Sean was very much like, yes we're going to do this, then from a marketing and the comms point of view the biggest thing was this needs to be authentic in the storytelling because fans and people are brilliant at smelling BS and really recognising if you've had a corporate hand in smoothing things over. Really, really tough and very hard for Ian [Holmes] who had to get the contractual agreements from the teams but I'm so pleased that we stayed true to that decision and we really stuck to our guns saying, 'No we have to give editorial control to Netflix and the production company and it's in their interest not to overstep the mark. If this is going to be a long relationship.' (Interview with authors, 28 November, 2022)

Within Netflix another key player was Brandon Riegg, Vice President, Unscripted and Documentary Series, who was on the look out to add to the Netflix slate, shows that would appeal to their European and Asian markets. Riegg was aware that under Liberty Media's ownership F1 was keen to expand into the USA market and saw potential for F1 to play across all their key markets. Riegg is also important because as Bruce Schoenfeld notes:

Before signing off on 'Drive to Survive', Riegg insisted on keeping creative autonomy. And unlike the NFL teams that HBO accessed on 'Hard Knocks', or the soccer clubs

featured on Amazon's 'All or Nothing' series Formula 1 didn't have the standing to refuse. (Schoenfeld, 2022: 44)

This aspect of the access was to prove important as the series progressed. It would be Nat Grouille, Vice President Unscripted Series who suggested to Riegg that they should look at a London based production company Box to Box Films run by James Gay-Rees and Paul Martin the former having produced the BAFTA award winning documentary *Senna* (2010) which had examined the life and career of one of F1's most iconic drivers.

Reflecting on the success of the series in 2022, James Gay-Rees admits that as film makers they were less certain of the narrative trajectories that would come to dominate the series when they began filming in 2018. He notes that:

> I'm not sure we knew what we were trying to achieve when we set out. But the difference with this show is that it covers the whole sport. So unlike, say, [Amazon Prime's] *All or Nothing*, which follows a single a team, this is following the whole paddock around the globe for 10 months of the year. (Wilson, 2022: 6)

With Box to Box onboard, Bratches has his series that he hoped would showcase the sport to a differing and younger F1 audience, but with two of the ten teams refusing to take part, ironically Mercedes who were originally approached by Amazon and Ferrari, no one, least of all producer Gay-Rees was sure *Drive to Survive* would be successful. Gay-Rees recalls:

> You never know how these things are going to work out. You have no idea at all. The worst thing you can possibly do as a filmmaker, is to try and second guess your audience and try to plan for this kind of reaction because it doesn't work out that way [] These things tend to come down to timing. It was the right show, right time. It's just so pleasing because it's an incredibly hard show to make. If nobody watched it, I think we would be pretty suicidal. We definitely did not expect people to react in the way they have. (Gibson, 2022: 72)

They were also fortunate in that those two central components in making such a series access and coverage were both readily available. While initially the teams from Mercedes and Ferrari refused to get involved, F1 gave the Netflix team access to all their weekend televisual race footage which they could use and intercut with their own original material. At a stroke, this addressed the challenge of the physical scope and scale of capturing F1 footage from across paddock and capturing on and off track events and helped address the issue facing any filmmaker of having your camera in the right place at the right

time to capture an event (although as we see below, in keeping with the best documentary traditions, if you miss the event you can always attempt to re-create it for the cameras at a latter date). It also gave the team access to wealth of F1 archival footage with no issues around securing and paying for rights to this material.

Significantly the promotion of the first series to drop on Netflix in March 2019 promised to offer insights into not just the drivers, but the team principals and also the management team of F1. Running throughout the core of series one is the narrative of conflict (between drivers, teams and team principals). In addition it introduced the viewers to the drivers, many of whom were relatively unknown beyond the dedicated F1 fanbase, and even for these diehard fans there was real value in getting to know some (not all) drivers 'up close and personal' with major beneficiaries of this being for example Australian F1 driver Daniel Ricciardo whose journey from Red Bull Racing to the Renault team were followed and whose profile was significantly enhanced by the exposure he secured in the series.

The other aspect of the first series that is worth noting, is also the focus on the off-track teams and the role of the team principals, with Red Bull's Christian Horner particularly keen to engage with the filmmakers. The Red Bull Racing Team Principal Christian Horner was a keen supporter of the series from its inception. Initially Netflix were interested in doing something on the Red Bull racing team, but as we noted at the start of the chapter, F1 under Liberty Media, were keen to increase exposure of the sport with a new audience demographic and hence wanted something more expansive. Horner is in no doubt about the impact of the docu-series on the US market. Speaking to *The Athletic* in 2021 he argued:

> It's taken Formula One to the masses and brought us a new audience. It's incredible, to be honest with you. My 15-year-old daughter now thinks Formula One is cool and so do all her mates. That's purely because of Netflix. Suddenly, you can see the personalities of the drivers and team principals. It's a TV show, at the end of the day, but it's based on reality and it's had a phenomenal effect. It's really engaged with the US market and opened that up to F1. (Slater, 2021)

Horner was also quick to recognise the commercial value that may come from increased exposure. He noted that:

> We embraced it [Netflix] from the very beginning, we opened the doors. The value of that in terms of commercial sponsorship has been significant. We've added five part-ners. I wouldn't say it's directly attributable to Netflix but it's certainly a contributing

factor, particularly as three of them are US-based. Formula One has been so paranoid about not giving away secrets that to suddenly peel back the curtain and have a look behind the scenes, it's a fascinating story to tell. You don't have to be die-hard fan to enjoy it. Formula One is a soap opera at the end of the day. There's a lot of money involved, a lot of competition. There are some big characters and I think it intrigues people to see the world we operate in. (Slater, 2021)

This commercial value to the F1 teams involved of increased media exposure was quickly picked up by Mercedes and Ferrari who engaged with the 2nd series. But the series also highlighted the scale of the teams and hinted at the complexity of the business away from the stars of the track.

Stylistically the series steered away from using the authorial voice over to guide the viewer and help make sense of the material on screen. Instead the tone was looser, framed by interviews to camera from journalists and presenters such as Will Buxton (who works for the F1TV platform) and some re-recorded scene setting voice overs from race day Sky commentator David Croft. One of the challenges faced by the filmmakers was that the series is basically a retelling of the previous F1 season, so fans of the sport know the outcome of the races and the championships. So rather than an earnest retelling of those stories, they tended to focus on various conflicts, often taking place further down the paddock and injecting some aspect of jeopardy into the narrative by not playing out the championship in a linear form across all the ten episodes, but rather focusing on the human/personal stories of those involved. As Gay-Rees suggests:

Sport is such a big business these days and we all see it through the broadcast lens, which is obviously the primary way into it. But what people don't realise, and maybe why Drive to Survive has worked, is the human reality behind the performance [] the audience love seeing the reality of modern sport and not just the broadcast version. (Wilson, 2022: 8)

To this end the expansion of the cast of characters in the series, beyond the drivers to the team principals and in some cases the owners was vital to its success. The linking of sporting narratives to television soap opera codes and conventions has been around for decades (O'Connor and Boyle, 1993), but rarely has it been so well realised than in the *Drive to Survive* series. Sport as a cultural form has at its core competition, with attendant winners, losers and the associated human emotions of hope, joy and despair that are interwoven into the culture of sport. Add the ritual and symbolic nature of sport and its ability to act as a conduit for the expression of individual and collective

expressions of identity and you begin to see the cross overs with other forms of popular culture. Of course, soap opera narratives thrive on character conflict, and as the season developed the tension between team principals of Mercedes Toto Wolff and Red Bull's Christian Horner became a staple of the series.

At the core of the series has been the personalisation of the drivers and those working for the teams. The pretext that it offers a glimpse of their lives away from the track is also part of the backstory function that has always been important in building fan and or viewer engagement with sport. As we have noted earlier in the book, the hidden nature of much the skills associated with the sport, has proven to be a challenge for television, whose mantra in the codes and conventions in covering sport, has always been get 'up close and personal'. For the BBC's Andrew Benson, part of the success of the series has been its ability to allow the viewer into the hidden aspects of the sport. He argues that:

> It's also answered back against people who might in the past have said well Formula 1's not a sport; they're just sitting down driving their car. And you're going, no, no, no you don't understand. That's not what it is at all. Yes, they're driving the car but it couldn't be more different from what you're experiencing when you're driving to the supermarket. And you try and explain to them about g-force and heart rates and temperatures and all the rest of it and the athleticism of the drivers. To a lot of people who were only casually acquainted with Formula 1, that stuff wasn't clear and I suspect that seeing the drivers close up in Netflix has opened that door a little bit because it's clear on Netflix that they are athletes. (Interview with authors, 22 September, 2022)

For teams further down the grid the challenge was not about giving access to the filmmakers, but the increasing domination in having predetermined story arcs that required to be realised (redemption being a particular favourite). As a former journalist, Matt Bishop, then Chief Communications Officer of Aston Martin Cognizant Formula One Team, well understood the importance of narrative frames. He recalls:

> I might say would you like to come and film this and suggest something, they might think this really doesn't fit our narrative arc. Well, it's what we're doing. So, if it was normal documentary reporting, it's not a question of fitting the narrative arcs that you have in mind it's a question of coming along and filming what we're doing, but they might not be interested because it doesn't fit their narrative arc. So, you have to bear that in mind. With the team principals, some of them love it, Christian Horner seems to love it. Others are much more recent or retiring about it and are nervous

about not being able to control the narrative. And to be honest, that negotiation is difficult. (Interview with authors, 11 July, 2022)

Bishop also notes the differing aspect of editorial control that might exist by way of comparison with more traditional media access. He argues that:

> I would say would you [the media] like to interview Lance Stroll [F1 driver] for a feature that will be run in the French Grand Prix coverage. And we will discuss what is going to be talked about. I will be there for the filming. It might take 15 minutes to film but it will probably run for four minutes or five minutes in pre-race build up, but you'd be absolutely sure that it was going to appear. And you'd be pretty damn sure that you knew what the editorial angle is going to be. This is absolutely not the case with Netflix, first of all, you wouldn't even know if it was going to end up on the cutting room floor, and a lot of good access to a lot of drivers has ended up on the cutting room floor because they shoot a gazillion hours of film and they haven't got the time to deliver it all. They don't know when they're filming it whether it's going to make the cut or not. And then you also don't know how it's going to be featured into the narrative arc. In fact, when it's filmed they may not even yet know what their narrative arc is. They might film something in Bahrain at the first race of the year. Other things may develop which means that it either doesn't get included or gets included in a slightly different way because the narrative arc has changed. So, it's a risk. And it's something that I think we're all learning. And, and there's an element of trial and error. (Interview with authors, 11 July, 2022)

For the documentary makers, faced with hours of footage captured over 10 months and then re-shaped into 10 40–45 min episodes, it will always be about capturing the essence of the story that has to be genuine. As we note later in the chapter, criticism can arise when elements of that construction may not in essence be 'true' and straddling that line between reality and less than genuine story-telling is something faced by all documentary makers, be their focus be on sport or other areas of society.

Reaction

For Bradley Lord, Chief Communications Officer, *Mercedes-AMG PETRONAS F1 Team* the Netflix series has also come with challenges, not least for some of the established media rights holders. He notes that:

> One of the other challenges that it's brought is, broadcasters paying big rights fees, seeing Netflix get access to things that they wouldn't be given access to while paying a lot less. And that can be hard for them. It's explainable because so much of what we do matters in the moment or in the next fortnight and doesn't really matter as much 6 months later. So, putting Sky inside our engineering meetings, you can't do because

Red Bull and Ferrari are going to learn from it on that weekend, and it would compromise our relative competitiveness. But putting Netflix inside it to show it 6 months later; the relevance of most of that content has expired. So, it's different modes of storytelling and that has exposed some areas of disparity of access that led to a sensitivity for live broadcasters, who are the core of our income as a sport, feeling initially marginalised by that. I think that has now been allayed somewhat by the growth in popularity that they've seen and actually it's helping grow the sport overall and that's good for everybody. So, the rising tide dynamic has taken that over (Interview with authors, 1 December, 2022).

This is echoed by Stuart Morrison, Head of Communications with MoneyGram Haas F1 team. As one of the newest teams on the grid and the smallest in terms of staff and budget (the 2020 season for example saw the Haas F1 budget being $173m, compared to Ferrari's $463), they are aware of the importance of gaining media profile has always been central to communications strategy at the team. Morrison recalls the frisson among the media when Netflix arrived on the grid:

Netflix just changed the dynamic and obviously a lot of broadcasters weren't happy with that. But the broadcasters missed a bit of a trick, they all felt well why is Netflix getting all this behind-the-scenes access. And the reality is a lot of the broadcasters didn't ask. And as a new team [Haas F1], our attitude was different, where in the past some of the established teams wouldn't have given that level of access. Whereas we came in at the right time, we came in with a yes attitude. I knew from my team that a lot of press officers and heads of comms were gate keepers and the first word usually out of their mouths is no. Whereas we always tried to say, yes. Because we knew our place in the scheme as a backmarker and as a minnow and as somebody that had to prove themselves.

The one thing we could do was give access to the team, give access to the drivers, give access to personal. And I have to say, we did that very well and that set us up in good standing. We probably have the best relationship with Box To Box, which is the production company that makes *Drive to Survive*. (Interview with authors, 5 December, 2022)

The working out of the editorial boundaries between the teams and the filmmakers was obviously and evolving situation, helped somewhat by the delayed delivery of the series content after the completion of the season. The element of trust between the key stakeholders is obviously key, and as Bradley Lord noted above, once the F1 teams began to the collective benefit of greater exposure of the sport, particularly in the USA this process became slightly easier.

Of this ongoing process between the sport and the filmmakers, Gay-Rees suggest that:

> It's a respectful relationship. We know what the boundaries are. They give us a bit more every year because they know we are not going to turn them over. You always want more – it's the nature of the job. And it's a pretty challenging show to make – the schedule is pretty punishing. But it's a pretty health model. (Wilson, 2022: 6)

For Stuart Morrison at Haas F1, the focus on their team principle Guenther Steiner, has had a massive impact on the media profile of one of the smallest teams in the paddock. Steiner himself claims he has never watched the show (Steiner, 2023: 16) an admission reinforced by Morrison. He comments that:

> Guenther has obviously become the de facto number one star, not that he changes for the camera. I mean, Guenther has never watched an episode of *Drive to Survive*; he is not interested in seeing himself, he doesn't want to change the way he behaves based on how he sees himself. Nobody believes that, but I mean, it's genuinely true. And that access that's given has been huge but we were a fairly early adopter on just saying, come on in guys, because the reality is that anything that Netflix film, a, as teams we have approval over it and secondly, it doesn't come out until the start of the new season anyway. So, it's not like a Sky who could be filming something live, for example, and suddenly showing a part of the car that they're not meant to be showing and what not. So, there's never a fear in that but there's still a traditional mindset amongst some of these teams and that's why the first season of *Drive to Survive*, Mercedes didn't take part, Ferrari didn't take part (Interview with authors, 5 December, 2022).

For Bradley Lord, Chief Communications Officer, *Mercedes-AMG PETRONAS F1 Team* the Netflix series has helped amplify aspects of the sport, that were already present. He suggests:

> ultimately if there wasn't the drama, if there weren't the ingredients; it [*Drive to Survive*] wouldn't be a success. It has helped to do that also by not trying to be a documentary but being a story and a narrative told around true events. It is not a historically entirely accurate portrayal. But that's what you need for storytelling, and I think, as a sport, we've got used to that. I think *Drive to Survive* was boosted during the pandemic; when many people ran out of things to watch. So, I think being stuck at home and exploring the outer reaches of Netflix really helped bring a different audience to it.

Lord also reflects on the importance of this in creating new fans and the challenges this also presents in communication terms for teams like Mercedes.

And where it's been affective, not just in creating a new audience but converting them, too. It's something like 80% of people who watch it then go on to watch a race and 60%; 10 or more races. These are really compelling numbers, not just for its outreach but it's conversion ability as well, and that brings opportunity with a new fan base. We need to talk to them in a different way. I think Formula 1 fans love to believe they know more than everybody else who is a Formula 1 fan. So, there's a kind of top trumps of knowledge, insight and things like that. You've got to talk in a different way to that brand new audience. You've got to explain some of the nuance and complexity of the sport. Equally the sport is having to adapt, simplify some of what it does to speak better to that fan base (interview with authors, 1 December, 2022).

The BBC's Andrew Benson argues that the growth of audience is not solely the preserve of the success of the *Drive to Survive* series. He suggests:

obviously *Drive to Survive*; the Netflix series has had a big impact on Formula 1's increasing popularity but it's also hard to separate out that from the impact of social media because they've kind of happened more or less at the same time. [] I'll give you a BBC anecdote about the power of social media. About ten years ago the BBC Sport website had grown its audience consistently from the moment in started up to and we got to a point where we were getting about 3 million unique users a day. And it had gone up to that point steadily but then it plateaued and we would be having management meetings and going, well what's going on? Why is it plateauing? What can we do about it? It was around about that time that Facebook and Twitter [now X] particularly were starting to really gather pace in terms of their popularity. We started using Facebook and Twitter as means of promoting our content on the BBC Sport website and suddenly it started going up again, and it's gone up pretty consistently ever since to the point that our audience is now triple what it was at the time that I was talking about. That gives you an example of the power of social media. So, I think while we talk about the Netflix effect on Formula 1, I think it would be remiss and I don't know because it's impossible to be scientific about this because how can you possibly interrogate the question properly? But it would be wrong to talk about the one effect without talking about the other. (Interview with authors, 22 September, 2022)

The importance of social media platforms and the emerging growth in online content that connected to a new F1 is also something that content creator, turned SkyF1 producer, Jess McFadyen believes underpinned the success of *Drive to Survive* series. She argues that:

So a lot of people always look to the Netflix documentary *Drive to Survive* as one of the major precursors for F1's massive meteoric rise in popularity but I think it's way more nuanced than that, it comes from using the social platforms, and opening the doors to more people, allowing it to be more consumable, engaging with fans and kind of just embracing this new way of talking about the sport as well as the *Drive to*

Survive documentary, and also with the introduction of younger drivers that are more digital savvy, they are more accessible, they understand that they need to be always on. (Interview with authors, 5 October, 2022)

For McFadyen the pandemic and as a result of this the turn to platforms such as Tik Tok (where a new generation of content creators where discussing all things F1, and building an audience during Covid lockdowns) was also crucial in enhancing the popularity and interest in the sport. This rise of new F1 fans is something we examine specifically in more detail in the next chapter.

Hence a range of factors, from lockdowns, to an upsurge in social media creators and also the fact that the sport restarted racing, (albeit without trackside fans) in July 2020 in Austria completing 17 races in 13 countries, coalesced around the timing of the Netflix series. Former F1 executive and business analyst Mark Gallagher also notes that:

the added ingredient was that when Netflix came to Formula 1, Ferrari and Mercedes refused to contribute to the first series which meant that Netflix decided to go ahead by story-telling around the 8 lesser teams. And the lesser teams at that time started with Red Bull and finished with Haas and Williams. So, the narrative of the first series was not about the people that you normally see on Sky Sports F1, they were about all the other people who you almost never see. And it answered a big question amongst the fan base, the old fan base and the new fan base which was, what's the point of everyone else turning up because they never win anything? Well suddenly Netflix told the story of what motivates and inspires people to turn up who will never win a Grand Prix whose biggest achievement is to score a point or finish tenth or whatever. So, there was all of those things happen and it was fly on the wall only to the extent that the fly was fully briefed and scripted. And of course, Netflix then decided to get a couple of decidedly friendly media personal to provide the discourse during each session and indeed Will Buxton now works full time (he's a paid employee of Formula 1) so, he's not even independent. They've turned it into a 10-part advertorial for Formula 1 which is fantastic for the sport, it scratches the surface in a way which is very useful. So, the fans are seeing the personalities in a way they wouldn't normally have seen them. Does it go into the detail? No, it doesn't, it doesn't begin to go into the reality of how things are within the sport on a day-to-day basis but it definitely scratches the surface; and that's good. And it's giving a voice to people that you wouldn't otherwise hear about. (Interview with authors, 25 October 2022)

With this in mind, the next section of the chapter looks at in more detail the claims that the series distorts or falsifies aspects of the sport.

Faking It?

The former Hass F1 driver Romain Grosjean, perhaps most famous for surviving a horrendous fireball of a crash at the Bahrain GP in 2020 (featured in Series 4 of *Drive to Survive*) is open about the veracity of the series. He notes that:

> On paper, the modernisation of the sport, transformed into an 'American show', was fairly beneficial: with the series *Drive to Survive*, the public discovered what our trade was and the drivers earned more respect. Even if the reality was bogus! With the risk of disappointing some of you, I have to tell you that the episodes are out together in a way that suits the producers best to arouse, obviously maximum interest. Too bad if events have to fit the screenplay. (Grosjean, 2021: 149)

He then documents a scene, when it appears he has not attended a Haas dinner at the French GP because he has been reprimanded for poor performance in the Saturday qualifiers. However, as Grosjean points out, the dinner in question actually took place on the previous Wednesday, and his agreed absence had been due to him attending an end of year show at his children's school (Grosjean, 2021: 150).

Another example is in Season 4 of *Drive to Survive* when Mercedes team principal Toto Wolff tells George Russell that they have decided to offer him the Mercedes seat for next season. In fact, Russell had been told weeks earlier and this conversation was then staged with the cameras present and offering the viewers the great soundbite from Wolff, who after giving Russell the good news, then says 'The bad news is you're driving against Lewis Hamilton'. For *The Times* F1 journalist Rebecca Clancy these types of manipulations can be concerning. Reflecting on the impact of the series on the sport she notes that:

> I have two feelings about it. One is that it's been unbelievable for F1. I think we're all shocked by how many people it's brought to the sport. I don't think any of us expected that. But talking about the art of story-telling, they've made a lot up or they've inferred stories that weren't really there. For example, *The King of Spain* [Series 1, Episode 2] stories between [Carlos] Sainz and [Fernando] Alonso, the rivalry between [Lando] Norris and [Daniel] Ricardo in their first year as teammates. There's just a lot which isn't accurate and I think Max Verstappen decided not to be involved with it, you know you can't criticise him for that. They take a lot [of quotes] from our press conferences. And then you're watching it and you're like, 'That's not when he said it, that doesn't tie up.' And even though Max didn't do the last season, they've still used quotes from him and put it in and it's not an accurate portrayal. (Interview with authors, 31 May 2022)

She also recognises that it has raised the media profile of many in the paddock, beyond the traditional stars of the sport, the drivers.

The Team Principal's of a number of the F1 teams have become much more well-known among the public and beyond the traditional F1 fanbase. Clancy recalls:

> I interviewed Guenther Steiner [Team Principal Haas F1] in Australia in the paddock and as I was doing the interview, all I could hear was Guenther, Guenther. You know, certain people play up to it more than others, so Ferrari and Mercedes didn't even do the first season and now you can't get enough of it. Oh yeah, [Christian] Horner loves it, Horner is the mark.... You know spot the marketing man. Horner, Steiner, [Toto] Wolff you know. And Cyril [Abiteboul] when he was there at Renault. They absolutely love it and to be fair to them, they saw the opportunity and they went with it. (Interview with authors, 31 May 2022)

Steiner (2023) himself claims to have not watched himself in the series (a fact reinforced in our interview with his head of communications at Haas, Stuart Morrison). Steiner documents (2023: 105) how the impact of the series has raised his profile among the fans at race events and as the only US team on the grid the growth in US based interest has been significant in recent years.

By series 5 of *Drive to Survive* (released February 2023) it's clear that the production team and its cameras have become increasingly embedded in the paddock. Episode 2, *Bounce Back*, featured a heated clash at a Team Principal's meeting between Mercedes' Toto Wolff and Red Bull's Christian Horner over the impact of the porpoising (bouncing) of the cars as a result of the changes in regulations introduced for the 2022 season and being keenly felt by the Mercedes team. Although in episode 2 of the series, the meeting actually took place half way through the season on 18 June 2022 before the Canadian Grand Prix. In his book Haas F1 team principal Steiner recalls the meeting and the clash between Wolff and Horner, noting that:

> There have been rumours that teacups were thrown during the meeting but that's bullshit. Toto did get quite animated at one point but that's normal. Netflix were there so those guys will be celebrating tonight, for sure. (Steiner, 2023: 163)

The extent to which Wolff may have played to the cameras present, is open to debate, but what is clear is that, as is the case in any television soap opera, there are a number of key storylines that the producers are keen to sustain and develop as they resonate with the audience and the dislike and distain between Wolff and Horner is clearly a storyline that they are keen to amplify.

The fixation with developing compelling storylines has led to some concerns also with in the paddock. Matt Bishop, then Head of Communications at Aston Martin F1 notes that:

> It's quite frustrating to watch because you think that didn't happen. It wasn't really like that. No, no, that's not what he meant. You think like those kind of things all the time I remember, not the most recent series, but the series before [Series 3, Episode 8] the two McLaren drivers who were then Lando Norris and Carlos Sainz. They were well known to be very chummy, got on well with each other, actually did get on well with each other and just didn't just do it for the cameras, they were mates. And yet the narrative that Netflix developed for them was that they had this terrible cutthroat rivalry, and were always bitching at each other, and it shows what you can do with editing. (Interview with authors, 11 July, 2022)

While for another insider such as Head of Communications, Stuart Morrison at Haas F1 this can be frustrating, but there is also a realisation that insiders, like himself and Bishop are not the target audience for the series. He notes that:

> You know it's kind of like, well you've put in this scene … I mean in the episode I've just approved, it's around, it's something to do with Saudi Arabia, but then they cut away and it's meant to be like Guenther on the phone but it's in Baku. So, of course, I'm just like, your continuity is out, but they don't care about that. Because
> it's the narrative. And that's always what I have to remember because it's not designed for me. So, sometimes when I am trying to pin point them on certain things and continuity; it's like, but I only know that because I'm a nerd and I know what race track that is and when that's from. They don't really care about that and I will have to kind of watch things one step removed knowing that Cathy in Kansas does not know that that is the paddock in Baku as opposed to the paddock in Saudi Arabia. (Interview with Authors, 5 December, 2022)

Indeed, in his own account of the 2022 season, Steiner noted how Netflix suggested that he spends the day (30 August, 2022) with his Ferrari counterpart Mattia Binotto who has just bought a vineyard in northern Italy. He recalls how after being collected by the production company they spent the day together being filmed by Netflix as they visited a couple if vineyards. The material filmed in August, 2022 actually opens season 5, episode 1 (*The New Dawn*) with close friends Steiner and Binotto reflecting on life and the pressures of F1. The point here is that this intervention and construction by the production company is testimony to the growing extent to which they are shaping the narratives and shooting material that allows them to illustrate

what they feel are wider truths, in this case the genuine friendship between two rival team principals.

The embedded nature of the Netflix team also has other journalistic impacts for the rest of the media pack covering the sport. The BBC's Chief F1 writer Andrew Benson also reflects on the impact of the series:

> one of the minor impacts of having the Netflix cameras around is that you've sometimes got to be a little bit careful about what you're saying to who and where. Because I've been involved in a number of situations where I'm having a sort of quiet lean against a transporter, off the record chat with whoever, someone important and they'll suddenly say, quiet or let's go somewhere else because Netflix are just over there. Or let's go to my office or whatever, just because you can get caught out in those situations. It still a fly on the wall series in that way but it raises the question of how much of what you see is spontaneous conversation. Take for example Christian Horner and Cyril Abiteboul in some of the Red Bull Renault antagonistic episodes of past series, of course it's true but how much were they also playing up for the cameras? Because the cameras were very much there and they knew that they were there because they get told what the focus is going to be that weekend. (Interview with authors, 22 September, 2022)

Despite some of these issues for the commercial rights holder of F1, any pain is offset by the commercial uplift that the increased popularity of the sport in the US specifically has had on the revenues and profile of their asset. Metrics from F1 suggest somewhere in the region of 70million new fans came to the sport on the back of *Drive to Survive* with many between 16 and 35 and more than half of these women. Stuart Morrison, Head of Communications at Haas F1 team notes that:

> It really is the Netflix thing that I think has helped move the needle. People have just been able to see the personalities of the drivers. You know, they've not been watching a race that they think is boring because I mean, honestly IndyCar racing is better racing. I mean, I spent a lot of time working in IndyCar. It's much better racing, you go into every race weekend and there could literally be 12 or 13 drivers that are all capable of winning the race whereas in Formula 1, you know, going into it, there's maybe 4 or 5 guys that have got a shot of actually winning the race on that day. But I think what Drive to Survive helped to do, was provide the entertainment and it didn't judge its audience. They always tell me that *Drive to Survive* was designed for Cathy in Kansas. They want her to be on Netflix, scrolling through and going, what is that?. (Interview with authors, 5 December, 2022)

The next section of the chapter looks at how the focus on the US market has been a crucial element in the commercial and corporate strategy of Liberty Media and its development of the sport.

Born in the USA

While Netflix is widely viewed as being the key agent of change in shifting the popularity of the sport in the key US market (Lawrence, 2021: Moshakis, 2022), as noted above we would argue it was the coming together of a range of factors, including the central role of social media and the disruption in media consumption habits of the pandemic, that generated the growing awareness of the sport in this key market. Ellie Norman, was Head of Marketing and Communications for F1 during this period and argues that the role of ESPN, as much as Netflix was crucial. She argues that:

> What I would say is Netflix has been the most famous noisy new thing to have come out of Formula 1 but I think I would stress that it was a series of lots of things happening to reignite the sport and actually I would pay great credit and compliments to ESPN as a broadcaster within the US. I think they don't get maybe enough of the credit but being the home of sport in the US actually the investment that they made from a resource point of view, the quality of the production and actually a series of cross sport activations that the ESPN would do with my team were important. So, whether that was the direct to consumer streaming app, the opening up of social media channels, a website, an app, making data and timing available, redoing the broadcast graphics, bringing in celebrities, I genuinely believe it was a combination of all of those things meant everything was kind working together. (Interview with authors, 28 November, 2022)

Matt Bishop, then Chief of Communications at Aston Martin F1 is under no doubt of the impact of the series on the USA market specifically:

> I think the effect of Netflix *Drive to Survive* series has been and is dramatic, you know, enormous. In terms of turning on a different audience, age demographic in general but specifically age younger people, and also new territories and specifically the United States of America. You know, When I used to speak. Five years ago or 10 years ago. If I used to tell young people, by which I mean, you know, 18 to 25 that I, I worked in Formula One. They might say, oh yeah, yeah, yeah Formula One, I think my dad watches that. Or they might even say I think my granddad watches that. Now if an 18-year-old finds out that I worked in Formula One, they're full of questions. What's Lewis Hamilton really like have you met Charles Leclerc is so and so going to sign and so on. The idea of people like that, knowing about Formula One drivers and

even team principles and being curious about them, it never happened. And now it always happens. (Interview with authors, 11 July, 2022)

Bishop also recognises as Red Bull's Christian Horner noted earlier, this profile in the USA has also had important commercial impact on the F1 teams.

> In the States you used to get in the taxi, they hadn't heard of Formula One. Let alone McLaren or Lewis Hamilton, let alone they might have heard of Aston Martin as a race car. Now they know more about Formula One. They now ask detailed questions so that is the change that is difference, and we're seeing more and more, we now have three races in the States. It used to be none not very long ago. Now it's three. And we have interest from another team. The Andretti team wants to come in, they are desperate to come in. We have tons of American sponsors. Many more than they used to be, they've always been some but increasingly more. If you look down on our website many of our partners are basically American companies. And all of that is the result of Netflix. (Interview with authors, 11 July, 2022)

By 2022, the sport had over 100 US based companies as official sponsors across the grid, an all-time high and up on the figure of 44 US companies when Liberty Media initially acquired the sport. In that same year F1 Grand Prix across ABC, ESPN and ESPN2 averaged over 1 million (1.2 million) for the first time ever. Aided by the addition of Miami as the second US GP on the circuit in 2022, by the end of 2023 there will be three US races with Las Vegas joining in November of that year. Also, importantly, the Las Vegas GP event will be the only race solely promoted by F1 itself (involving significant upfront investment from Liberty Media, but offering significantly greater returns for the company) another indication of the shift in the centre of gravity of the sport under Liberty from its European heartland to north America.

This impact on the USA market is also echoed by Haas F1 Communications head, Stuart Morrison who recalls the years when the impact of F1 was always being overshadowed by the indigenous US car racing culture. Despite the sport having a presence in the USA over the years, it never gained significant traction beyond its hard-core supporters. For Morrison the Netflix show has changed this.

> I have to say, I think it was a game changer. I spent 12 years living in Canada, and the Canadian Grand Prix has always been huge. Like, the number of Americans that would actually go to Montreal, because it is a destination city, it's a great historic race track and it's just a good place to be. But America had always struggled. So, the only underlying trend I would say, that had been successful is, at least the establishment of a permanent home [at the Circuit of the Americas, COTA near Austin, Texas).

I think the first few races, they probably had a couple of hundred thousand people there. I mean now they have 400,000 people there and that is the Netflix effect. I genuinely think the Netflix thing, it just hit home at the right time. And you have to say, Liberty is an American company so they were always going to do something that would try and drive business to their backyard. We now have the Miami Grand Prix and then next year (2023) we've got Vegas. And the fact that they've changed the business model so Formula 1 is the promoter of its own race. That's kind of stuck in the craw of some other promoters because that obviously is a threat to them that if Formula 1 says, we don't really need to bargain as much with you guys anymore; because we can run this show ourselves. But it shows the financial commitment that Liberty are prepared to put in. (Interview with authors, 5 December, 2022)

When the F1 circus returned to Miami in 2023 for the second GP there, the pre-race focus was very much on entertaining the US crowd. Just 20 minutes before the race the drivers were introduced to the crowd by rapper and actor LL Cool J, with musician will.i.am conducting an orchestra that was playing his original composition of the F1 theme tune 'The Formula'. In the UK, many newspaper commentators found the spectacle cringeworthy and not what was needed before a race while a number of drivers, with the notable exception of Lewis Hamilton, thought it was distracting so close to the start of the face.

However, if F1 wants to continue to grow in the US media sports market, then serving that audience and the differing cultural and social role that sports play in that culture will require to be continued. This challenge between a more European idea of sport as a rooted cultural form and the more US based notion of sport primarily as another form of commodified commercial entertainment is not easily reconcilable (we discuss this in our final chapter). Other US voices (Blackstock, 2023) also raised concerns about the corporate nature of the Miami race events, which seemed orientated to extract the maximum revenues from spectators rather than focus on providing a great at track experience for those 90,000 fans already paying on average $600 for three days of admission. The idea that the sport, now with three races in the US for the first time since 1982, will continue to develop and grow seems misplaced, without significant ongoing investment and careful management of events. The fact that F1 have decided to promote the Las Vegas GP itself perhaps suggest they understand this challenge.

Veteran sportswriter and F1 author Richard Williams also strikes a note of caution about the long-term evolution of the coverage of the sport and the role played by *Drive to Survive*. He suggests that:

Netflix is now part of the sport through *Drive to Survive*. Which obviously Liberty Media loved because it's opening up new audiences for them. But the corollary of Netflix's involvement is that every race, every championship has to produce excitement, a denouement, it has to produce something that makes you go 'Wow'. Now, grand prix racing didn't used to be like that, sometimes you had boring races, and a boring race was a boring race. I think legacy fans like me … are not important anymore and will disappear. I think the world is changing so much and I think the generation that is now 15 to 25 is now so different and thinking in such different ways that who knows what will happen. Can you interest them in a sport whose season might very well be over with 16 of 22 races gone. (Interview with authors, 31 May, 2022)

As the sport becomes increasingly aligned to being another media entertainment brand, the focus in some ways shifts from the races to the importance of the personalities as a way of sustaining interest, particularly as during periods of domination by one team or a driver, the world championship can appear to be a foregone conclusion. Despite efforts by the sport to prevent domination through ongoing technical changes, the introduction of cost caps and so forth, it will be the narratives and the stars that have become increasingly central in retaining interest among a new generation of more media literate fans engaging through various social media platforms.

Conclusion

We would argue that *Drive to Survive* in many ways fulfils a role that as we saw in chapter Two, the tabloid press used to fulfil back in the late 1980s and into the 1990s in personalising the sport. In many ways F1 is an ill-suited sport for television where the skills of the drivers are largely hidden from view (even more so with the advent of the safety halo on the cars in recent years). Unlike other sports such as tennis, where the viewer can see the player's backhand, and television can get up close and personal, the skills of elite athletes are on full televisual display, in F1 they are hidden. Hence television has to work hard to transform the sport into a television experience (hence multiple graphics and the central importance of the commentary team in helping to make sense of the event for the viewer). So, that key background function of story-telling, that used to be filled out by the tabloids in particular with their stories focused on the rivalries and tensions in the paddock is now fulfilled by *Drive to Survive* and extensively augmented by various social media platforms. All now engaged in that crucial personalisation of the sport that is such an important lubricant for contemporary fan engagement.

For former Jordan F1 executive Mark Gallagher there is also the challenge of how you keep a series fresh and exciting. He reflects that:

> But where do they ultimately take it? Because sooner or later, all that Netflix is doing is providing a few months after the season has finished, an insight into what people already know happened. And because the discourse in social media is 24/7, by the time you watch Netflix, actually all you're seeing is edited footage of what you already know happened. So, is it that fresh? So, I do wonder where they ultimately will be left to take it because I'm a great believer that all things have their moment and I think Netflix, *Drive to Survive* has probably had its peak moment. It's a question now of how long the tail to that beast will be and whether indeed there's something new that they could do. My own personal view is that having now told the story of everyone, the really good thing for Netflix to do would be to tell the story of someone really in detail. And literally live the life of a team on a year-to-year basis because that would be, there's so much there that they could build story telling around. (Interview with authors, 25 October, 2022)

A central aspect highlighted here is the relationship of the sport to the new fans it has acquired in the last number of years. The next chapter turns our focus specifically to this area and examines how F1 has achieved what many other sports aspire to do: grow a younger fanbase in the digital age of audience distraction.

· 6 ·

CONSUMING F1: NEW PATTERNS OF FANDOM?

I think Formula 1 in general has a lot of room for growth on fan engagement. Other sports are further ahead. It was a broadcast sport for so long – we were late as a sport to digital and that came back to the previous ownership which thought 'my bread and butter is broadcast television'. But [with] broadcast you're projecting and you're not getting anything back. Now, the whole sport is on fire digitally because it's such a digitally-rich sport.

Zak Brown, CEO, McLaren F1 Team, *SportBusiness*, 5 July, 2022.

As Zak Brown of McLaren F1 Team acknowledges, although late to the digital party, as a spectator sport F1 has never been more popular. The post Covid demand to attend live races, augmented by the growth of new fans to the sport was clearly reflected in 2021 with three Grands Prix weekends attracting more than 300,000 spectators in the USA (400,000), Mexico (371,000) and Great Britain (356,000). All of these figures up substantially from 2019 the last season to have spectators. The 2022 season saw further growth and record attendances at a number of races including the 420,000 spectators attending the three days of the Australian Grand Prix in Melbourne, the largest figure ever at any GP weekend and the attendance of 302,000 set at the Singapore GP, up 34,000 since the last spectator race in 2019. As Alex Fynn and Lynton Guest (1998) proclaimed of sport at the start of the digital era, 'Where there's passion, there's profit' and such was the demand for 2023 British Grand Prix tickets at Silverstone, that when released in October 2022 the site crashed, with eventually with tickets (at increased prices) eventually selling out quicker than ever.

The scaling up of attendances at F1 races has been matched by the growth of new locations to host grand prix racing, which for decades was largely focussed on European circuits but is now global, with the axis moving towards more races across the Arabian Peninsula and North America. Where the majority of contracts for the new frontiers of F1 are secured into the 2030s, many of the historic European venues for F1, such as in the UK, Belgium, Italy and even Monaco, are on shorter contracts. Races in two of Europe's largest nations, Germany and France were jettisoned from the F1 season in 2019 and 2022 respectively, along with the termination of F1's contract for the Russian Grand Prix due to the invasion of Ukraine in 2022. The shift to expand F1 to new global locations, especially in Arab states and the USA, is principally motivated by a desire to grow the market for F1 and its commercial sponsors in new territories, but also reflect specific geo-political forces to use sport for soft power influence (Dewhirst, 2023). How fans have responded to the shifting tectonic plates of F1 and the influence both private and state investors are having on the sport is something this chapter will consider.

Beyond the live event, the growth in fans has also been significant across social and media platforms (see chapter Three). While across global television coverage the sport in 2021 had its most popular television season since 2013, with a cumulative TV audience of 1.55 billion. Some national markets had unprecedented growth in viewing figures, especially the Netherlands up 81%, reflecting the success of its new motorsport hero Max Verstappen. Just as important were year-on-year growth in audiences in the US (58%), France (48%), Italy (40%) and the UK (39%) (F1, 2022). The audience trends for growth in the consumption of F1 were also reflected across the leading social media platforms. In 2021 F1 reported being the fastest growing major sports league in the world, with nearly 50 million followers across its key platforms of Facebook, Twitter [now X], Instagram, YouTube, TikTok, Snapchat, Twitch, Weibo and WeChat. In a relatively short period of time from 2017, F1 has transformed its digital media presence from a sport brand with a large global appeal but no digital footprint to one that now connects with a new generation of fans across the digital spaces they regularly occupy.

This chapter focuses on how the consumption of F1 content, for many years tightly controlled by limited media coverage, has dramatically altered in the last few years. The advent of social media and digital media engagement strategies across investors, teams, drivers and other stakeholders in the media and sports industries has been significant in transforming the opportunities to engage with F1 content. This chapter examines the impact of this on the type

and nature of the audience engagement and in turn asks whether this change also plays back into changing structures and tensions within the sport itself. Are we seeing a growth in the entertainment and commercial values of F1 clashing with some of the wider ethical, political and social values associated with such a high profile, international and controversial sport?

The F1 Fan: Characteristics and Changing Consumption Patterns

Studies of sport fandom reveal the complexity in defining what and who 'a fan' is, and how the highly mediated forms of sport spectatorship are transforming the relationship between sport and fandom (Wenner and Gantz, 1998; Hills, 2002; and Sandvoss, 2005). Most of these long-standing debates are focused around the authenticity of fandom and levels of affect, emotional attachment, or depth of feeling fans have to a particular sport, team or sport star (Grossberg, 1992; Hills, 2002). F1 in many ways in an exemplar of global mediated fandom, as most fans experience the sport as a mediated spectacle, only rarely attending in person when F1 rotates to a racing circuit in a fans home nation. Even then, the cost of tickets, travel and accommodation around attending an F1 event is a challenge or beyond the resources of many fans. Midway through the 2023 season the specialist motorsport travel company F1 Destinations (2023) estimated the average price of a three-day pass to a Grand Prix was $500 USD, the cheapest average price for attending in Hungary ($184) and the most expensive the inaugural race in Las Vegas ($1,667). For local spectators in Azerbaijan, Brazil and Mexico the average price of tickets equates to more than fifty per-cent of the average monthly wage in those countries. There is little doubt that such financial commitment to attend F1 makes it an elitist spectator sport.

Within motor sport fan communities, the attributes that constitute an authentic F1 fan can be hotly disputed. Writing back in the late 1990s, the sportswriter Richard Williams noted that:

> The fans now have an investment in their heroes as characters in the celebrity soap opera, created by the symbolic relationship between television and tabloid newspapers (Williams, 1998: 280).

What Williams identifies here is the sense of investment (both emotional and financial) that is required to sustain fandom around a sport such as F1.

That has not changed, what has changed as we noted above is the media and cultural context and environment of the current generation of potential sports fans and the need for sports to recognise this and adapt accordingly. In a fascinating, self-reflexive, auto-ethnographical study of his F1 fandom and its relation to masculine identities, Damion Sturm (2011: 237) suggested that 'via fluctuating forms of affective intensities, attachments and investments, Formula One is something that 'matters' in the fan's quotidian existence.' This connection between sport fandom and identity has been the focus of socio-logical, anthropological and popular cultural research since the 1970s, but Sturm's personal reflections on his performative display as an F1 fan remains a rare critical sojourn into the experiences of motor sport fans. Of relevance here, is Sturm's analysis of F1 and mediated fandom.

As a resident in New Zealand Sturm reflects on a series of 'vignettes' of viewing F1 telecasts, often requiring commitment to early-morning, anti-social hours of viewing because of the global nature of the sport and its 'Eurocentric' scheduling. Reflecting on the object of fandom, the racing driver Jacques Villeneuve, he concludes that his fandom is both heavily reliant on the televised form of the sport, which could be distracted and fractured as the broadcasts might not always focus on his favourite driver, but also his experiences as an F1 fan are riven through with diverse forms of transmedia experiences as multiple media or meta-texts related to Villeneuve and F1 are consumed, experienced and embodied within his fandom at the same time (Sturm, 2011). In 2011, this would have included web-based texts, but also magazines, and other ephemera related to the sport. More than a decade on, the meta-texts instantly available to F1 fans include web content, Tweets, Instagram posts, YouTube live-streams, podcasts, data-streams and a host of other mediated texts.

The most comprehensive research carried out with F1 fans have been the Global F1 Fan Surveys conducted by publisher Motorsport Network since 2005. These surveys are part of the industry's need to understand the changing dynamics of motorsport fans, as the scale and scope of F1 digital media has grown, transitioning from the eras of Ecclestone to Liberty Media. Motorsport Network, with a customer base of 62 million unique users of their titles across fifteen languages have been able to track this transformative period in F1 through the voice of motorsport fans (Motorsport Network, 2023).

In 2015, 35,000 F1 fans completed the survey to reveal the levels of com-mitment many fans have for the sport, with two thirds (64.6%) of respondents having followed the sport for more than fifteen years, and a similar number

(67.6%) having travelled to a different country to watch a race live (Autosport, 2015). The survey is a fascinating snapshot of F1 fans two years prior to the corporate takeover of F1 by Liberty Media in 2017. Less than one in ten of the 35,000 respondents were female (7.8%), the majority were aged between 18 to 40 (59.3%) and most cited the 1990s or early-2000s as their favourite era of F1 motor racing (50.6% combined). Their views on changes in the sport were largely conservative, particularly regarding FIA regulatory constraints on cars (either on design features or cost caps) and competition (particularly the FIA's governance of the sport), and a significant number (43.4%) were unwilling to pay anything to download video or watch F1 on a mobile device.

Fast forward to the F1 survey conducted in 2021 which received data from 167,302 respondents. Compared to 2015, the demographics, media consumption and attitudes towards the structure of F1 looked radically different. The report included responses from a higher proportion of new F1 fans, with nearly a third of respondents becoming fans of F1 within five years of the survey. Crucially, the number of female respondents to the survey nearly trebled from 2015 to 2021 (from 7% to 18%) which Motorsport Network (2023: 12) suggested 'displayed the greatest success in attracting an increasingly female audience.' While such claims inflate the benchmark of 'success', it does reveal an emergent trend in the gender balance of F1 fans, albeit remaining a heavily male-oriented spectatorship.

The survey's conducted in 2017 (just after the Liberty Media takeover) and 2021 revealed a more positive perception of F1 as a sport, what the report calls its 'Brand Health', and in a wider context symbolises how fans feel towards the sport and its governance. Where fans were largely critical of the sporting spectacle and governance of F1 in 2015, perhaps reflecting the denouement of the Ecclestone era, the 2017 and 2021 surveys revealed more positive responses to the structure of the sport. In 2015, three of the top four keyword indicators for the sport were 'expensive', 'boring' and 'corrupt', hardly an endorsement. In 2021, the top keywords had shifted to 'exciting', 'technological', 'expensive', 'competitive' and 'entertaining', all attributes a global elitist sport brand such as F1 would aspire to. The 2021 survey also weighted the positive and negative key attributes fans assign to F1, which revealed highly positive measures towards F1 delivering exciting racing, the best drivers, the fastest cars, pioneering technology and close competition. The main negative was lack of overtaking, an attribute of F1 many fans find the most exhilarating aspect of racing.

The fan survey also reveals a sense of F1's heritage as part of its brand, which poses some serious questions for its global aspirations. We noted above how F1's expansionist approach to gain new commercial investment and reach new audiences has led to new Grands Prix, especially in North America and the Arab Peninsula. Since 2010 fans have been asked to indicate their preferred shape of the F1 calendar ranking circuits in order of importance. The top four circuits, labelled as 'The Untouchables' in the report, are Monza (Italy), Spa (Belgium), Silverstone (UK) and Monaco. These Grands Prix circuits have an historical lineage and significance that fans feel are at the heart of F1, which reflect emotional attachments to sporting places, previously described by geographer Bale (2002) as a form of sporting 'topophilia'. Looking forward, we can anticipate increasing concessions to be made to the economic imperatives of F1's global expansion which may compromise, or even usurp, these long-standing circuits in the F1 calendar. F1 has increasingly looked to global tourist cities introducing races in Las Vegas and Miami, with an increasing number of Grands Prix held on street circuits (with Jeddah, Albert Park, Baku, Miami, Marina Bay and Las Vegas joining the historic street circuit of Monaco). A question for the future of F1 is the extent to which the heritage value of F1 circuits in Europe and the topophilia felt by many fans towards circuits like Monza, Spa, Silverstone and Monaco, will weigh up against new circuit investment in other parts of the world? Will the 'new' financing of the sport from the Arab Peninsula and the United States create new forms of topophilia for a new generation of fans? The economic, geopolitical and media logic of the F1 racing calendar suggests the most profitable circuits will ultimately succeed. But such logic may also conflict with deeply held emotional ties many fans hold for the circuits with longstanding legacies within the broader cultural heritage of the sport.

This snapshot of the F1 fan survey reflects very positively on the sport and its new owners Liberty Media. A key dimension of the respondents to the survey is the changing demographic of Motorsport Network's consumers, who reflect the transformation in both the age and, to some degree, the gender profile of F1 fans. Motorsport Network's fan survey reveals the average age of respondents has fallen since 2005 from 36 years, 8 months to 32 years, with more than a third of respondents under the age of 24. We now turn to examine how this changing age demographic reflects the digital transformation of F1 communications.

F1 and Generation Z

One of the themes that has run through this book is that sport, as is also the case with other media forms and genres, is facing new technological disruption through the nature of fandom and patterns of media engagement driven by generational change. This concern among media sports, keen to access Generation Z and the Millennial audience has become more widespread in recent years as audiences (willing to pay) for sports content have become older. It should be noted it is an anxiety that exists among senior media executives across most areas of the media industries as they seek to change their businesses to address this cultural shift in media consumption and the nature of the audience. In the UK, Channel 4 Chief Executive Alex Mahon recognised this challenge with regard to the future of public service media. She argued:

> Older generations – those that grew up as Channel 4 grew up in the 80s and 90s – were the last of 500 years of people whose world view was shaped by Gutenberg and the printed word. Gen Z live in a Google world – video-first search; the algorithmic selection of their information and entertainment diet; an agenda of influence that derives from unimaginably large numbers of invisible connections across an unseeable network. Our social norms are in flux: it is too early to say what normal behaviours or boundaries will settle to (Mahon, 2022).

While at a *Sport Matters* conference held in October 2022 to coincide with the Singapore Grand Prix, this issue with regard to the future of sport and sports content was much debated (1). What emerged from the discussions among researchers, specifically with regard to the Gen Z audience was not that they were less engaged in sports and sports content, than previous generations. Rather, what was being argued was that they engaged in sports content in differing ways and had a far greater range of alternative sources of cultural engagement than was on offer to previous young people. Four key trends about Gen Z and their relationship to sports content emerged from the conference. These were the importance for this audience of authenticity in a sport, the need for a high level of connectedness in a sport, a normalisation among this group of virtual sporting activities and the importance of a sport being always online and available.

To this end a more curated sporting experience, with a strong digital dimension was crucial if a sport was to secure the attention of an audience that had access to alternative sources of entertainment. What sports and in

the case of this research F1 specifically can offer this audience are passion points of engagement and the ability to seek out communities of sporting tribes online as part of that experience. In this sense sport as a cultural form is offering what it has always done and that is it is a vehicle for the expression of individual and collective expressions of identity. The connected digital environment, mean that process is available 24/7 and is not curtailed by restrictions of space/time/geography. Again, in another aspect of continuity, sport is about character, narratives and drama, it has always been these aspects that the media, particularly through television coverage has been able to amplify and indeed construct, select and organise for its audience. The digital age has intensified this experience by bringing the sporting experience and its key protagonists closer still to that audience through the mediation of digital platforms and the activation of fan engagement strategies.

As we have noted earlier in the book, Liberty Media were clear on taking over F1 in 2017 that a better understanding of the F1 fan was central in any plan to strategically grow the commercial value of the sport. Ross Brawn F1 Managing Director, Motorsport argued in 2020 that:

> We are an amazing and unique sport. For example, you can talk to a driver five minutes before he gets in his car and competes. You can hear him communicating with his team in the race. You couldn't do that in football; you couldn't do that in any other sport I can think of. We've got this fabulous opportunity of engagement that fans can have with the sport and we've got to sensibly maximise that and fully recognise the unique sport we have. (Hamilton, 2020: 12)

Greg Maffei, Chief Executive of Liberty Media, is clear that creating new (and younger fans) has been a key objective of the media company since securing control of F1. Speaking in 2022 he argues that by bringing down the average age of the F1 fan they have,

> opened up a whole bunch of consumer products and a whole bunch of other kinds of brands that find it appealing. So, we've really been very lucky to have all sorts of sponsor interest. About the young audience, we credit Netflix for opening it up to a lot of people. But what's fascinating is how many of these people have come in in different ways. Social media has an enormous part. Gaming: you can go on and play Lando Norris and race the same track that Lando does. That's very appealing to a lot of young fans. That didn't exist seven years ago, it really was not planned. And so opening up the sport, making it more appealing. Yes, it's got elements of exclusivity, for sure. But there are elements that all fans can touch. (Allen, 2022)

The importance of gaming as a way in to F1, or as complimentary to other forms of the mediated experience, was echoed in the Motorsport Network (2021: 48) fan survey. Over 50% of respondents to the 2021 survey revealed they regularly engaged in motorsport gaming. Nearly two-thirds (61%) of the motorsport gamers were under the age of 24, predominantly male, and from either Europe or the Asia-Pacific regions. The demographic shift towards young people's multi-media engagement with F1 is firmly established and has consequences for F1's commercial strategies going forward. This has been recognised by stalwarts of the sport, who have seen the F1 fan base transform before them, and also transform their own fame. Italian engineer and Haas team manager Guenther Steiner has been involved in the sport for over two decades, and in his autobiographical account of the 2022 season acknowledged how Liberty Media's strategy has begun to change the demographics of sports' fan base:

> With regards to the future of the sport, I would say that Formula 1 has put itself in good position in the medium to long term just by engaging with younger fans. As long as they carry on doing that and don't forget about what they are doing, it should be OK. I don't know the exact figures but the difference between an average F1 racegoer in 2001, which is when I joined the sport, compared to 2022 is pretty noticeable. For a start, there are a lot more of them! That's for sure. But they are also a lot younger these days and there are also far more women at races than there used to be. That's all positive. (Steiner, 2023: 187)

Steiner has acknowledged that the Netflix series *Drive To Survive* has brought new fans to the sport and, as a consequence, the representation of his own extrovert and avuncular personality has turned him into a cult hero with viewers of the documentary. His book, *Surviving to Drive*, a clever pun on the Netflix title, was clearly marketed with the new fans of F1 in mind. Although ghost written, the book is structured in diary format reflecting on the pressures of being an F1 team manager. However, its appeal is the vernacular style of writing which echoes his persona within the documentary series with plenty of swear words, no-nonsense commentary and humour.

Steiner's new-found fame, which he has embraced albeit in a somewhat perplexed manner having never watched *Drive to Survive*, reflects the crossroads the sport is facing as the fan base broadens. Crucially, there is an increased focus on the entertainment values of the sport, its personalities and rivalries (either real or constructed by the media), something Steiner has been very astute to accommodate. How the needs of different generations of

fans – the 35+ 'petrol heads' and the Gen Z digital natives – will be met is therefore a fundamental marketing challenge for the sport. Ross Brawn, with over 40 years' experience at the top of F1 as either a Technical Director of teams or a Team Principal acknowledged the implicit challenge in any growth strategy that seeks to add new fans to the F1 community. He noted that:

> Of course, as well as bringing new fans to the sport we mustn't alienate the ones that we have built up over the years. We need to protect what they enjoy. (cited in Hamilton, 2020: 12)

So called 'legacy' fans are notoriously hostile to major structural changes in any sport that they will have significantly invested in both financially and emotionally over many years, not least if they see this change dismantling key element of the sport that have helped to sustain their loyalty over the years. The attempt by a number of elite football clubs to set up a breakaway European Super League in European football in 2022, was in no small part derailed by the ability of the legacy fans of a number of the English clubs to mobilise public and political opinion in a manner only possible from those with a significant emotional investment in those clubs.

Drivers, Social Media and the F1 Lifestyle

Sporting heroes and heroines are figures who are celebrated for their skill, courage and achievements. They also come to represent particular values associated with an era, culture and society that links them to their fans. F1 has a long roster of heroes who have come to represent the pinnacle of bravery and skill in one of the world's most dangerous sports. While F1 drivers are largely judged on their performances and victories – an important narrative trait in heroic myth and fiction – there are also intangible discursive traits drivers develop largely through their relationship with the media and fans (Whannel, 2002). For example, biographies and documentaries on the Brazilian and former world champion driver Ayrton Senna focus as much on his personal character, style and charisma as they do his achievements in F1. Senna's heroic status symbolises a collective identity through sport, inscribed by meanings created about him by media narratives and F1 fans. His tragic death in 1994 had a profound impact on the Brazilian nation, whose president Itamar Franco declared three days of national mourning. For many Brazilians, such as fellow motor-racing driver Christian Fittipaldi, he represented the

ultimate hero who 'goes out into the world to represent a Third World country and succeeds against people from places where the conditions are very much better' (quoted in Williams, 2010: 4). Senna became famous in what was then a new global televisual age of F1, with every race live on free-to-air channels across the world, but his death did cause a rethink of safety in the sport by the FIA and F1 which has ultimately changed the design of cars and the nature of racing.

The processes by which societies confer heroic status on drivers shifts with the culture in which they now operate (Hughson, 2009). The F1 stars of today, and the narratives of their professional and personal lives, are radically different due to social media. Fans only really got to know the behind-the-scenes character of Ayrton Senna after his death in the highly acclaimed feature-length documentary *Senna* (2010) directed by Asif Kapadia. Drivers in the digital age of disintermediation – where smart phones with powerful cameras and video capacity – can connect with millions of fans, sharing backstage moments of F1 as well as intimate moments of their personal lives away from racing (Haynes and Boyle, 2018). Today's F1 drivers operate in the era of social media which is globally connected, instantaneous, always on and for the most part unregulated. This has radically shifted the relationships between drivers as elite sports people and the fans – as we discussed in chapter Four, drivers can directly connect with their fans without the need for journalists or broadcasters as intermediaries. For photographers, in particular, the use of smart phone photography, especially selfies taken by drivers or fans, has radically shifted an F1 fans relationship with the sport. As we noted in chapter Four, former F1 photographer James Bareham believes smart phones transformed how we view the image, and concludes, 'It's changed everything. It's not just sport, it's changed society' (Interview with the authors, 21 October, 2022). Fans attending F1 are as likely to get a close-up image of their favourite driver as a press photographer during signings or sponsorship events. While the framing of the image may be different – perhaps more hurried and lower resolution – these vernacular images captured on smart phones present a particular way of seeing an event, full of emotional meaning for the fan taking the image, which can be shared and annotated via social media networks instantaneously. Fan selfies, with drivers or with other fans, also embody the fan in the F1 space to say 'I'm here', acting as forms of self-witnessing, and connecting them to a wider universe of F1 fans as a form of cultural capital (Van Dijk, 2013).

The motivations for fans to share images from sport can vary dependent on the social media platform being used, with platforms such as Snapchat popularised for socially sharing the experience of a moment, and Instagram used to memorialise a fans presence at an event (Billings et al., 2015). Motorsport Network's 2021 fan survey revealed Twitter [now X] to be the most used platform for F1 fans, with over 40% using it for their information needs. Where Instagram grew in use for the sharing of images, Facebook saw a significant decline in use (from 40% to 20%) perhaps reflecting its wider decline among younger people more generally.

Drivers, increasingly in the Gen Z generation, are acutely aware of the value of using self-produced imagery and selfies to build their connectedness with the F1 fan community and build their personal and sponsor brands. The 2021 World Champion Max Verstappen was viewed as the most popular driver, most notably with adults aged 25–45, while newcomer Lando Norris was the second most popular driver, who's following mainly came from young adults aged 16–24, many of whom were young women. Lewis Hamilton, came third in the 2021 popularity poll, remaining the most popular among older adults aged over 45. However, when one reviews the level of followers on driver social media platforms, Hamilton is the most popular driver by some margin, with over 30 million followers on both X (formely know as Twitter) and Instagram, three times the number of any other driver.

One aspect of this changing ecology has been a broadening of the points of connection to F1 which no longer solely relies on the live television race content of the Grand Prix. Drivers such as Lewis Hamilton have used social media to build their own personal brands and emotional connections with fans by revealing other dimensions of his lifestyle. His Instagram postings in particular reveal an individual who likes to relax away from the circuit by surfing or his interest in popular cultural areas such as music and fashion. F1's communications are very attuned to this broadened focus around drivers and their lifestyles, as Liam Parker, Director of Communications at F1, explained at length:

> So, you know our social media platforms are growing exponentially, so are the teams, so are the drivers. The way they interact with their fans across fashion, across different things. They're not just talking about racing, they're interacting with other celebrities, other stars. They're doing content that's interesting to people not necessarily interested in Formula 1 and that's dragging people in. I think also the way that the media are covering things now is, if you are a young woman in the United States who reads a certain type of magazine every week and you're used to seeing NBA players

and NFL players and all of a sudden you've got a really interesting Formula 1 driver talking about life, mental health, their struggles, what they do, the pressures on them as a driver, you've got more chance of someone then saying, 'I'm interested in that person. I'm going to look them up on social media, or watch Netflix or maybe tune into the next race,' than you would if we weren't engaging with those kinds of publications. So, I think it transcends sport. There's interest in Formula 1 as a thing but not necessarily know what it is and I think all of these things have kind of broken-down barriers and dragged people in. (Interview with the authors, 27 January, 2023)

The potential challenge for F1 teams is how the individual driver engagement with the fans via social media aligns with their mission to grow the manufacturers or the sponsors brands. Bradley Lord, Chief Communications Officer for the Mercedes team explained how they have managed this relationship with Lewis Hamilton:

It's about dialogue and trust, to be honest – and a shared objective, which is to win. As you say, there are guidelines and then they evolve and we adapt them and if things pop up, we talk about them. And just get ahead of it, obviously with Lewis we've got an athlete who is building a very strong brand; a personal brand that overlaps into the athlete brand. Generally, as a team you contract for the rights to the athlete brand and then leave the personal space alone. So, that there's still a rights perimeter to commercialise there as well but it's really in dialogue around where those boundaries are and to what extent they can flex one way or the other. (Interview with the authors, 1 December, 2022)

The opening up of F1 by Liberty Media (discussed in chapter Three) have given access to F1 related content across a range of platforms and helped facilitate a level of fan engagement unimaginable under the previous rights holder's regime. The younger generation of fans are connected via social platforms and some (not all) have come to the sport via the personalities (drivers) or the teams and their brand. Motorsport Network's 2021 fan survey supports the general trend here towards the use of specialist F1 web and podcast content, an increasing use of social media platforms like X (formely know as Twitter) (the most used platform) and Instagram (the most used platform for F1 fans aged 16 to 24). The 2021 survey suggested that 'Formula 1 continues to engage fans on a sport-first basis, in sharp contrast to most team-based sports, especially ball sports' (Motorsport Network, 2021: 38). The report suggests F1 remains largely 'non-tribal', with two-thirds of respondents following a number of teams and drivers. Jess McFadyen then Digital Director of Motorsport

Network and now a senior producer with Sky Sports F1, explained how their findings reflect an increasingly global fan base:

> It's become a fully globalised product so the driver doesn't have to be the same nationality as you, the team doesn't have to be the same nationality as you. It's about who do you relate to more and that's also guiding the way that Formula 1 speaks to people that I think has changed. (Interview with the authors, 5 October, 2022)

Nevertheless, long-established teams such as Ferrari still have enduring appeal to F1 fans since the survey began in 2006, in spite of the exclusive championship success of Red Bull and Mercedes since 2010. The enduring popularity of Ferrari does suggest a level of tribal following, and when viewed through a national lens Ferrari remains resolutely associated with Italian F1 fans. National pride and popularity of drivers also follows the success of particular drivers – Lewis Hamilton, knighted in 2021 for services to motorsport, has been central to maintaining British interest in F1, and the more recent driver championship successes of Max Verstappen has dramatically increased the popularity of the sport in The Netherlands where television audiences for F1 grew by 81% in 2021 (F1, 2022).

F1 fandom then, is a very mixed picture and the trends ebb and flow with both the relative success of drivers, as well as the effort different teams put into their social media presence. Performance in racing does not always translate to popularity. In the 2021 fan survey McLaren came out as the favourite team, knocking Ferrari from the top which reflected a more strategic approach to their digital presence across different social media platforms. As Jess McFadyen explained, 'McLaren had gone all out, fan focus, the drivers that they'd had had been extremely marketable and popular and that had seen their popularity rise even though they were tooting around at the back of the grid.' The effort teams in the middle-to-bottom end of the grid put into their digital communications reflects the business stresses they are under from sponsors to reach out to and broaden their fan base in innovative and engaging ways. In 2022, McLaren's social media recorded 1 billion video views from 240million social media engagements across its digital platforms (McLaren, 2023: 21).

McLaren's digital strategy has centred around revealing the inner workings of the entire F1 team over a race weekend. It has done this primarily through its 'Unboxed' series on YouTube. Claire Cronin, McLaren's chief marketing officer, explained their approach is to use their employees with specialist knowledge to tell the story of each aspect of McLaren's operation.

'We're always trying to draw up different personalities within the team across the different race series to ultimately serve our goal,' she argues, 'which is to grow our fanbase and to monetise that fanbase better than anyone else' (Brittle, 2022). Cronin views that fanbase as being made up of two broad tribes, the 'avid' fans who were socialised into the sport from an early age, and 'trend' fans, who are more transient and interested in the broader life-style aspects of F1. McLaren are increasingly learning from sponsorship part-ners how to use data about their fanbase to enhance the loyalty of their fans, such as the Hilton group in the hospitality business. 'It's a great way to cross-fertilise knowledge and raise the levels and standards that everyone's working to' Cronin has been reported as saying, thus revealing the reach of business and marketing knowledge to contemporary F1 teams which had previously just focused on the core activity of motorsport. McLaren's F1 racing profile also directly feeds into the McLaren Groups financial health with a successful order book for its hybrid Artura luxury supercar heavily linked to the popular-ity of driver Lando Norris.

As McFadyen has stressed, the digital presence and success of F1 teams like McLaren is more complex than the exposure created by *Drive to Survive*:

> So a lot of people always look to the Netflix documentary *Drive to Survive* as one of the major precursors for F1's massive meteoric rise in popularity but I think it's way more nuance than that, it comes from using the social platforms, opening the doors to more people, allowing it to be more consumable, engaging with fans and kind of just embracing this new way of talking about the sport as well as the *Drive to Survive* documentary, and also with the introduction of younger drivers that are more digital savvy, they are more accessible, they understand that they need to be always on, almost. (Interview with authors 5 October, 2022)

One consequence of F1's digital presence is that while television remains a key element of the overall fan experience (particularly for those aged over 35) the social media platforms and myriad of content producers are crucial in underpinning the popularity of the sport. This includes F1, through its web and OTT platforms and also rights holders such as Sky Sports. Sky's digital offering of content extends well beyond the GP race and the weekend, as it offers short form content and news across its own in-house platforms as well as external touch points such as its YouTube platform, or through Monday, post-race weekend show *Any Driven Monday*, streamed on that platform, rather than Sky Sports' television channels. Again, the 2021 fan survey provides

evidence of this trend for Pay-Tv and specialist motorsports websites as the key places to access F1 news updates at any time of the year.

How fans engage and what motivates that engagement is increasingly being diversified. As some observers of the F1 industry argue:

> Now fans only really identifying closely with drivers through social media and that is often their only media involvement – they only follow the social media channels of their favourite drivers and teams. And it is has also become very clear that only a small minority of fans want to absorb the technical side of the sport which, up to very recently, was widely thought to be one of the biggest draws – it isn't. In reality the fan base has many different touch points. (*BusinessF1*, 2022: 61)

The heterogeneity of F1 fandom in the global digital age of the sport, also means that fans come from a more diverse range of communities and backgrounds. Many of F1's new fans are drawn to the celebrity status of drivers, who are increasingly profiled in global lifestyle magazines or advertising endorsements of leading lifestyle brands. In a 2022 feature in lifestyle magazine *Vanity Fair* young F1 drivers including Lando Norris, George Russell, Pierre Gasly and Estaban Ocon were profiled wearing designer clothing by global brands including Saint Lauren, Armani, Prada, Dior and others to combine their growing fame in F1 with the wider prestige of luxury goods. The article includes interviews with drivers and new celebrity fans of the sport, including New York designer Sandy Laing who states, 'I was never really into F1 until the Netflix show', concluding, 'I'm so invested because I follow their social media and I feel like I know them through the Netflix show' (Adler, 2022). Laing's comments echo that of many new fans to the sport, who have been drawn into the rivalries and personal interest stories of drivers behind-the-scenes. This new community of fans have also embraced social media platforms to both build their own personal brands as digital influencers in the sport, as well as connect themselves within the sport in creative and innovative ways.

F1's New Content Creators

As we noted in chapter Four, F1's media has been overwhelmingly dominated by male journalists and broadcasters, covering the deeds of an almost exclusively male sport. The Liberty Media era has, however, brought some distinctive transformations in this respect, largely connected to the ubiquity of social media use by fans and the rise in prominence of female content creators

who have focussed their cultural production on motorsport. Most crucially, the growth of fan media in the first decade of the twenty-first century era of networked media sport (Higgins and Rowe, 2012) has been enhanced and consolidated by 'platformization' (Nieborg and Poell, 2018) a process that provides communicative infrastructures for fans as cultural producers. The platforms most central to the boom in F1 fan content creation have been Instagram, Tik Tok, Twitch and particular platforms that host fan podcasts. While other social media such as Facebook, X (formely known as Twitter) and YouTube remain important to certain constituencies of fans, and content will be cross-promoted through them, it is clear particular F1 fans have developed their largest and committed audiences in other platforms.

Nieborg and Poell (2018) have argued the production and circulation practices on platforms influences the nature of cultural creativity in terms of market structures, governance frameworks and the digital infrastructure. F1 content creators have gravitated to contemporary popular platforms Instagram and Tik Tok because of their accessibility for creative production, their visual focus in either photography or short-form video, and their substantial growth as useful marketing platforms driven by data on user interactions. Similarly, the livestreaming platform Twitch connects F1 fans passion for motorsport to e-sports experiences of F1 gaming by enabling audiences to communicate in real-time using a chat window that accompanies the video feed. Podcasting, which can be hosted across different platforms in an open architecture, and predates social media, has nevertheless gravitated towards consolidation as storage, discovery and consumption are dominated by services such as Apple Podcasts, Spotify and Google Play (Sullivan, 2019).

The consolidation of these distribution platforms has occurred in the same period of Liberty Media's ownership of F1, which has arguably led to a proliferation of new podcast producers, some fan-led and others produced by legacy media outlets. WTF1 podcast was originally founded by motorsport enthusiast Tom Bellingham in 2010 which echoed the masculine performativity of 'petrol head' fans outlined by Sturm (2011). The success of the podcast led to its purchase by The Race Media whose fan-led creative content and had 85 million video views from a subscriber base of 1.4m in 2023. Bellingham and his podcast co-host Matt Gallagher parted company with The Race Media in 2023 due to creative differences, but they soon established a new podcast P1 with Matt and Tommy with podcast company Stak which soon reached the top of the F1 podcast charts with Apple and Spotify.

The opportunities to create content through these platforms is global, exploiting the convenience of cloud computing storage which makes content visible to search algorithms and produces media experiences that are contingent on personal preferences. Podcasts and livestream fan experiences on YouTube and Twitch for gamers offer richly layered mediated F1 experiences, reflecting the 'second screen' culture of audiences consuming sport from more than one electronic device (Cunningham and Eastin, 2017). For F1 fans, each race can be consumed across multiple platforms, produced by different cultural producers in different media forms, all at the same time or asynchronously. Second screen culture has revolutionised the volume of content, personalisation and participatory culture of F1 fandom. As a corollary it has also created new social media stars who are influencing the meaning of F1 to a new virtual community of fans.

As a way to explain the rise of female social media content creators in F1 we now focus on the growing profiles and content produced by individuals who have used their personal profiles on Instagram and Tik Tok to not only develop large followings but also forge a new form of media career in F1. Two of the best known F1 creators in the 2022/23 season were Toni Cowan-Brown a British social media entrepreneur based in California and Lissie Mackintosh a content creator who has transcended being a fan to become a new kind of communicator in the F1 media environment. What is immediately noticeable about their profiles on their most popular platforms of Instagram and Tik Tok is their popularity as communicators on F1 does not stem from the usual professional practices of sport journalism. Rather, as either innovative creators of digital content or social media influencers with large followings, they receive media accreditation to operate as fans with journalistic access. This means they transgress the barriers that prevent regular fans entering into the professional racing spaces of F1, such as the paddock, team hospitality centres, the circuit prior to the race and corporate hospitality in and around F1 racing. The content they create does represent recognisable aspects of motorsport fandom, but also has touchpoints to other areas of popular culture more usually seen in fashion, travel and style magazines than sports media. The form of the content produced is a mixture of smart-phone photography, editorial imagery and short-form video which may focus on themes related to a personal worldview of being a motorsport fan, which is embellished with behind-the-scenes access most fans would never achieve without media accreditation.

Toni Cowan-Brown is founder of Not Another Media Company and describes herself as an entrepreneur operating at the intersection of tech, pop

culture, politics and F1. Following an early career at the European Commission working on technology issues and subsequent work for technology start-ups in the US she established her own social media company which features podcasts on the subject of women and technology as well as her passion for F1. In 2023, Cowan-Brown had 87,000 followers on her Tik Tok channel @f1toni which grew following her attempt to produce a 'Beginner's Guide to F1' on the website *Sunday Fangirl*. The Tik Tok channel broke down the guide into manageable bite-sized content and in an interview with online fashion magazine *Who What Wear* Cowan-Brown explained the rationale for the move from fan to social media entrepreneur:

> I realized that people enjoyed going on this research and discovery journey with me and that the gap I was filling was this desire for knowledge and learning. [] I'm hoping to break down some of the stereotypes in this space and the toxic traits we are seeing with certain fans who think the sport belongs to them because they can name every race Michael Schumacher won. [] There is no one way to be a fan – that's the beauty of fandoms. (Huber, 2023)

The feminist impetus in Cowan-Brown's mission to break through certain communications barriers through the use of social media platforms is apparent in this and other public statements made throughout 2022/2023 season. In an interview for *The Athletic* Cowan-Brown also explained what she believes to be the difference between a content creator and social media influencer in F1.

> Influencers, in my experience, tend to want brand partnerships with brands and products. Whereas content creators seem to be building their own franchise and their own products. (Coleman, 2023)

The distinction may seem trite, but content creators are building careers as communicators by identifying with the needs of fans, whereas influencers are arguably building their celebrity through association with the brands of teams and their sponsors.

Lissie Mackintosh directly addresses the 18–24 demographic of the new F1 fanbase. In doing so she used her own rapid trajectory as a young fan of F1 to build a trajectory into more mainstream media success. Mackintosh moved into content creation on the back of watching *Drive To Survive* during the Covid19 pandemic in 2021. Her Tik Tok profile gained popularity as her videos focused on her personal fan journey from watching the Netflix

series to engaging with the 2021/22 F1 season. Much like Cowan-Brown she attempted to break down the complexities of F1 with videos appealing to teenage girls and young women, the new profile of F1 fan transitioning from the documentary series to watching F1 racing live. Mackintosh's content on Tik Tok cleverly distilled key facts on racing rules and F1 terminology into the three-minute constraint of the platform. Her success in clearly communicating the complexity of F1 in an enthusiastic and relaxed style endeared her to a new F1 fan base keen to understand what is going on in any F1 weekend. Mackintosh's images and videos resonate with fans because of their informal framing, in contradistinction to television broadcasts, for example.

Mackintosh's persona on social media represents a confident enterprising young woman engaged as a fan in the highly masculine technological domain of elite motorsport. The style of her posts, similar to other young women in F1's social media environment, is foregrounded by a socially feminine subjectivity, more commonly seen in social media channels on fashion and beauty. Brooke Erin Duffy and Emily Hund (2015: 9) note how such entrepreneurial femininity and self-branding of bloggers often draws on three inter-related tropes that foreground 'the destiny of passionate work, staging the glam life, and carefully curated social sharing'. Mackintosh's postings on Tik Tok certainly contain such feminine tropes but also showcase masculine tropes of technological authority and competitive strategy. In doing so Mackintosh transcends the historic sexual objectification of women in motorsport (Tippett, 2023) offering new modes of engagement for female fans with F1. On Instagram Mackintosh presents a personal perspective of her new life in F1 with a mixture of self-filmed videos preparing for global trips between F1 races, the selection of clothing choices, or showcasing the latest merchandise from teams and sponsors. At the same time, she provides informed comment and insights on any given race weekend. The appeal of Mackintosh's self-presentation, therefore, lies in the skill of combining tropes of feminine and masculine subjectivities which draws praise in the comment threads for her glamorous style and the knowledgeable substance of her F1 postings.

By 2023, Mackintosh had over a quarter-of-a-million followers on Tik Tok and was well known among drivers, teams, sponsors and the mainstream sports media. In 2022 the meteoric popularity of her Tik Tok videos led to employment with F1's Track TV providing behind-the-scenes perspectives and interviews on race weekends from the paddock and on the circuit. Mackintosh also produced content for F1 teams and sponsors.

The inroads of female social media content creators in the F1 media space have not been without challenges. Both Cowan-Brown and Mackintosh mention in several media interviews how their legitimacy to present content on F1 as fans of the sport have been challenged by male fans who view their style of presentation as inauthentic because of their gender. As Mackintosh notes, 'I have been told too many times to stay in the kitchen or explain what DRS is in front of a large group, but I remember that I need to use it to fuel me. What I'm doing is so much bigger than hateful or small-minded people' (Coleman, 2023). Such experiences of misogyny represent moments of cultural resistance to male attempts to reassert masculine hegemony in motorsport. F1's new female content creators are challenging such arcane views, and innovating new modes of communication in motorsport which combine feminine style with technological knowledge.

As well as being enticed into the intriguing world of F1 competition and the life behind-the-scenes of drivers through the social media postings of content creators, fans are also being drawn into the wider cultural politics of the sport. In the next section we focus on some of the challenges F1 faces in dealing with the politics of social justice and the environment which pose significant challenges and contradictions for a sport premised on global competition and a carbon-based motorsport.

Growing the Global F1 Fan: Where Sport, Marketing and Politics Collide

The expansion of F1 to circuits in countries where some nation states hold different political views to those commonly held by the international community through organisations like the United Nations and their Sustainable Development Goals raises issues regarding the rights of citizens and the role of motorsport in delivering both economic and cultural prosperity for the host nation. F1, and sport in general, occupies a contradictory place in the geopolitics of human rights and social justice campaigns, not least because it garners support from states and global corporations which contradict its own mission 'to leave a legacy of positive change wherever we race, enriching local communities and economies, and supporting the natural environment' (F1, 2019).

While it falls on sport leaders to negotiate the diplomatic nuances that exist towards progressive policies and cultural relations (Jarvie, 2023), F1 arguably has a larger job to do than most given its historic reliance on fossil

fuels and the sponsorship of transnational corporations (which for many years focused on the tobacco industry). Under the commercial stewardship of Ecclestone, the brokering of positive economic outcomes for F1, the Teams and himself, dictated the terms of reference for all decisions on F1. Under the ownership of Liberty Media, economic imperatives remain but a new commitment to be pioneers in the motor industry to sustainable forms of transportation, and for F1 to be a net zero carbon sport by 2030 have formed a key part of the organisations public affairs. The ambitious sustainable policies of F1 are also important for its relationships with its fans and have far reaching consequences for both spectators who attend races and those who consume the sport across digital platforms. F1's public relations with its global fan base have been acutely tested with the decision to expand races in the Arab Peninsula, not least in Saudi Arabia since 2021.

Claims of 'sportswashing' by the European media with regards to the Arab Peninsula's investment in sport and increasing involvement in the running of major sports leagues and events has become a major geopolitical dynamic of contemporary global sport, including F1 (Rayman, 2023) and other motor sports (Næss & Hölzen, 2023). The Saudi Arabian Public Investment Fund, is linked to a wider reforming programme 'Vision 2030' instigated by the country's leader, Mohammed bin Salman, which has turned to sport to 'open' Saudi Arabia to the wider world and deflect from its fossil fuel-led economy and historic human rights abuses. Heavily criticised by human rights organisations, such as Human Rights Watch, especially in the context of the murder of journalist Jamal Jashoggi in 2018 and the war with the Iranian-backed Houthi's in Yemen, the decision to hold an F1 race in Jeddah in 2021 was heavily criticised. The moral principles of western-based sport organisations to hold sporting events in states with well recorded accounts of human rights violations have fallen to the wayside at the promise of multi-million-dollar contracts. Although Saudi family investment in F1 was not new, having previously backed the Williams team in the 80s and 90s (Rayman, 2023), the scale of new investment to host F1 was a signal of ambition to gain influence within motorsport's premium arena.

The 2022 race raised security concerns when a Houthi missile targeted the Armco refinery only a few miles from the Jeddah circuit. Ahead of the 2023 race many drivers echoed the official line that improvements had been made to enhance security of the race for F1 teams and fans. In 2023, Lewis Hamilton was a sole dissenting voice among the drivers, albeit appearing to keep his critical comments of the Saudi regime and its poor human rights

record in check. In an interview with *Autosport*, Hamilton set out his own views on the Saudi involvement in F1:

'I still feel that, as a sport going to places with human rights issues such as this one, the sport is duty bound to raise awareness and try to leave a positive impact. And I feel like it needs to do more. What that is, I don't have all the answers. But I think we always need to do more to raise awareness for things that people are struggling with.' (Kalinauckas, 2023)

As Ben Carrington (2023: 356) observes, Hamilton's public persona has transformed 'from a once quietly spoken, almost shy, driver, who for the first half of his career cautiously avoided topics beyond the track, into one of the world's most politically conscious and outspoken athletes.' In 2021, human rights organisation Codepink, backed by 41 organisations, urged Lewis Hamilton to speak to Saudi leaders to highlight rights abuses (Richards, 2021). Hamilton purposely drew attention to LGBTQ+ rights by wearing a rainbow helmet at races in Qatar and Saudi Arabia. Hamilton has been forthright in the use of X (formely Twitter) to comment and campaign on social justice issues. The scale and scope of his social media networks provide him with a genuinely global platform to share his views on the social injustices of racism, sexism, homophobia and the impact of climate change. Social media has enabled him to connect with collective action mobilised through social media platforms, but in doing so he has also been open to hostile counter-publics that have coalesced to criticise his involvement in such movements as Black Lives Matter or Me Too. Carrington (2023: 378) rightly suggests that Hamilton's shift to critical consciousness reflects an elite black athlete 'comfortable with his own shape, his own skin, without having to contort himself to fit into the all-white, class-exclusive worlds' of F1. Hamilton's personal proactive stance on particular social justice issues, which have been largely supported by the Mercedes Team hierarchy, have nevertheless been at odds with host regimes where the human rights have been heavily criticised by the international community.

In spite of individual driver disquiet on the Saudi race, others in F1 have sought to use the presence of F1 as a space for sport diplomacy. Following the 2023 GP in Jeddah, the Alpine Team website carried an article focused on Aseel Al-Hamad, the first female board member of the Saudi Arabian Motor sport Association (Alpine, 2023). The article celebrates the increased opportunities for women in F1, echoing the wider

policies of equality and inclusivity for women included in Saudi's Vision 2030 goals. The rhetoric is upbeat and attempts to dispel perceptions that oppression of women in the Kingdom prevails. 'Women have only been driving for the past few years and they aren't familiar with driving' Al-Hamad stated, concluding, 'To have someone, who drove a Formula 1 car thanks to Renault and Alpine and who is leading transformational change, be on the podium presenting an award is a big statement' (Alpine, 2023). The article includes an image of Al-Hameed holding a detachable high-tech steering wheel from the Alpine F1 car, a symbolic image of women's emancipation in the world of motor sport. Its positive message is clearly aimed to reflect a sense that F1 and motorsport more generally is a domain open to women as motoring enthusiasts, and Al-Hamad as a global advocate for women in F1. The image also echoes the much-heralded lifting of the Saudi ban on women driving in 2018, suggestive of how far Saudi women's inclusion into the world of cars and motoring has come in a relatively short space of time. Academic research on the lifting of the driving ban in the Kingdom reflects a different reality. Initial analysis of the 2018 policy suggested that 'the government's new gender inclusive driving policy embodies a rebranding effort from the top, rather than responsiveness to Saudi women's rights activism, or public opinion' (Wheeler, 2020). Longitudinal analysis of Saudi women's mobility in the post-driving ban era also reveals 'that the de jure change in women's mobility does not necessary translate into de facto change, as underlying societal and family challenges remain.' (Macias-Alonso, 2023).

Further evidence of the continuing constraints on women's liberty in Saudi Arabia gained international attention in May 2023 when Manahel al-Otaibi, a 29-year-old social media commentator and rights activist was arrested after using a hashtag promoting the end of male guardianship in the state (Kirchgaessner, 2023). The incident followed several other arrests of women using social media to criticise human rights abuses in the country, and flagged the hypocrisy of Saudi's actions to promote positive images of women, including in sport, at the same time denying them some fundamental human rights of freedom of expression and movement. The arrests of Saudi dissidents who used anonymous Twitter [now X] accounts to criticise the Kingdom were linked to potential data breaches of the platform by Saudi spies identified by the FBI (Menn, 2023). The Saudi controversy regarding Twitter has also been linked to the Kingdom's investment in the company by Prince Alwaleed bin Talal who is the second largest investor

in the company behind Elon Musk (Kichgaessner, 2023). The arrests and legal cases around the dissident use of social media indicates there remains an extremely long way for the Kingdom to go in terms of equality and freedom of speech regarding women's human rights. F1's commercial relationship with the Kingdom therefore, indicates there are structural inconsistencies in its mission for equality, inclusion and diversity when it continues to agree deals with states with well-known human rights abuses.

Conclusion

All of the interviewees we spoke to when researching this book mentioned the changing nature of F1 fandom. In most cases, they pointed to the promotional impetus *Drive To Survive* had given to creating a new fanbase for the sport, subsequently bolstered by fan activity across social media platforms. This view is supported by the global fan surveys by Motorsport Network which captured the changing demographic of F1 fans. It is a model other global sports, tennis and golf, have subsequently followed with their own Netflix series *Break Point* and *Full Swing* in an attempt to capture new, younger and diverse sets of fans around the world. What is noticeable about this phenomenon is that live broadcasting of the sport is not necessarily the key hook pulling new audiences in. Instead, the documentaries build narratives that focus on personalities in the sport, using behind-the-scenes storylines to deliver intrigue and insights of what motivates elite sporting performance and rivalry. The world of social media acts as a hinterland of what Umberto Eco termed 'sports chatter', which in today's visually-led networked media sport produces short-form video which is globally accessible, instantaneous and accelerated. F1 actively promotes engagement between drivers, teams and sponsors with fans through social media. It skips the intermediary focus of journalism and broadcasters, and affords control of the message. Fans as content creators are also actively encouraged and welcomed into the F1 communications ecosystem. Fan social media engagement and quasi-professional content creators scale up the storylines and emotional attachments to the sport, all positive traits for the 'brand health' of F1.

At the same time, social media platforms present challenges for the 'brand health' of F1 through discriminatory content, abuse of F1, teams, drivers and sponsors, copyright and other licensing transgressions, and

legitimate political dissent or criticism from human or environmental rights organisations seeking change F1's operations or business partnerships. F1 fans will continue to have an important voice across social media platforms, acting as the ultimate arbiters of the sport's appeal and ethical approach. In the final chapter, we return to the issues we foresee dominating F1 in the coming decade, and how its commercial and media model will shape the parameters of what the sport means for its millions of fans.

CONCLUSION: INTO TOMORROW

The world of Formula One probably contains more first-class brains than any other three sports put together, but all the intellectual activity in the world could not compensate for a colourless race…

Richard Williams, (1998) Racers, page 194

We opened this book, with a quote from sportswriter Richard Williams as he reflected on the sport he found in the mid 1990s. We would argue, that his assertion of the powerful business and sporting intellects that can be found in F1 remains more than applicable today, as does his view that the sport can produce less than exciting races, despite attempts by the media to suggest otherwise. As argued throughout the book, sport and its relationship to the media is being shaped by the wider trends of digitisation, marketisation and globalisation, and F1 is a microcosm of how these are being played out in a particular sport. This chapter returns to the issues raised at the start of the book and highlights some of the key findings from this study that emerge from both the case study of F1, but also the wider evolving media-sports relationship. As we stand on the cusp of more technological innovation through the potential cultural and commercial changes offered by the metaverse, what does this case study of F1 tell us about the future of sport and its relationship with the audience, the media and its ongoing cultural, economic and cultural impact?

The Importance of Storytelling

In this new age of television content and increased competition as new streamers enter the market, sports content remains important for many key incumbents. In 2018, Comcast (owners of Universal Studios and the NBC television network), paid £32 billion to secure control of Europe's largest Pay-Tv operator Sky. Despite the competition from the streamers and the arrival of new competition into the European market such as Disney+ in 2020 and

Paramount + in 2022, the importance of sport and F1 to Sky remains crucial as it transforms into a streamer itself through Sky Stream and NOW TV. The business model may be changing (millennials and Gen Z's do not generally wish to be locked into 18-month television content contracts and pay in the UK £70–90 for the privilege), hence Sky's move into streaming and adoption of the monthly contract model initiated by Netflix back in 2012, while keeping other parts of the market on the full Sky longer term deals.

Against this intensely competitive market, sport's appeal to television has always been about the ability of the form to produce a compelling narrative that engages supporters and keeps them coming back for more. As sport as a cultural form has transformed into mediated sport, this process has intensified, initially through the press, then radio and finally television (Boyle and Haynes, 2009). What we argue in the book is that the streaming age has elevated this process to a new level, augmented by social media and an increasingly easily distracted audience base. Unlike previous epochs, when sport was deeply rooted in cultural practice, not least in an age of less media choice and potential access to various forms of entertainment, sections of the sporting audience are not as deeply immersed or invested in sports culture as some supporters. They are more likely to be drawn in by a particular aspect of the story, but their interest can wane and they will move on to the next mediated story that catches their eye, or appears in their social media feed.

As we have argued elsewhere in the book, given the hidden nature of much of F1 and its complex rule bound formula, as a sport it requires a lot of media production work to transform into a televisual spectacle. Perhaps more than many sports the commentators on race day are required to provide a plethora of information to augment and make sense of the pictures, while graphics and on-screen information is crucial in order to follow what is actually happening during a race. Without these it would be impossible to follow the sporting event. This transformation is a continual process, often aided by technological developments, but driven by commercial concerns as rights holders seek to maintain the interest (and value) in their sport. Sky, for example, as providers of the UK and world feed on race days for the 2023 season, introduced a number of innovations into their coverage. What is significant about the constant incremental intrusion of television into F1 is the level of access required from the teams and the sport, that previously would have been difficult to achieve, even by Ecclestone who was acutely aware of the importance of television to his business model.

At the core of this change have been greater use of on-board cameras and microphones. Before 2023, Sky had access to nine cars with on board cameras, and then control rested with F1 as to what was allowed to be broadcast (Miller, 2023). From 2023, Sky had access to all twenty cars, and were listening to team radio traffic (between drivers and their engineers) during the race and broadcasting, introducing what they feel adds real value, without compromising the drivers and the team. This is a challenging editorial line and Sky brought in Bernie Collins, the former Head of Strategy at Aston Martin F1 to help the Sky production team as well as inform the viewer at home. The increased use of cloud storage, allowed Sky to scale back on its on-circuit hardware, thereby facilitating access to more content. The enhanced digital storage of content has enabled the broadcaster to integrate a more diverse range of content into the live race coverage, to spin off previously unused content into additional channels, or provide short clips as instantaneous news on social media platforms to add value. The multi-platform approach has enable Sky F1 to reach a new fan base that is happy to access the sport on the platform of their choosing.

While all sports rights holders want to maximise their revenue, this is usually done through the selling of these rights to a third party. What makes the F1 case both interesting and distinctive is that a media content company own the entire commercial rights for a whole sport. As a result, the commercial logic is to develop that asset (the sport) in order to maximise revenue from a range of sources. As F1 business analyst Mark Gallagher observes when examining the desire by Liberty Media to add more races to the F1 calendar:

> It is the most straightforward way to grow revenue from promotors, broadcasters, sponsors, merchandise and corporate hospitality sales. It translates into greater profitability, the sine qua non for a publicly listed company focused on driving shareholder value (Gallagher, 2023: 62)

We noted how the 2023 Las Vegas Grand Prix was one of the first to be promoted and controlled in terms of event delivery by F1 itself, rather than a local promotor, while the historic television coverage provided by French broadcaster TF1 at the Monaco Grand Prix, also ended during this season. The latter came about as a result of a new deal between F1 Group and the Automobile Club de Monaco (ACM) that secures the Monaco Grand Prix until the 2025 and sees the revenues paid to F1 to stage the event rise to around $10m. Both are examples of the tighter commercial control being

taken by a media-oriented rights holder, keen to refresh and update the 'product' and expand interest in that important USA media sports market.

Sport as Entertainment

Another theme that has emerged from the research is the increased blurring of the lines between mediated sport and aspects of the reality TV genre. In short, the latter is scripted drama, while the appeal of elite television sport is the element of its unscripted nature, the possibility that, on any given day, the underdog might beat the favourite, the possibility of the late goal, that moment of individual or collective creativity that changes the outcome of a sporting contest. When does sporting entertainment shape shift into sport as entertainment?

This is a complex debate. We have long argued that the marriage of television and sport was never a meeting of equal partners (Boyle and Haynes, 2000). Historically television has always called the shots with regard to sporting forms and formats, adapting and reshaping to suit the codes and conventions of television and its institutional needs, be that tie-breaks in tennis, twenty-twenty and white ball cricket, hours of hype around a major boxing fight or penalty shoot outs in football. However, the ever-closer pulling of sport as cultural form into the orbit of the media entertainment industry can raise issues about something more than these historical reshaping of sporting rules, to fit the desires and whims of its financial underwriter, television. What is being suggested here is increasing manipulation of the event (and the audience) through the deliberate intervention of television into sporting contests to change and alter the event for commercial reasons.

We opened the book with the hugely controversial final race of the 2020 F1 season and the crowning of a new world champion in Max Verstappen. The extent to which that race was manipulated to create an exciting and highly impactful final lap for the global television audience, transforming what had been a routine Grand Prix, into one of the most controversial in the history of the sport, remains contested. What is not in doubt, is that in an age of social media, disinformation and the ability of various sporting and political conspiracy theories to gain traction and prominence at an astounding rate, anything which appears to tamper with the sporting integrity of an event leaves that sport wide open to the perception of manipulation. In other words, the engineering of the sporting spectacle for the television audience.

The danger of such a process, is that while it may allow some short-term spike in the attention economy, so beloved of media content creators, in the long term it damages sporting integrity and the authenticity of the brand.

The appeal of sport is the human struggle to be successful within meaningful rules and regulations, after all sport is a rule bound activity, differentiating it from simple play. An element of impartial interpretation of those rules is central to the meritocratic discourse so important in any sport. Sport as a form of media entertainment still requires an element of the unscripted and the spontaneous, rather than the predetermined and contrived (elements often found in other television genres). Another key part of the sporting mix, is the importance of passion, both of the sporting participants and the fans. In F1, for example, there exists a growing lack of transparency around the implementation of the rules, or a seemingly never-ending desire to tinker and change rules and regulations. In so doing there is a danger that the sport becomes engulfed in an opaque culture that lends itself, in the age of the rush to judgement, to be (mis)interpreted by the legions of social media followers keen to impose their own narrative on events. Veteran F1 journalist and writer Maurice Hamilton argues that:

> [Liberty] allowed this Netflix series, *Drive to Survive*, which is incredible. I mean it has gone right behind the scenes and exposed stuff that I would never have known myself even though, I've never seen before. Very, very good; it's incredible, showing the angst, and the stress and bereft and the detail that's going on. It's been very, very good at that and opening up to an audience that were kind of half interested; didn't really know. And you look at it and go, 'My god, I never realised it was like that.' You know, a lot of people thought, when they saw a pit stop and the 20 guys go round the car that that plus a few others was the team; they didn't realise there was another 700 back at base. So, it's exposed and drawn people in and the downside of that, I don't know if you had probably read about it if you did, saw it maybe, the fiasco of the last lap in Abu Dhabi last year; when the championship was decided on the last lap after 22 races which was truly appalling. I mean absolutely, the way the thing was done, basically the race director made a mistake. What it boils down to in my view is, it was the referee made the wrong decision, which they do, do. As Alex Ferguson [legendary former Manchester United manage] will tell you, from time to time, that's what happened. He made the wrong decision, but the referee's word is final so that's the way it is. However, because of Liberty's chasing of getting it out and making it attractive, a lot of people actually believed that that was done deliberately for Netflix, the series. They actually believed that, and you can see why. It's kind of came back and bitten them on the bum a wee bit, you know. Now that's the downside of it. (Interview with the authors, 3 June, 2022)

Hence issues of sporting integrity and authenticity remain extremely import-
ant with regard to the long-term wellbeing of the sport, yet the temptation
by those who now control sport as media content to tamper and intervene for
short term impact has never been greater. As also noted earlier in the book an
added complication for F1 is the barely concealed tension that exists between
the FIA (responsible for the rules and governance of the sport and other parts
of the motorsport world) and the F1G, owned by Liberty Media that control
the commercial rights for the sport.

There is also evidence that Liberty Media are keen to extend aspects of
the F1 brand into other areas of the media entertainment sector. 2023 sees an
Apple Studios funded F1 movie in production, starring Brad Pitt and includ-
ing Lewis Hamilton among the producers, with filming taking place around
the British Grand Prix at Silverstone during July of that year. The F1 Group
are also moving into scripted television drama, with the announcement in
June 2023 of Bedrock Entertainment's television series *One* (with F1 as a pro-
ducer and officially sanctioned by the commercial rights holder). The series
will focus on a family run F1 team (and the attendant drama), promising to
blend fiction with aspects of the actual F1 season. In many ways these devel-
opments and the access offered by the sport to these film and television series
is a natural extension of a media company attempting to stretch the value of
their rights and build and extend the core sports brand among new and non-
sporting media audiences.

Direct to the Audience

One of the key issues to emerge from this research is the ongoing shift in the
delivery of sports content direct to the audience. The political economy of
media sport has operated for decades along a specific rights model, one in
which governing bodies and rights holders give access to their sport to be mar-
keted and promoted by a third party. Historically as we have noted in chapters
Two and Three, this was a television broadcaster and the value of live sport
has acted as the driver of change within the television industry, helping in
no small part to usher in the era of pay-TV and the mixed economy of FTA
sport and subscription-based sports content. The streaming economy and a
more robust internet structure have changed the rules of engagement, bring-
ing much needed (to the rights holders, if not the viewers) competition at a
stage when the pay-TV market in both Europe and the North America had

reached a level of maturity that the ever-increasing value of tier 1 elite sports (such as the EPL in the UK) to pay-TV was potentially plateauing.

Enter the new (and as we have seen throughout the book) the not so new players in the streaming market, with the added bonus, for rights holders of the possibility of developing your own platform and selling your content direct to the fans, retaining control and also the data that can now be harvested through such arrangements. Of course, this paradigm shift in the sport media economy is not new and we have documented (Boyle and Haynes, 2004) the attempt, led by Roger Mitchell of the Scottish Premier League (SPL) way back in the early 2000s to implement such a model, only to be undermined by a combination of some risk averse clubs and a much less robust digital infrastructure where accessing content across multiple screens was still a niche activity.

What the F1TV and F1TVPro developments detailed in chapter Three highlight is that this process of rights holders delivering content direct to its audience is well underway but will be far from linear in its development. It will work better for some sports than others. For the top tier sporting events the value still attributed to them in particular markets mean that the numbers do not yet add up to cut out the traditional broadcasters and or streaming platforms. As we discussed earlier in the book, F1 has trailblazed in this area, but in a highly strategic manner. In key European markets F1 has worked with the dominant pay-TV broadcasters, such as Sky (with the basic F1TV available here). In other markets, such as India where they were unhappy with the value placed on F1 by domestic host broadcasters (it might be argued that many in that market had overpaid for cricket, the key sport in the Indian market) F1 launched the F1TVPro platform to deliver all their content to Indian motorsport fans willing and able to pay.

In 2022, the media rights to F1 generated revenues of $936m, around 40% of total revenue for the commercial rights holders of the sport (Agini, 2023), with direct to audience revenues from their own F1TV platform estimated to be over $50m, up from $19m in 2020. We argue that for some sports this process of moving to deliver their sport direct to consumers will happen more quickly than others, and while the direction of travel is clear, we feel it is not preordained that pay-TV and the third-party rights model will simply whither on the vine in the next decade and every top-flight sport will move to deliver their main broadcast via their own platform. Rather, that the platformisation of the sports media economy has added a further disruptive layer to a new more complex era of rights exploitation by sports and clubs that will not see any

one-size fits all template being adopted. For some sports, the value of selling their rights will continue to offset the, albeit tempting for many sports, idea that there is more revenue to be made in controlling delivery of their sport. For some sports the value added through brand association with a key sports broadcaster and/or platform will allow new audiences to be built, while the access that FTA live and highlights coverage can afford to large non-sporting audiences will remain an element in the strategic growth of some sports.

The success of the women's football game in the UK (in both England and Scotland), has in no small part been accelerated by the extensive promotion and prominence given to the sport and its stars across all the extensive platforms of the public service BBC (Ramon & Haynes, 2019). Growing the game to the extent that it has in the last few years through the development of both its live and television audience would simply have been impossible had the sport resided behind a paywall or on a niche subscription platform.

Sport and Technology

The accepted wisdom has often been that it's the liveness of sport, that helps make it such a compelling cultural form for television. The advent of the streamers has not changed this, but, as we noted in chapter Five, they have added a new layer of complexity to this through the rise of sports documentaries, in the case of F1, specifically *Drive to Survive*. As streamers have moved from simply licensing intellectual property (IP) to creating and controlling their own IP, it is beginning to alter the relationship for media companies between live and non-live sports content and its value to their audiences and subscribers.

Ever since Netflix extended their investment into sport docu-series, there have been expectations and rumour the streamer would seek to carry live sport to augment and build its audience already enticed by its non-live sports content. It is notoriously difficult to predict the precise shape of media development, but it would seem unlikely, without a significant financial downturn that Netflix would jump into that market. But the AppleTV move into the live US sports of basketball and soccer through its link up with MLB and MLS suggests a direction of travel, that will see a tightening of the relationship between key media players (of which the streamers are not part of that environment) and sports, with a range of live and non-live content. The signing in 2023 of footballing superstar Lionel Messi for the MLS team Inter Miami,

involved Apple TV as the MLS broadcast partner as part of the complex financial contract attracting the 35-year-old star from Paris Saint Germain (PSG). Apple TV announced a four-part docuseries on Messi in the same week he signed for Inter Miami, providing a good example of the increasingly close linkage between sport, the streamers and the importance of celebrity in adding commercial value as platforms, such as Apple TV seek to stand out in a crowded market place in an attempt to attract the sports fan.

F1 fans are also being drawn to the sport through other computing technologies, most notably E-sports, in which racing games have long been the bedrock of video game play and online communities. Motorsport has been a theme in gaming since arcade race games were introduced in the 1970s, and F1 style cars featured in *Pole Position* launched by Namco in 1982. Personal computing and exclusive licensing agreements for F1 games to home gaming platform Sony Playstation, and subsequently British-based developer Codemasters (owned by EA Sports since 2020), brought simulated F1 experiences to millions of gamers around the world. The demand for simulated experiences has continued to grow (Formula 1 consistently appears in the top ten most popular E-sports), with opportunities to occupy the driving seat of contemporary F1 cars around the world's leading circuits in modes which are increasingly immersive. The high-definition accuracy of graphics and driving experience has blurred the boundaries between the sport and simulated racing to such a degree that contemporary F1 drivers regularly use software such as iRacing and rFactor2 to prepare ahead of grand prix races. Sim-racing communities also modify games and circuits to revisit F1 cars from previous seasons. The scale of the gamification of motorsport has led F1 to develop new partnerships with the industry to exploit the commercial opportunities for the sport. In 2022, F1 signed a franchise partnership with Kindred Concepts to launch F1 Arcade that combines full immersive F1 experiences with premium hospitality and other F1 themed entertainment. Developments such as F1 Arcade provide further evidence of the entertainment focus of the sport as well as the opportunities computer simulation technology allows fans to bridge the experiential gap mentioned by Murray Walker that most F1 fans do not know what it is like to race an F1 car.

The advent of the metaverse also opens up numerous opportunities for a media centric sport to enhance its engagement (and increase revenues) with its fans. By metaverse we mean the development of the interconnected network of 3D virtual worlds, that will both potentially act as a gateway to the online environment, as well as increasingly underpin much of the physical

world (Ball, 2022). Mathew Ball, in his study of the business impact of the metaverse argues that:

> Sports fandom is currently isolated between watching a game, playing a sports video game, participating in fantasy sports, making online wagers and buying NFTs, but we'll likely find that each of these experiences melds together and in doing so, creates new ones (Ball, 2022: 259).

Given the early adoption advantages that media companies will enjoy as this process develops (and is being driven by the big technology/media companies such as Apple) expect any sports closely aligned with media corporations such as F1, to be at the forefront of sporting engagements with this new more immersive world.

The Future

As sport has got pulled more and more into the orbit of the media industries, and, certainly at the elite level becomes an entertainment brand, then often a certain commercial logic follows as sport becomes increasingly commodified. The lexicon has been evolving for years, with sport often being discussed at corporate and executive levels as a media 'product' or 'content'. The case of F1 carries that logic to its endgame, where a media company Liberty Media control the commercial side of an entire sport. While in 2023, they are profiting handsomely from their investment (estimated to be close to a $1 billion a year), initially they were making a loss. But the logic of such asset acquisition is to sell at the top of the market. Potential buyers may include political states such as Saudi Arabia through their Public Investment Fund, keen to extend their soft power and influence in the sports world, or media platforms and businesses such as Apple, Paramount, Disney or even Netflix. A possible $22 billion price tag (including any outstanding debt) may not be something certain media organisations would baulk at (Comcast paid $40 billion for Sky after all) to secure a global sport, controlling commercial rights and other revenue streams.

Against this corporate backdrop, issues around the role of tradition within the sport and the tension between this and the changing nature of F1 as it seeks to grow and retain new audiences, looks set to be an ongoing feature of the sport in the next decade. For example, the introduction of three 100 km sprint races (lasting about 25 mins) during the 2021 season on the Saturday

of a Grand Prix weekend had been driven by the desire of Liberty Media to provide more compelling content for both those that attend the event in person and the television audience across all three days. By the 2023 season this had increased to six sprint races. However, it remains not universally popular among the drivers, with world champion Max Verstappen stating about the sprint format.

> I don't find it's the DNA of Formula One to do these kind of sprint races. F1 is about getting the most out of qualifying and then having an amazing Sunday, good long race distances. That's the DNA of the sport and I don't understand or I don't know why we should change that. (Reid, 2023)

It should be noted that other drivers such as Lewis Hamilton and Ferrari's Charles Leclerc have been much more receptive of this change.

The development of F1 also mirrors the wider trend that has seen the centre of gravity of international sport increasingly move away from its traditional European heartland. In 1998, almost 70% of sixteen races in the F1 season were held in Europe. Twenty years later, there we now twenty-one races in the expanded F1 calendar, with only nine Grand Prix (around 43%) now held in Europe. By 2023 the percentage of European races in the season had fallen to just under 40%, indicative of a global expansion and an increasing focus on the USA market with three Grand Prix.

The paradox of sport as form of media content is that while it can offer brilliant unscripted drama, it can also be dull and anticlimactic. The former components television wants, the latter less so, but that is part of the essence of sporting competition and it's impossible to have one without the other. As Ben Hunt, F1 correspondent for *The Sun* reflects:

> I do wonder what happens when Lewis stops and Max keeps winning. I also worry that when Netflix grow tired of producing their shows, what happens? I think ultimately what happens is that it then falls back to the journalists to start telling the story, and I hope that newspapers and independent sources are still going then, because I think that is very important. We will need to dig into those characters in the lower Formula and try and bring the sport to life again. Because I think there is a danger, having mentioned the way the Press Room has gone, and the way that there is a reliance on other people asking questions at the track. If those people aren't going and asking those questions, and everyone is more content to take the responses, the social media from the teams, then we could be left with a sport which is a little bit empty, and we're seeing it all artificially played out rather than seeing the stories and the nitty gritty behind the stuff that we really do like to talk about. I think it's always funny that, from a TV point of view, they turn the cameras off on a

Sunday and they go home, and then in the coming days it's always the written press that keep the narrative going – we fill in the blanks – but then we also set the agenda for the Thursday when they come back into the paddock, which is something which the TV companies automatically pick up, because it's a talking point. But that's the written press doing that. If you haven't got the written press doing that, and you've just got people reporting lap times and new wings and stuff like that, then it becomes very sterile, very boring, and you also lose that new fan, or the casual fan, and think 'oh hang on a minute, this is a bit of a closed shop, it's now become too technical, too boring, Max is going to win every weekend'. So that's the difficulty for Formula One – it needs to protect those old school relationships and the old school style of reporting and storytelling, and if it doesn't have that, then it's in difficulty. (Interview with authors, 15 September, 2022)

It is not that the sport is unaware of these challenges ahead. Liam Parker, Director of Communication and Corporate Affairs at F1 argues that:

Yes, one of the two lines in my communication strategy is to anticipate and move early to head off any risk of the shine diminishing. We're at a great moment and there's interest everywhere but like every sport, like every politician, like every band, superstar it comes in cycles and we had the period where Schumacher dominated for many years and people tuned out Formula 1 then we saw a resurgence in battles of three people going for a title in one race and then it comes back again. We need a system where firstly the racing needs to be good. If the racing is good and the product is good and exciting people will watch it and I think that's one of the great things the [English] Premier League has, you can have shock results that spice things up. Now we're on a journey towards that in Formula 1 with these new regulations but the sport needs to be good. The racing needs to be fun as otherwise the reason to watch it disappears. But we also need to lock a generation in now so that they follow us through that journey. So, if there is a period of dominance, be it Verstappen or someone else, that they're willing to stick with us and you also need the media to understand and the social media and the fan base. You need to explain the process we're on. (Interview with authors, 27 January, 2023)

Is Parker then concerned that periods of dominance by one driver, as we have noted already a not uncommon feature of the sport over the years, will seriously impact on the popularity of the sport in media terms? He suggests that in this regard:

I am optimistic but the concern is how do we safeguard against the other side of the mountain? And you've got to do that by locking in a lot of things now and continuing to evolve your content to give people another reason to be interested in Formula 1 other than just pure racing. You know, what else is interesting? There's music events, there's entertainment, there's fashion, there's unique hospitality, there are world events we go to, amazing cities. There are so many things more than the

racing but the racing still needs to be the best. Obviously also, at some point sadly Lewis will retire. We need to make sure that once the big shining lights go, that there's a big affiliation with the new generation, that they are the new Lewis, they are the new Max etc, etc. We need to make sure that they're known so that we don't have to do a two-year job of building their profile, they need to be known now, and that's done extensively through their teams and their social media outlets. (Interview with authors, 27 January, 2023)

Also the importance of reframing the narratives around the sport for the new audiences. Former Head of Marketing and Communications at F1 Ellie Norman suggests that:

> but you also have what I would describe as headwinds, so car manufacturers going into electric motor racing, certainly a generation of people millennials and Gen Z far more conscious and aware of the environment, Greta talking about it. You've got all those headwinds and yet, and we know that we have this perception of being like an old school billionaire boys' club that's inaccessible. For me it's how do we use communication and marketing to pivot what luxury means and luxury in now isn't what we thought luxury was in the '70s and '80s when actually there is something that is aspirational and desirable, I think, around how you can be pushing forward technology, innovating, creating new fuels, still actually having an incredible spectacle and this media entertainment but also know that you can still do a little bit of good from that as well. (Interview with authors, 28 November, 2022)

What this also highlights are that the importance of being open about the close relationship between sport and wider social, cultural and political change. The mythological division between sport and society, or in media discourse between the news and sport, is not sustainable, and interestingly the audience now increasingly accepts this, and it appears that it is the media that is struggling to play catch up.

Endgame

For some the essence of a live sporting event remains compelling, and integral to that is the unscripted element of the cultural form. As journalist and F1 Historian Maurice Hamilton notes:

> One of the moment's I've always loved is the hour before the start of the race. And you start to walk around the paddock, you start to walk around the pit lane and you see the mechanics all getting ready and they're out the back having a final coffee and a smoke before they get it on. The tension builds up and you go on to the grid, alright

there maybe are more people on the grid now and more personalities and maybe more technicians and so on and so forth compared to back in the day but that tension, that feeling that something's about to happen, that the weekend's work, the 2 days that have gone before, all the efforts that has gone into it; it's still the same because the one guy in the car is now the man. That hasn't changed. At the end of it all, after the end of 75 laps, whatever it might be; world championship points are going to be awarded. This is a round of the world championship and the tension and drama is still there; that bit has not changed. I'll go to Silverstone this year, I'll be on the grid just to savour that and to stand on one side and take that in, because it's magic; wonderful. That hasn't changed. (Interview with authors, 3 June, 2022)

The extent to which that sport as a cultural form still exists, despite the layers of distortion and mediation that come with the territory of contemporary sport in the digital platform age is reflected on by journalist and former McLaren and Aston Martin F1 Communications Chief, Matt Bishop. He notes that:

You know I fell in love with the sport when I was 11 or something. Nothing's the same since, you know, I am completely different. The world is completely different, and the nature of how you consume sport as a fan utterly different. Over the past, while. But at the end of the day, there is still an extremely fast racing car. I mean the fastest of its era, whether it was 1974 or 1984 or 1994 or now. And so it was the fastest pinnacle of motorsport projectile on wheels that you could get. And you have brilliant, and brave athletes, called racing drivers inside, risking their lives. That hasn't changed the nature of the car has changed. They've got faster, much faster. They also got safer. But you can still die. But I think that nature of man and machine against the circuit is still there, and the courage is still there and the skill is still there. It's just very difficult to see. For me, it's your heroes, whether it's music or film, or football, whatever other sports, or most but it's the you know between nine to 15, where you completely fall in love with your heroes including your sporting heroes. And even though Lando Norris may be just as good a driver as James Hunt but he is not going to get you excited in a way that James Hunt will have done when you were 11. (Interview with authors, 11 July, 2022)

This book has been an attempt to capture a moment of transitional change across a sport and media industry with a focus on the centrality of the media in that process. We argue that the evolution of F1 offers some insight into the direction of travel sport will take in the digital age. But here's the rub. Sport is unscripted drama and thrives on competition and elements of jeopardy. Having drawn in new audiences the uncompetitive nature of the 2022 and 2023 seasons that sees Max Verstappen win race after race often by up to 20 seconds will not appease or retain the interest of some of these new fans. Of course, the history of F1 is often characterised by long periods of dominance

by one driver. But that was when the sport relied on a particular television fan base and not one enticed by the allure of the *Drive to Survive* narratives and the extraordinary conclusion to the 2021 season. Addressing how to make F1 racing competitive is not a new challenge, but the sport has become so complex with so many moving parts that finding a solution may not be easy.

Sport will continue to play an important role within the global supply chain that is the international television streaming industry. In so doing it will continue to evolve and be driven by media demands and imperatives, perhaps in ways, some of us would rather it wasn't. The danger for sport is forgetting that its core business is entertaining by offering authentic competition and rivalry, and as long as we can stream the rivalry (and its underpinned by compelling and engaging storytelling that connects aspects of our individual and collective sense of identity) then sport will continue to matter culturally and commercially within the cultural and media industries.

BIBLIOGRAPHY

ACTT History Project. (1987). Bill Mason, film director, film producer, recorded on 4th October 1987, interviewer Alan Lawson. <http://historyproject.org.uk/interview/bill-mason>

Adler, D. (2022). Netflix, *Drive to Survive*, and the New Cult of F1 Fandom, *Vanity Fair*, April.

Agini, S. (2023). How F1 found a secret fuel to accelerate media rights growth, FT Scoreboard. <https://www.ft.com/content/0c762af6-81c4-4c86-9258-33fea8d474dc>. Accessed 27 May.

Allen, J. (2022). Why F1's top bosses are thinking about a 'bigger future'. <https://www.autosport.com>, June 1.

Alpine. (2023). Through their eyes... Aseel Al-Hamad at the 2023 Saudi Arabian Grand Prix. <https://www.alpine-cars.co.uk/formula-1/f1-news/aseel-al-hamad-saudi-arabia-gp-2023.html>

Anderson, B. (2022). An unacceptable finish to an amazing season. *GP Racing*, February.

Andrews, D. L. (2001). *Sport stars: The cultural politics of sport celebrity*. London: Routledge.

Andrews, D. L. (2021). Uber-sport. In M. L. Butterworth (Ed.), *Communication and sport* (pp. 275–292). Berlin: de Gruyter.

Autosport. (2015). Full Formula 1 fan survey results revealed. 29 July 2015. <https://www.autosport.com/f1/news/full-formula-1-fan-survey-results-revealed-5003454/5003454/>

Bacallao-Pino, L. M. (2016). Transmedia events: Media coverage of global transactional repertoires of collective action. In B. Mitu & S. Poulakidakos (Eds.), *Media events – A critical contemporary approach* (pp. 189–206). New York: Palgrave Macmillan.

Baime, M. J. (2021). The Journalist Who Broke the Biggest Story in Motorsport History, Road and Track, 1 December 2021. <https://www.roadandtrack.com/car-culture/a38400686/the-journalist-who-broke-the-biggest-story-in-motorsport-history/>

Bale, J. (2002). *Sports geography* (2nd ed.). London: Routledge.

Ball, M. (2022). *The meta-verse: And how it will revolutionize everything.* New York: Liveright Publishing.

Barden, M. (2021). Multiplatform sports journalism. In R. Steen et al., (Eds.). *Routledge handbook of sports Journalism.* London: Routledge.

Barnett, S. (1990). *Games and sets: Changing face of sport on television.* London: BFI.

Barr, K., & Kretchmer, M. (2022). *Channel 4: Streaming on the world stage? Competing in the changing media landscape.* CREATe Working paper. <https://www.create.ac.uk/blog>. Accessed 30 May 2022.

Barwise, P. (2022). Who shall save a benighted BBC? *British Journalism Review, 33*(1), 39–42.

Baxter, R. (1953). Silverstone special!. *Radio Times, 43*, 10 July 1953.

Baxter, R. (1964). Motor racing. In P. Dimmock (Ed.), *Sports in view.* London: BBC.

Baxter, R. (2005). *Tales of my time.* London: Grub Street.

BBC. (2006). *Raymond Baxter: Gentleman and broadcaster.* BBC Two, 12 October 2006.

Benson, A. (2002). F1 to boost TV coverage. BBC Sport, 19 November 2002. <https://www.theguardian.com/media/2002/jul/19/broadcasting.kirchmedia>

Benson, A. (2022). Formula One: Safety car rules tweaked by FIUA in wake of controversial 2021 title decider. *BBC Sport,* <https://www.bbc.co.uk/formula1/60758648>. Accessed 19 March.

Billings, A. C. (2008). *Olympic media: Inside the biggest show on television.* London: Routledge.

Billings, A. C., Qiao, F., Conlin, L., & Nie, T. (2017). Permanently desiring the temporary? Snapchat, social media, and the shifting motivations of sports fans. *Communication & Sport, 5*(1), 10–26.

Blackstock, E. (2023). Formula One's race strategy in America isn't convincing fans to stick around, JALOPNIK, <https://jalopnik.com/f1s-us-race-strategy-not-convincing-fans-stick-around-1850374011>. Accessed 28 May 2023.

Bose, M. (2012). *The spirit of the game: How sport made the modern world.* London: Constable.

Bower, T. (2011). *No angel: The secret life of Bernie Ecclestone,* London: Faber and Faber.

Boyle, R. (2006). *Sports journalism: Context and issues.* London: Sage.

Boyle, R. (2015) Battle for Control? Copyright, Football and European media rights, Media, Culture and Society, Vol. 37, No 3, 359–375.

Boyle, R. and Haynes, R (2009) Powerplay: Sport, the media and popular culture, 2nd Edition, Edinburgh: EUP.

Boyle, R. (2018). *The talent industry; television, cultural intermediaries and new digital pathways.* London: Palgrave Macmillan.

Boyle, R., & Haynes, R. (2000). *Power play: Sport, the media and popular culture.* London: Longman.

Brawn, R., & Parr, A. (2017). *Total competition: Lessons in strategy from Formula One.* London: Simon & Shuster.

Brittle, C. (2022). 'We want to be penetrating popular culture': How McLaren Racing are engaging the next generation of motorsports fans. *Sports Pro Media.* 31 May 2022. <https://

www.sportspromedia.com/analysis/mclaren-f1-indycar-extreme-e-sponsorship-strategy-cla ire-cronin-interview/>

Bruce, T. (2016). New rules for new times: Sportswomen and media representation in the third wave. *Sex Roles, 74*(7–8), 361–376.

BusinessF1. (2022). Insight: Dumbing down the audience. November, 7(11).

Butterworth, M. L., (Ed.). (2021). *Communication and sport*. Berlin: de Gruyter.

Button, J. (2018). *Life to the limit: My autobiography*. London: Blink Publishing.

Button, J. (2019). *How to be an F1 Driver*. London: Blink Publishing.

Carrington, B. (2023). Can the Formula One Driver speak? Lewis Hamilton, race and the resurrection of the Black Athlete. In D. Sturm et al. (Eds.), *The history and politics of motorsport*. London: Palgrave Macmillan.

Carter, D. M. (2011). *Money games*. Stanford: Stanford Business Books.

Campbell, A. (2015). *Winners and how they succeed*. London: Hutchison.

Chadwick, S. (2022). From utilitarianism and neoclassical sport management to a new geopolitical economy of sport. *European Sport Management Quarterly, 22*(5), 685–704.

Chadwick, S., Widdop, P., & Goldman, M. M. (Eds.). (2023). *The geopolitical economy of sport: Power, politics, money and the State*. London: Routledge.

Chalaby, J. K. (2023). *Television in the streaming era: The global shift*. Cambridge: Cambridge University Press.

Choe, Y., Park, H. Y., & Kim, D. K. (2017). Holding or not holding a mega-event: the case of the F1 Korea Grand Prix. *Asia Pacific Journal of Tourism Research, 22*(1), 88–98.

Clancy, R. (2022). Are Mercedes already out of the Formula One title race?. *The Times*, 29 March 2022.

Clarke, M. (2002). Obituary: Bill Mason. *The Guardian*, 18 February 2002. <https://www.theg uardian.com/news/2002/feb/18/guardianobituaries>

Coleman, M. (2023). F1 'content creators' fuel the sport's growth by embracing its newest fans. *The Athletic*, 25 April 2023. <https://theathletic.com/4445664/2023/04/25/f1-cont ent-creators-fuel-the-sports-growth-by-embracing-its-newest-fans>

Collings, T. (2001). *The Piranha Club: Power and influence in Formula One*, London: Virgin Books.

Cooky, C., Messner, M. A., & Hextrum, R. H. (2013). Women play sport, but not on TV: A longitudinal study of Televised News Media. *Communication & Sport, 1*(3), 203–230.

Coulthard, D. (2008). *It is what it is: The autobiography*. London: Orion.

Coulthard, D. (2018). *The Winning Formula: What F1 teaches us about the business of life*. London: Blink.

Couldry, N., Hepp, A., & Krotz, F. (Eds.). (2010). *Media events in a global age*. London: Routledge.

Crombac, G. (2002). *Colin Chapman: The man and his cars*. London: JC Haynes Ltd.

Cronin, B. (2022). F1's growth in US worth extra 50% in team sponsorship, says MccLaren boss Brown, *SportBusiness*, 5 July. <https://sponsorship.sportbusiness.com/news/f1s-gro wth-in-us-worth-extra-50-per-cent-in-team-sponsorship-says-mclaren-boss-brown/ ?_ga=2.114021891.503973750.1667569510-1509740526.1667569510>. Accessed 4 November.

Cunningham, N. R., & Eastin, M. S. (2017). Second screen and sport: A structural investigation into Team identification and efficacy. *Communications & Sport, 5*(3), 288–310.

Daily Mirror. (1978). 'Vroom! The Grand Prixs Back', 28 January 1978, 15.

Day, J. (2003). Toyota cancels F1 sponsorship on ITV. *The Guardian*, 29 October 2003. <https://www.theguardian.com/media/2003/oct/29/broadcasting.marketingandpr>

Deans, J. (2004). ITV wraps up F1 until 2010. *The Guardian*, 23 April 2004. <https://www.theguardian.com/media/2004/apr/23/broadcasting.formulaone>

de Melo, V. A. (2011). Before Fittipaldi, Piquet and Senna: The beginning of motor racing in Brazil (1908–1954). *The International Journal of the History of Sport*, 28(2), 253–267.

Dennis, R. (2016). Ron Dennis pays tribute to Alan Henry. <https://www.mclaren.com/racing/inside-the-mtc/Ron-Dennis-pays-tribute-to-Alan-Henry/>

Dewhirst, Tim. (2023). The geopolitics of money versus morals: Location, Location, Location of the Formula One race calendar. In: S. Chadwick, P. Widdop, & Michael M. Goldman (Eds.), *The geopolitical economy of sport: Power, politics, money and the state*. London: Routledge.

Donaldson, G. (2020). Jabby Crombac (1929–2005). <http://www.f1speedwriter.com/2020/02/jabby-crombac-1929-2005.html>

Duncan, S. (2020). *The digital world of sport: The impact of emerging media on sports news, information and journalism*. London: Anthem Press.

Duffy, B. E. (2017). *(Not) Getting paid to do what you love: Gender, social media and aspirational work*. London: Yale University Press.

Eason, K. (2019). *DRIVEN: The men who made Formula One*, London: Hodder & Stoughton.

Evans, T., & Donders, K. (2018). *Platform power and policy in transforming television markets*. London: Palgrave Macmillan.

Evans, T., Tickell, S., & Erik Naess, H. (2023). Ecclestone out, liberty media in: A look into the shifting ownership structure of Formula One. In D. Sturm et al. (Eds.), *The history and politics of motorsport*. London: Palgrave Macmillan.

Elberse, A. (2022a). *Toto Wolff and the Mercedes Formula One Team*. Harvard Business School, Case Study 9-522-075, Feb. 1.

Elberse, A. (2022b). Number One in Formula One: Leadership lessons from Toto Wolff and Mercedes, the team behind one of the greatest winning streaks in sport. *Harvard Business Review*, November–December, 70–78.

F1. (2019). Sustainability Strategy. <https://corp.formula1.com/wp-content/uploads/2019/11/Environmental-sustainability-Corp-website-vFINAL.pdf>

F1. (2022). Formula 1 announces TV, race attendance and digital audience figures for 2021. 17 February 2022. <https://www.formula1.com/en/latest/article.formula-1-announces-tv-race-attendance-and-digital-audience-figures-for-2021.1YDpVJIOHGNuok907sWcKW.html>

F1. (2022). Formula One announces audiences and fan attendance figures for 2021. <https://corp.formula1.com/formula-1-announces-audience-and-fan-attendance-figures-for-2021/>. Accessed 4 November 2022.

FIA. (2022). Executive Summary of the analysis and clarification exercise conducted by the FIA following the 2021 Abu Dhabi Grand Prix, FIA. <https://www.FIA.com>. Accessed 19 March.

F1 Destinations. (2023). F1 ticket prices on the rise in 2023. 6 June 2023. <https://f1destinations.com/ranked-how-much-do-f1-tickets-cost-in-2023/>. Accessed 13 June 2023.

Finn, M. (2021). From accelerated advertising to Fanboost: mediatized motorsport. *Sport in Society*, *24*(6), 937–953.

Flew, T. (2021). *Regulating platforms*. Cambridge: Polity Press.

Folley, M. (2017). *Monaco: Inside F1's greatest race*: London: Arrow Books.

Frandsen, K. (2020). *Sport and mediatization*. London: Routledge.

Franks, S., & O'Neill, D. (2016). Women reporting sport: Still a man's game? *Journalism: Theory, Practice and Criticism*, *17*(4), 474–492.

Frederick, E. L., Hambrick, M. E., Schmidt, S., & Shreffler, M. (2019). Queue the Drama: Netflix's *Last Chance U* and the Portrayal of Myths in Sports Documentaries. *Journal of Sports Media*, *14*(1), 113–136.

Fruh, K., Archer, A., & Wojtowicz, J. (2023). Sportswashing: Complicity and corruption. *Sport, Ethics and Philosophy*, *17*(1), 101–118.

Fry, N. (with Ed. Gorman) (2019). *Survive. Drive. Win. The inside story of Brawn GP and Jenson Button's Incredible F1 Championship Win*. London: Atlantic Books.

Fynn, A., & Guest, L. (1998). *For love or money*. Boxtree; London.

Gallagher, M. (2021). *The business of winning* (2nd ed.). London: Kogen Paul.

Gallagher, M. (2022). The long interview: This is David Coulthard. *GP Racing*, August.

Gallagher, M. (2023). Ford falls back in love with Formula 1. *GP Racing*, March, p. 19.

Gallagher, M. (2023). Burnout. *GP Racing*, June, 60–66.

Garcia, C. J., & Proffitt, J. M. (2022). Recontextualizing Barstool Sports and Misogyny in Online US Sports Media. *Communication & Sport*, *10*(4), 730–74.

Gibson, O. (2008). F1 returns to BBC but ITV wins Champions League. *The Guardian*, 21 March 2008. <https://www.theguardian.com/media/2008/mar/21/sportsrights.bbc>

Gibson, T. (2022). James Gay-Rees: His soap opera has defined Formula One. *Business F1*, *7*(7), July 66–77.

Gilboy, J. (2019). Formula One absorbs classic footage archive for streaming service. *The Drive*, 25 July 2019. <https://www.thedrive.com/accelerator/21110/formula-1-absorbs-classic-footage-archive-for-streaming-service>

Gourley, A. (2021). A lesson learned the hard way. *fcbusiness*, June, pp. 10–11.

GPL. (date unknown). Franco Lini. <https://www.thegplcollection.com/franco-lini>. Accessed 10 January 2023.

Grosjean, R. with Grosjean, M. (2021). *Facing death*. London: City Biography.

Hall, S. (1978). The Treatment of 'Football Hooliganism' in the Press. *Football Hooliganism: The Wider Context*. London: Inter-Action Imprint, 15–36.

Hamilton, M. (2002). *Ken Tyrrell: The authorised biography*. London: Willow.

Hamilton, M. (2020). *Formula 1: The official history*. London: Welbeck.

Hardin, M., & Shain, S. (2006). 'Feeling much smaller than you know you are': The fragmented professional identity of Female Sports Journalists. *Critical Studies in Media Communication*, *23*(4), 322–338.

Harvey, C. (2022). Did BBC Four kill the arts on Tv. *Prospect*, May, pp. 74–75.

Hassan, D. (2011a). Prologue: The cultural significance and global importance of motor sport. *The International Journal of the History of Sport, 28*(2), 187–190.

Hassan, D. (2011b). Epilogue: The evolution of Motor Sport Research. *The International Journal of the History of Sport, 28*(2), 319–322.

Hay, J. (1965). Car race chiefs will meet over clash. *Birmingham Daily Post*, 11 May 1965, 9.

Haynes, R. (2015). William [Bill] Boddy. *Oxford Dictionary of National Biography*. Oxford: Oxford University Press.

Haynes, R. (2016). *BBC Sport in Black and White*. London: Palgrave.

Haynes, R., & Boyle, R. (2018). Sport, the media, and strategic communications management. In D. Hassan (Ed.), *Managing sport business: An introduction* (2nd ed.). *Foundations of Sport Management*. Abingdon: Routledge.

Haynes, R., & Robeers, T. (2020). The need for speed? A historical analysis of the BBC's Post-War Broadcasting of Motorsport. *Historical Journal of Film, Radio and Television, 40*(2), 407–423.

Hearn, B. (2022). *My life: Knockouts, snookers, bullseyes, tight lines and sweet deals*. London: Hodder & Stoughton.

Henry, A. (2003). *The powerbrokers: The battle for F1's billions*. USA: Motorbooks International.

Hill, D. (2017). *Watching the wheels*. London: Macmillan.

Hills, L. and Kennedy, E. (2009). *Sport, media and society*. London: Berg.

Horne, J., & Manzenreiter, W. (2006). An introduction to the sociology of sports mega-events. *The Sociological Review, 54*, 1–24.

Huber, E. (2023). The female content creators ushering in a new era of Formula One. *Who What Wear*. 25 March 2023. <https://www.whowhatwear.co.uk/formula-one-female-content-creators>

Hughson, J. (2009). On sporting heroes. *Sport in Society, 12*(1), 85–101.

Humphrey, J. (2013). *The Inside Track*. London: Simon & Schuster.

Jhally, S. (1989). Cultural studies and the sports/media complex. In L. A. Wenner (Ed.), *Media, sports and society*, 70–93. Newbury Park: Sage.

Jenkins, M., Pasternak, K., & West, R. (2016). *Performance at the limit: Business lessons from Formula 1 motor racing*. Cambridge: Cambridge University Press.

Johnson, V. E. (2021). *Sports TV*. New York: Routledge.

Jordan, E. (2008). *An independent man*. London: Orion.

Judde, C., Booth, R., & Brooks, R. (2013). Second place is first of the losers: An analysis of competitive balance in Formula One. *Journal of Sports Economics, 14*(4), 411–439.

Kalinauckas, A. (2023). Hamilton doesn't share other F1 drivers' views on Saudi GP safety. *Autosport*, 16 May 2023. <https://www.autosport.com/f1/news/hamilton-doesnt-share-other-f1-drivers-views-on-saudi-gp-safety/10444347/>

Keating, F. (2021). Murray Walker obituary. *The Guardian*, 14 March 2021. <https://www.theguardian.com/sport/2021/mar/14/murray-walker-obituary>

Khanna, T., Varma, K., & Lane, D. (2003). Formula One Motor Racing, *Harvard Business School*, Case Study.

Kim, M. K., Kim, S. K., Park, J. A., Carroll, M., Yu, J. G., & Na, K. (2017). Measuring the economic impacts of major sports events: The case of Formula One Grand Prix (F1). *Asia Pacific Journal of Tourism Research*, *22*(1), 64–73.

Kirchgaessner, S. (2023). Saudi Arabian woman arrested over Twitter and Snapchat posts promoting reform. *The Guardian*, 30 May 2023. <https://www.theguardian.com/world/2023/may/30/saudi-arabian-woman-detained-over-twitter-and-snapchat-posts-promoting-reform>

Kunz, W. M. (2020). *The political economy of sports television*. New York: Routledge.

Lawrence, A. (2021). 'Big egos, power struggles, stunning betrayals': How Netflix's Drive to Survive turned Americans into F1 fans. *The Guardian*, Friday 17 December.

Liberty Media (2020) Formula 1: Strategic Plan, https://corp.formula1.com/wp-content/uploads/2020/01/Formula-1-Strategic-Plan011320.pdf

Liu, D., & Gratton, C. (2010). The impact of mega sporting events on live spectator's images of a host city: A case study of the Shanghai F1 Grand Prix. *Tourism Economics*, *16*(3), 629–645.

Lobato, R. (2019). *Netflix nations: The geography of digital distribution*. New York: NYU Press.

Lotz, A. (2021). *Media disruption: Surviving Pirates, Cannibals, and Streaming Wars*. Cambridge, MA: MIT Press.

Lotz, A. (2022). *Netflix and streaming video*. Cambridge: Polity Press.

Lovell, T. (2009). *Bernie Ecclestone: King of sports*. London: John Blake.

Lowes, M. (2018). Toward a conceptual understanding of Formula One Motorsport and local cosmopolitanism discourse in urban placemarketing strategies. *Communication and Sport*, *6*(2), 203–218.

McCullough, K. (2022). Sports media's 'multi-polar' world. *SportsBusiness*, Issue 273, 16–17.

McKenzie, L. (2022). *Inside F1*. London: Black and White Publishing.

Mahon, A. (2022). *Beyond Z: The real truth about British Youth*, speech given by Channel 4 Chief Executive, 1 November, 2022.

Mansell, N. (2015). *Staying on track*. London: Simon & Schuster.

Inmaculada, M., Kim, H., & González, A. L. (2023). Self-driven women: Gendered mobility, employment, and the lift of the driving ban in Saudi Arabia. *Gender, Place & Culture*. DOI: 10.1080/0966369X.2023.2189570

Matchett, S. (1995). *Life in the fast lane: The story of the Benetton Grand Prix Year*. London: Weidenfeld and Nicolson.

Matchett, S. (1999). *The Mechanic's Tale: Life in the Pit-Lanes of Formula One*, London: Orion.

Matchett, S. (2004). *The Chariot makers: Assembling the perfect Formula 1 Car*, London: Orion.

Matthews, J. J. K., & Pike, E. C. J. (2016). 'What on Earth are They Doing in a Racing Car?': Towards an understanding of women in Motorsport. *The International Journal of the History of Sport*, *33*(13), 1532–1550.

McDonald, I. (2007). Situating the Sport Documentary. Journal of Sport and Social Issues, 31(3), 208-225.

Menn, J. (2023). Jailed Saudi dissident, sister sue Twitter under RICO act in spy case. *The Washington Post*, 16 May 2023. <https://www.washingtonpost.com/technology/2023/05/16/twitter-rico-saudi-arabia/>

Miller, M. (2023). How Sky Sports has reinvigorated its F1 Coverage. *Broadcast*, May.

Miller, T. (2016). Greenwashed sports and environmental activism: Formula 1 and FIFA, *Environmental Communication*, 10(6), 719–733.

Milmo, D. (2002). Sky's grand prix ratings stay in the pits. *The Guardian*, 19 July 2002. <https://www.theguardian.com/media/2002/jul/19/broadcasting.kirchmedia>

Moshakis, A. (2022). Track or Treat: How a Netflix show gave millions a new passion for sport. *The Observer*, 20 March.

Mosley, M. (2015). *Formula one and beyond*. London: Simon & Schuster.

Moss, P., & Carllson, E. (1964). The end of Grand Prix Racing?. *Sunday Mirror*, 12 July 1964, 22.

Motorsport Network. (2023). Elite Motorsport in 2023: Global fan insight into the world's premier motorsport championships. Management Report, January 2023. <https://cdn-1.motorsportnetwork.com/survey/2023/Elite%20Motorsport%20in%202023%20%281%29.pdf>

Mourao, P. (2017). *The economics of motorsports: The case of Formula One*. London: Palgrave Macmillan.

Naess, H. E., & Tjonndal, A. (2021). *Innovation, sustainability and management in motorsports: The Case of Formula E*. London: Palgrave Macmillan.

Næss, H. E., & Hölzen, M. (2023). Twitter Activism (or Lack of It) during the Saudi Arabian Formula E Motorsport Races in 2018 and 2019: Does anybody care? In H. E. Næss & S. Chadwick (Eds.), *The future of motorsports*. London: Routledge.

Neiborg, D. B., & Poell, T. (2018). The platformatization of cultural production: Theorizing the contingent cultural commodity. *New Media and Society*, 20(11), 4275–4292.

Nelson, D. (2015). The rise and fall of BBC F1. *Motorsport Broadcasting*, 21 December 2015. <https://motorsportbroadcasting.com/2015/12/21/the-rise-and-fall-of-bbc-f1/>

Newey, A. (2017). *How to build a car*. London: HarperCollins.

O'Connor, B., & Boyle, R. (1993). Dallas with Balls? Televized sport, soap operas and male and female pleasures. *Leisure Studies*, 12(2), 107–119.

Olesen, M. (2022/in press). Tour de France on Twitter. In: K. Frandsen, C. Thompson, & B. Fincoeur (Eds.), *The Tour de France in the 21st Century – current and emerging issues around TdF*. EPFL Press/Chicago University Press.

Plunkett, J. (2011). Sky to launch F1 channel in HD. *The Guardian*, 25 November 2011. <https://www.theguardian.com/media/2011/nov/25/sky-f1-channel-hd>

Poell, T., Nieborg, D., and Duffy, B. E. (2022). *Platforms and cultural production*. Cambridge: Polity Press.

Posbergh, A., Andrews, D. L., & Clevenger, S. M. (2023). 'Willpower knows no obstacles': Examining neoliberal postfeminist messaging in Nike's transnational advertisements for women. *Communication & Sport*, 11(4), 724–743.

Priestley, M. (2018). *The mechanic: The secret world of the F1 Pitlane*, London: Yellow Jersey Press.

Ramasamy, B., Wu, H., & Yeung, M. (2022). Hosting annual international sporting events and tourism: Formula 1, golf or tennis? *Tourism Economics*, 28(8), 2082–2098.

Ramon, X., & Haynes, R. (2019). Sports coverage on BBC ALBA: Content, value, and position in the Scottish broadcasting landscape. *Communication and Sport*, 7(2), 221–243.

Rayman, J. (2023). The end of oil? Formula One's changing face. In S. Chadwick, P. Widdop, & M. M. Goldman (Eds.), *The geopolitical economy of sport: Power, politics, money and the state*. London: Routledge.

Reid, A. (2023). Formula One gets quick and dirty with new Sprint Shoot-out format. *The Times*, pp. 62–63

Richards, G. (2021). F1 under pressure to speak out against Saudi human right abuses. *The Guardian*, 1 December 2021. <https://www.theguardian.com/sport/2021/dec/01/f1-under-pressure-to-speak-out-against-saudi-human-right-abuses>

Rider, S. (2012). *My chequered career: Thirty-five years of televising motorsport*. London: J H Haynes & Co. Ltd.

Robeers, T. (2019). 'We go green in Beijing': Situating live television, urban motorsport and environmental sustainability by means of a framing analysis of TV broadcasts of Formula E. *Sport in Society*, 22(12), 2089–2103.

Roabuck, N. (2020). F1 in the 1960s: The end of innocence. *Motor Sport*, May 2020. <https://www.motorsportmagazine.com/archive/article/may-2020/70/the-1960s-the-end-of-innocence?v=79cba1185463>

Roberts, K. (2009). Life's good for Mr Happy. *Sport Business*, November 2009, 26–28.

Rowe, D. (1995). *Popular cultures: Rock music, sport and the politics of pleasure*. London: Sage.

Rowe, D. (1999). *Sport, culture, and the media: The unruly trinity*. Buckingham: Open University Press.

Rusbridger, A. (2009). I've seen the future and it's mutual. *British Journalism Review* 20(3), 19–26.

Russell, P., & Foxon, S. (2015). Born in 1915: 8 great British documentary filmmakers. BFI, 7 January 2015. <https://www.bfi.org.uk/features/born-1915-eight-great-british-documentary-filmmakers>

Schoenfeld, B. (2022). Drive to survive made Americans fall in love with Formula1. *The New York Times Magazine*, July, 14, 38–54.

Schreyer, D., & Torgler, B. (2018). On the role of race outcome uncertainty in the TV demand for Formula 1Grands Prix. *Journal of Sports Economics*, 19(2), 211–229.

Shackleford, B. (2011). NASCAR Stock Car Racing: Establishment and Southern Retrenchment. *The International Journal of the History of Sport*, 28(2), 300–318.

Slater, L. (2021). Drive to survive – The F1 documentary that has changed a sport. *The Athletic*, December 12.

Smith, D. (2021). 'Relive the first British Grand Prix this weekend, as Brooklands goes back to 1926'. *Motor Sport*, 3 August 2021. <https://www.motorsportmagazine.com/articles/history/relive-the-first-british-grand-prix-this-weekend-as-brooklands-goes-back-to-1926>

SportBusiness. (2022). *Motorsport Data Snapshot*, 1 November, <https://sponsorship.sportbusiness.com/2022/11/data-snapshot-motorsport-2022/?_ga=2.169603621.503973750.1667569510-1509740526.1667569510>. Accessed 4 November.

Spurgeon, B. (2015). A writer's take on Formula One, then and now. *New York Times*, 25 September 2015. <https://www.nytimes.com/2015/09/26/sports/autoracing/a-writers-take-on-formula-one-then-and-now-robert-daley-japanese-grand-prix.html>

Stalham, A., & Gallagher, M. (2023). *The future business Formula*. London: Rethink Press.

Steiner, G. (2023). *Surviving to drive: A year inside Formula 1*. London: Bantam Press.

Stewart, J. (2009). *Winning is not enough*. London: Headline.

Storm, R. K., Jacobsen, T. G., & Neilsen, C. G. (2020). The Impact of Formula 1 on regional economies in Europe. *Regional Studies*, 54(6), 827–837.

Sturm, D. (2014). A glamorous and high-tech global spectacle of speed: Formula One motor racing as mediated, global and corporate spectacle. In K. Dashper, T. Fletcher, & N. McCullough. (Eds.), *Sports events, society and culture*. London: Routledge.

Sturm, D. (2017). The Monaco Grand Prix and Indianapolis 500: Projecting European glamour and global Americana. In L. A. Wenner & A. C. Billings (Eds.), *Sport, media and mega-events*. London: Routledge.

Sturm, D. (2023). Formula One as television. In D. Sturm et al. (Eds.), *The history and politics of motorsport*. London: Palgrave Macmillan.

Sullevan, J. L. (2019). The platforms of podcasting: Past and present. *Social Media and Society*. Oct–Dec 2019, 1–12.

Sweney, M. (2008). ITV to show F1 grands prix online. *The Guardian*, 13 March 2008. <https://www.theguardian.com/media/2008/mar/13/itv.television>

Syed, M. (2022). F1 blurring the lines between sport and reality TV. *The Times*, Tuesday, 17 May.

Tippett, A. (2020). Debating the F1 grid girls: Feminist tensions in British popular culture. *Feminist Media Studies*, 20(2), 185–202.

Tippett, A. (2023). Gendered representations in motorsports and the case of the F1 grid girls. In H. E. Næss & S. Chadwick (Eds.), *The future of motorsports*. London: Routledge.

Turvill, W. (2022). Encounter: 'The BBC can't stop me talking about politics' Gary Lineker on his podcasting empire. *The New Statesman*, 28 October–3 November.

Van Dijck, J. (2013). 'You have one identity': Performing the self on Facebook and LinkedIn. *Media, Culture & Society*, 35(2), 199–215.

Walker, M. (2003). *Unless I'm very much mistaken*. London: HarperCollins.

Warner, E. (2018). *Sport Inc. Why money is the winner in the business of sport*, London: Yellow Jersey Press.

Wenner, L. A. (Ed.). (1989). *Media, sports and society*. Newbury Park: Sage.

Wenner, L. A. (Ed.). (1998). *MediaSport*. London: Routledge.

Wenner, L. A. (Ed.). (2023). *The Oxford handbook of sport and society*. Oxford: Oxford University Press.

Westerbeek, H., & Karg, A. (2022). *International sport business: Current issues, future directions*. London: Routledge.

Whannel, G. (1991). *Fields in vision*. London: Routledge.

Whannel, G. (2002). *Media Sport Stars: Masculinities and morality*. London: Routledge.

Wheeler, D. L. (2020). Saudi women driving change? Rebranding, resistance, and the kingdom of change. *The Journal of the Middle East and Africa*, 11(1), 87–109.

Williams, R. (1961). *The long revolution*. London: Pelican.

Williams, R. (2010). *The death of Ayrton Senna*. London: Penguin.

Williams, R. (2016). Alan Henry obituary. *The Guardian*, 7 March 2016.

Williams, R. (1998). *Racers*. London: Penguin.

Williams, R. (2022). *The boy: Stirling Moss: A life in 60 Laps*. London: Simon & Schuster.

Wilson, B. (2022). Getting under the Bonnet of F1, *Broadcast Sport*, Spring.

Wilson, J. (1967). "Ads' on race cars to beat cash shortage'. *Daily Mirror*, 30 November 1967, p. 25.

Witkowski, E., Midgley, G., Stein, A., Miller, G., & Diamond, J. (2021). Racing with the industry: An interview on motorsports, esports, livestreaming and the COVID-19 pandemic. *Sport in Society*, published online 15 November, 2021. <https://doi.org/10.1080/17430437.2021.1997989>

INDEX

Lawrence A. Wenner, Andrew C. Billings, and Marie C. Hardin
General Editors

Books in the Communication, Sport, and Society series explore evolving themes and emerging issues in the study of communication, media, and sport, broadly defined. The series provides a venue for key concepts and theories across communication and media studies to be explored in relation to sport. The series features works building on burgeoning media studies engagement with sport, as well as works focusing on interpersonal, group, organizational, rhetorical, and other dynamics in the communication of sport. The series welcomes diverse theoretical standpoints and methodological tactics seen across the social sciences and humanities. While some works may examine the dynamics of institutions and producers, representations and content, reception and fandom, or entertain questions such as those about identities and/or commodification in the contexts of mediated sport, works that consider how communication about sport functions in diverse rhetorical and interpersonal settings, how groups, families, and teams use, adapt, and are affected by the communication of sport, and how the style, nature, and power relations in communication are wielded in sport and media organizations are particularly encouraged. Works examining the communication of sport in international and/or comparative contexts or new, digital, and/or social forms of sport communication are also welcome.

For additional information about this series or for the submission of manuscripts, please contact the series editors:

Lawrence A. Wenner | Andrew C. Billings | Marie C. Hardin
lwenner@lmu.edu | acbillings@ua.edu | mch208@psu.edu

To order other books in this series, please contact our Customer Service Department:
peterlang@presswarehouse.com (within the U.S.)
orders@peterlang.com (outside the U.S.)

Or browse online by series:
www.peterlang.com

Printed by
CPI books GmbH, Leck